LIST OF CHARACTERS

Kenji "Ken" Hideyoshi—Brought up by a twisted code of samurai traditions, Ken's life is an odyssey in which he battles the world and himself. Always looking for something better, Ken journeys through the island of Oahu only to find himself back home on the Windward side where, ultimately, he must face his demons.

Koa Pauhi Puana—Ken's best friend and a should-be Hawaiian prince, Koa is about to inherit a wasteland decimated by imperialism, drugs, abuse and rage. Charming and vicious, loyal and vengeful, Koa is a bomb waiting to go off.

"Dad" Hideyoshi—A Vietnam vet and widower, Ken's father's life has been filled with hardship and tragedy. He is consumed with the need to teach his son that the world is cruel and harsh, no matter what the cost.

Kilcha "Mama-san" Choy—"Mama-san," the proprietor of a strip bar called "Club Mirage," is a Korean immigrant obsessed with money and status. A former "comfort woman" of the Japanese Army, she is willing to do anything to insure that her daughter's life is immune to the destruction that was once her own.

Claudia Choy—A half-Korean and half-Caucasian Art History major at the University of Hawai'i, Claudia has so far lived a life sheltered by her mother's overprotectiveness and money. Falling in love with Ken, her world is changed forever.

Kahala Puana—Raised in the upper-middle class suburbia of the Ahuimanu hills, Kahala marries Koa Puana right after high school. Three kids later, living in a skeleton house with an abusive husband, she dreams of the life that should have been hers.

Matthew "Cal" Brodsky—Ken's mute cellmate in Halawa Prison, "Cal" is the audience of Ken's life story. Both a tattoo artist and veteran of the prison life, he listens while he tattoos Ken's back, always seeing parallels between Ken's past and his own.

the TATTOO 空

Published by
Soho Press, Inc.
853 Broadway
New York, NY 10003

Library of Congress Cataloging in Publication Data
McKinney, Chris.
The tattoo / Chris McKinney.
p. cm.
ISBN 978-1-56947-450-1
eISBN 978-1-56947-746-5
1. Hawaii—Fiction 2. Mute person—Fiction. 3. Tattoo artists—Fiction.
4. Prisoners—Fiction. I. Title.
PS3613.C5623T38 2007
813'.6—dc22 2006052200

Printed in the United States of America

the TATTOO

CHRIS MCKINNEY

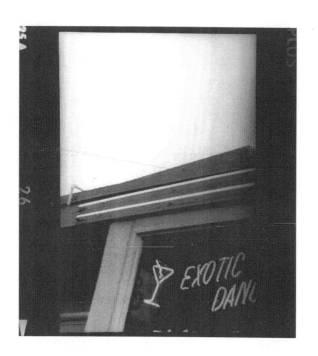

"It is said the warrior's is a twofold Way
of pen and sword, and he should have a taste
of both ways."

Miyamoto Musashi
Go Rin No Sho (A Book of Five Rings)

"I swore to myself that if I ever wrote another book,
no one would weep over it; that it would be so hard
and deep that they would have to face it without the
consolation of tears."

Richard Wright
How Bigger Was Born

table of contents

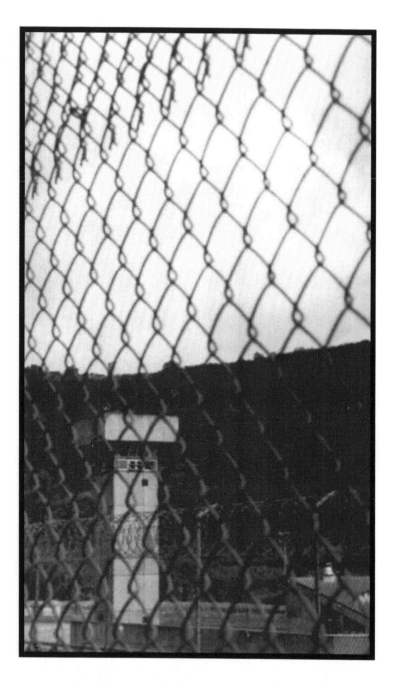

prologue

"Rusty old steampipes banging away,
letting me know it's another day,
in hell, in a cell.
For I've done wrong and I agree,
so punish me with humanity,
for I'm a human, not a dog."

Rusty Old Steampipes
Mākaha Sons of Niʻihau

fter breakfast, Cal was led to the doors of Module C. He took off his clothes and put his hands against the wall. He then let his hands fall and spread his ass-cheeks. After a few seconds, he turned around and faced the small, compact frame of Sergeant Miranda. He lifted his testicles. Cal watched the other guard, Officer Tavares, go through his clothes. After the routine inspection, Tavares tossed him his underwear, shirt, and pants. Cal glanced at Tavares' huge tattoo-covered forearms. More than me, he thought.

Cal put on his clothes and waited for the buzz of the metal door. When the buzz sounded, he went through and walked toward the barred door of Quad Two. He walked by the mirrored windows of the control box and felt the eyes behind it watching him. Another buzz sounded and Cal walked through to the door of his cell. He waited in front of the metal, brick-colored door. He looked through the skinny, rectangular window and saw his mattress, which smelled like dirty underwear. The final buzz sounded and Cal walked into his cell for lockdown.

Cal prepared the gun in his cell. He watched the Walkman motor wind and the guitar string vibrate. It sounded like a fly trapped under a thimble. Satisfied, he put the gun back into the hole of his mattress, placing it by a bottle of black ink.

A few minutes later, the door buzzed. Cal sat rigid as his new cellmate walked in. The new guy immediately dropped his

pillow, blanket, and box full of books on the floor. Cal didn't want to fight him, even though it was a jailhouse custom for a new guy to get his pillow and blanket taken away by his cellmate as soon as he walked through the door. Cal knew. He'd had just about every pillow and blanket taken away from him every time he'd moved.

The new guy took off his shirt. Cal was surprised at the sight of him, not because he was Japanese, though Japanese inmates weren't too common, but because he was a mean-looking Japanee. He was tall for an Asian, about five-eleven, not skinny, but cut-up. He would've been skinny if it weren't for the years he'd obviously spent on the weights. He had the body of a welterweight boxer. No, Cal, who as a constant victim learned to hate violence in prison, didn't want to fight with him.

The new cellmate's face had its share of pock marks. There were other scars, badges of violence, short jagged lines. None of the scars were too extreme, though — they didn't make him ugly. His hair was long, straight, thick. A ronin's hair, Miyamoto Musashi hair, Cal thought, put back in a ponytail, but not a slicked-back Steven Segal ponytail. It was a reckless, weary tie that let some of his long bangs come out on the sides of his face. His hair was more brown than black, the sun probably having toned down the darkness. His skin was dark, weathered, tough. He did not wear the skin of the cliché Japanese national, slicing-and-dicing American business. TeppanyakiGeneral Motors. He wasn't the president of Honda, Sony, not the one who bought up land from New York to Honolulu. He wasn't the bobora foreigner walking on Kalakaua Avenue, Louis Vuitton, Donna Karan, pale face, crooked teeth. He was also not the katonk of Berkeley, the A.J.A. majoring in business or engineering, devouring white jobs, trampolining off the affirmative action springboard, soaring in the white clouds. He was not even the Hawai'i townie Japanese, the upper middle-class Pearl City-living, private school-attending,

baseball-playing, gel-haired, car stereo-pounding, my-dad's-name-is-Glenn (he wears an aloha shirt to work) fucking dime-a-dozen Japanee. He wasn't townie, he was country.

His eyes were slanty eyes, but cold. Cal looked closely and saw the dark topaz, eyes that told Cal not to fuck with him. Doubting his eyes, Cal looked at his knuckles. They were scarred and broken.

The Japanese prisoner squatted on the stainless steel toilet. Marking his territory. Cal looked closer at the man's hands and saw an ugly, green tattoo on his right. It was between his thumb and index finger and it read SYN in homemade, capital letters. When Cal's eyes drifted up, he saw that the guy was looking at him with an angry frown.

"What, old man?" the new guy asked. "You neva seen one guy take one shit before?"

Cal looked away. He felt the scar on his throat. He recognized that look in those eyes, that extra hatred which came in a flash. It was because Cal was haole, he was white.

Cal remembered going through it all before. It was why he'd gotten his throat cut, why he could no longer speak. He was white and was hated in Halawa Correctional Center because of it. Besides, Cal thought, the swastika tattoo on his forearm didn't help either. The Hawaiians ran the prisons in Hawai'i. The only reason he was in the high security area of Halawa was because he was under protective custody. When he'd been in the middle security facility, he'd just taken too many beatings.

The toilet flushed, interrupting Cal's memory. He looked up at his cellmate, who ignored him, picked up his pillow and blanket, and went to the bottom bunk. Within a minute the guy was snoring. Cal took off his blue trousers and stuck his thumb and index finger up his ass. He pulled out a rubber glove. He opened the glove and took out a bent cigarette and a short sliver of telephone wire. He leaned over to the electrical outlet and put

the wire into the socket. He lit his ten-dollar cigarette off the wire and took a long drag. He looked at the box which the Japanee had brought with him. He saw a bunch of paperbacks. Macbeth, Native Son, Invisible Man, The Tripmaster Monkey, and A Book of Five Rings sat on the top. Cal reached out his hand. His cellmate stirred. Cal shot his hand back and took another drag from his cigarette.

An hour and a half later, the door buzzed. Slowly the prisoners of Module C, Quad Two made their way out of their cells. Cal was one of the first ones out and he walked up the stairs to claim his place at the stainless steel cafeteria-style table. He almost ran into Nu'u, who was walking down from the second floor. Nu'u, the bull of Quad Two, put his arm around Cal. "Hey, California Joe," he said, "what's your hurry?"

Cal shrugged his shoulders. Even though his real name was Matthew Brodsky, he'd accepted the name Cal. It was what everyone had called him since his arrival fifteen years before.

"Come," Nu'u said, "we go play dominoes."

Cal's new cellmate was the last to leave the cells. His hair was no longer tied back, so his bangs covered his eyes. Like most of the prisoners, he didn't put on his shirt. He walked up the stairs and sat next to Nu'u. "Who da fuck are you?" Nu'u asked.

The new guy let out a quiet laugh. "Ken. I jus' came from special holding. Da fuckas finally took me off max."

Cal thought he looked like a hard case. Most of the prisoners in Modules A, B and C were, but most were under closed status. The guys who carried max status were the real fuck-ups. They were the guys who didn't give a shit. These were the guys who were thrown in special holdings because of disciplinary problems. In special holdings, they were forced to stay in their cells for twenty-three hours of the day. During their hour out, they were let outside in the yard alone. The cells had no beds. They ate in their cells. There was no television, no visiting privileges, no phone

calls, no nothing. To say you were maxed meant you were someone who shouldn't be fucked with. Cal saw that Nu'u recognized this when Nu'u stopped playing to shake Ken's hand. "Howz it. I'm Nu'u. Dis California Joe. He no talk. His troat was cut. Fucka is one mean tattoo artist, though."

Ken extended his hand to Cal, who shook it. Ken looked at the scar on Cal's throat, then looked at Nu'u. "He got cut ova hea?"

"Nah, was in middle security. Dis fucka get one Nazi ting tattooed on his arm. Show 'um, Cal."

Cal raised his arm and showed Ken the tattoo. Ken laughed. "Bad place fo' have one swastika tattoo. You must be from da mainland."

Cal shrugged. Everyone assumed he came straight from California, but he had been in Hawai'i ten years before he killed his wife. He had gotten the tattoo when he was young, when he used to bike around in Texas.

"Hey, no worry," Ken said, "We all get tattoos we regret."

Cal smiled. The others in the room acted like they were watching T.V., but Cal could see they were listening to the conversation. Nu'u spoke. "So how much more time you get?"

"Shit," Ken said, "I would be out I tink if I neva fuck up. But all dis overcrowding, da time should be short. Parole maybe six months."

Nu'u nodded. "Bradda, befo' you leave, you should get one tat from Cal. Fucka is mean. You should talk to him, too. Da fucka is one mean psychiatrist. Good ah, he only listen, he no talk back. Besides, you know if you tell him da truth, all da fucked up shit, he cannot tell anybody anyway. Da fucka get mean patient confidentiality."

Cal grinned. I could write it down, you dumb Samoan. But he wouldn't tell. He loved listening to the stories. It reminded him of when he used to listen to country music or the blues as a

young man. He looked down at his swastika. What a dumb kid I was, he thought.

Ken pulled his hair back out of his face and tied it. He watched quietly as Cal and Nu'u played dominoes until the next lockdown.

When Ken and Cal returned to their cell, Ken plopped down on Cal's mattress. Cal flinched. Ken stuck his hand in the mattress and pulled out the gun and bottle of ink. He smiled. "You really dat good?"

Cal shrugged. He looked at the tattoo on Ken's hand, the one which read SYN. Ken smiled again. "You like hear da story?"

Cal shrugged again. He was surprised when Ken laid back, closed his eyes, dropped his pidgin and started with perfect English. "I got this one at my friend Koa's house," Ken said, as he pointed to his hand. "We were sitting in the middle of the dry-wall, door locked, cooking it up, basing for hours. It was a joke of a room: the floor was the closet, the back seat of an old Chevy Chevelle was the bed, a blue-vinyl bed. There was no carpet, only a cheap brown linoleum that was peeling at the corners and the edges of the floor. Koa had stacks of books and magazines at each corner of the room to hide the curling of the linoleum. In one corner were his Playboys, in another his hot rod magazines. The third corner was covered with a stack of Muscle and Fitness magazines, and in the final bend of the wall, closest to the door, sat some novels I'd given him, books he'd never read. As for the walls, they were peppered with fist holes, but none big enough to escape through."

He paused as if to wait for Cal to say something, then smiled and went on. "We sat in the middle of the room on Koa's dirty laundry, smoking it up. Koa lit the lighter and heated the bottom of the stained teaspoon and said, 'Hey, some of da boys at school get one tattoo, SYN, you know, for syndicate? It's one gang, an dey like us join. I went arready put mine.'

"He put down the spoon and raised his right hand so we could see the homemade block letters printed on for life. 'You guys should join, too. We goin' rule da Windward side.'

"There were five of us there, I was the only one who wasn't Hawaiian, and as Koa carefully loaded his glass pipe with the cooked up coke, we nodded to each other. Strength in numbers. Boys for life. Later, as the sun rose, we were finishing my tat last. Koa was poking the thread-wrapped needle into my skin. Every few seconds he dipped the threads on the needle into the bottle of black ink. Little drops of blood speckled the ink, and Koa sometimes had to stop and wipe my hand with toilet paper. Blood and ink smeared the letters. We were brothers."

Ken stopped and opened his eyes. He seemed to be looking at Cal trying to determine whether his story was interesting.

Cal knew Ken was kind of rambling, probably because he hadn't really talked to anyone for at least a month while in special holding. Ken seemed satisfied that Cal was interested so he pointed to his other tattoo, the one on his left deltoid.

Ken closed his eyes again. "My second tat, I got much later. On my eighteenth birthday I drove to Waikiki, by myself, and went to Skin Deep Tattoo. Because the first one had turned green because of bad ink and a worse artist, I wanted this one to be done professionally. I refused homemade tattoos. It's awesome walking into a tattoo parlor for the first time. Dozens of folios showing hundreds of designs. Choose one, they beckon. They have it all, old-fashioned anchors to new-wave tribal. We have kanji! Isn't kanji brushed on, not poked on? I entered armed with my design."

Ken pointed to the tattoo on his deltoid. It was a circle, about three inches in diameter, filled with a plant of some sort. Three balloon-shaped leaves were joined together. On top of each leaf, rose a stem. On the three stems sprouted small, clover-shaped leaves, on the top and on the sides. "I wanted the Paulownia crest," Ken said, "our Hideyoshi family crest, tattooed on my left shoulder.

Besides the Chrysanthemum, this was the most prestigious crest during the Tokugawa Era.

"I walked into the mirror-walled 'operating room' and showed the haole my design. He told me, 'No problem.' As he prepared his gun, I looked at his tattoos. His body was covered with them. Reapers, clowns, dragons, koi. All of this only on his arms and calves; his black T-shirt and aloha print surf shorts covered the rest of the collage. The koi struck me the most. It leaped from the waves and looked at me with its lifeless, black eye. It looked like a shark's eye. What did Quint from Jaws say about a shark's eyes? Lifeless eyes... Like a doll's eyes. Quint was right. I'd seen this eye before. I'd always thought of the koi design as a Yakuza tattoo. These fucking haoles, pick and choose what they like from other cultures and flush the rest down the toilet. 'Hey, we'll take your sushi, your tattoos, your women, the little geisha girls, you can keep the rest.' One-stop shopping. We don't get to shop, the medicine is forced down our throats.

"The tattoo guy walked across the white tile, approaching me. He asked if I had ever gotten a tattoo before. I casually covered my right hand with my left and told him, 'no.' He wiped my shoulder with a disposable, germ-killing towel. Then he eyed my shoulder and pressed a piece of paper against it. The Paulownia was on. He asked me if it was the right size, if it was where I wanted it. I faced my shoulder toward the mirror and nodded. He walked to his little work station and put on surgical gloves. The gloves slapped on his wrists. He picked up the gun. He pushed his chair next to mine, straddled it, and squeezed the trigger. The tiny engine buzzed and I felt the needle stab me fast, over and over again. Forty-five minutes later, the tattoo came out real nice. My heritage etched on to me for life by a haole. Not a needle, Indian ink and thread job. Better than a guitar string, Walkman motor, jailhouse tat. Professional job. Tattooed by the man by choice."

A lot of felons like to hear themselves talk, and it seemed Ken was no exception. But his references to haoles or Walkman motor, jailhouse tats didn't offend Cal. Cal had been here for so long, seen so much crazy hatred that little offended him at this point. He liked the way Ken talked, there was a strong rhythm in his deep, scratchy voice. He kind of talked like a book. Wanting to hear more, he carefully stepped toward Ken and picked up his tattoo gun and bottle of black ink. When he got everything together, he looked at Ken.

Ken smiled. "Sounds good. Let's start after rec time tonight. The idea I got for a tat might take a few days. I'll tell you what, while you put it on, I'll tell you my story. It's a pretty good one, I think."

Cal nodded. Ken picked up A Book of Five Rings from his box and began to read. Cal plopped down on the other mattress and decided to nap before dinner.

■ ■ ■

Dinner went smoothly. Ken ate quietly with Cal, while Nu'u talked the entire time. He told Ken how he'd killed two Filipinos at the projects in Kuhio Park Terrace. "Fuckin' flips," he said, "Fuckas like pull knife. I was jus' goin' fuck 'um up, until I seen one of 'um pull knife. I tol' da judge dat and nex ting I knew, murder one. Fuck, if I neva kill dem, dey would've killed me. And jus' because I knew, knife or no knife, I was goin' win befo' da fight even started, I get life."

Ken smiled. Cal knew Nu'u was trying to flex his muscles. He went on to tell Ken that after he got sentenced, he flipped the judge off and threatened his whole family. Cal sat quietly, watching Ken not show the smallest sign of being intimidated.

After dinner, the three sat at the table in Quad Two and played dominoes. Ken was rusty at first because there were no dominoes in special holding, so he lost several games before he

got the hang of it. Nu'u laughed. He seemed to enjoy beating on Ken. Though Ken seemed to be keeping a straight face, something about him told Cal that he was a guy who really didn't like to lose.

After rec was over, and the dominoes were put away, Ken and Cal waited for the buzz of the door. They got in their cell. Like the tick of a clock, another day in prison gone. Ken grabbed his A Book of Five Rings, turned to the back and showed Cal a page of Japanese writing. There was one big symbol in the middle of the page and a vertical series of smaller ones on the left side. The symbols were obviously done with a brush. "This was written by Miyamoto Musashi, the greatest samurai who ever lived," Ken said.

Cal nodded. "This," Ken pointed to the big symbol in the middle, "means The Book of the Void. It's kanji. I want it big. Three times as big as the one on the page. Can you do it?"

Cal took the book from Ken and nodded. A lot of tedious inking. The lighting was bad, but the moonlight helped. But beyond the small window, beyond the walls, beyond the two fences, the moon seemed an even farther away place. Cal shook his head and concentrated on the page of the book. Cal figured the writing on the side said the title of the book and the author. They smoked cigarettes while Cal started on the big symbol. Ken began to tell Cal his life story.

chapter one

"I'm nobody's child, I'm nobody's child,
Just like a flower, I'm growing wild.
No mama's kisses, and no daddy's smiles,
nobody wants me, I'm nobody's child."

Nobody's Child
Kapena

THE GROUND BOOK

My father told me I was a C-section baby cut out during the summer of sixty-nine. Tripler Hospital. The Year of the Rooster. Like Macduff, I was from my mother's womb untimely ripp'd. I imagine my birth differently. I was not born in some pristine-pink military hospital alongside white and black G.I. babies. The only gook-looking baby in the germ-free nursery. I was delivered in purgatory. A soul not going up or down. Only me. It was a room with walls covered in aged blood. My mother lay unconscious, stirruped in the middle of the room, while my father and the doctor worriedly gazed above her. As the doctor readied himself to make an incision, beads of sweat dripped from his head and fell upon my mother's ripe stomach. As the droplets rolled off my mother's round abdomen, I surprised everyone. Nobody had to cut me out of her peach belly. I am samurai. Momotaro. Not baby out of stomach, but rooster out of egg. I see it now...

I slice my way out of my mother's womb armed with the Hideyoshi family katana. Aiahhh! There's actually a moment when I fence with the doctor's scalpel. Don't cut Ma. Blood gushes out of her. It doesn't stop. A flood. Soon my father and the doctor are waist-deep in her blood. I am armed with my father's sword and armored by my mother's blood. I am not naked. I see my father. He's wearing one of those doctor masks, the cheap elastic arms hug the back of his head. He doesn't like

what he sees, and he knows the mask will not protect him from my infection. He fears the sword which he once wielded. He takes a step back. There is anger on my child-face, deadness in my ancient eyes. My father gains his composure. He picks me up and throws me into the pool, which was once a room. I sink. The ripples I leave subside. The surface is like crimson glass, unbroken, unshattered. My father wonders whether I can survive, whether I am worth keeping.

Suddenly I float up, face first. My body is like a single drop disturbing the entire pool. My new presence catalyzes waves, breakers. I stare at my father. After the first set washes over my infant body, he sees that the sword is imbedded in my belly. My father and the doctor step back in horror. My mother is still asleep. This is where the vision of my birth ends.

I know it couldn't have possibly gone this way. I remember being a scared child, the kind that has to be dragged kicking and screaming onto an amusement park roller coaster ride. Not a rooster, but a chicken. I wasn't born with a warrior's spirit. I don't really know when it was, but at some point in my life the fear began to seep out of my pores, like a rigorous flow of sweat, and I rehydrated my dried flesh with the salty concoction of hate and pride. What is a warrior, after all, without these weapons? Unarmed, naked. A warrior must hate his enemy. He must feel that his enemy is not only trying to strip him of his life, but his honor as well. This is the only way that one can destroy without remorse, instead to destroy with pleasure. The volatile potion is the only thing that can neutralize the disease of fear. Damn fear.

Did you know my name isn't really Ken? It's Kenji. Supposedly I was named after my father's grandfather, the first Hideyoshi who came to Hawai'i. I think it's a crock. My father probably named me Kenji just to make sure the kids in school kicked my ass every other day. Fucking Dad. I remember the first day of kindergarten. Roll call. "Kenji Hideyoshi?" The other kids

stopped picking their noses and looked up. "Kenji?" they all said
in unison. Fucking Hawaiians. It took the samurai in me years to
beat the name "Ken" into their goddamn heads. Like I said, I was
a scared kid, weak, I'd throw up in airplanes, I was afraid of the
ocean. My house in Ka'a'awa was right across the street from the
beach.

My father, I think, pulled most of the fear out of me. In
fact, he transplanted the hate. Armed with the scalpel-katana, he
cut my cranium open and removed the malignant tumor of fear.
Lobotomy. Exorcism. He spit on the hole and sewed me right
up. The fertile saliva blossomed red.

Or sometimes I'd see him like a man with syringes for
arms. With his left syringe-arm, he would jab me in the head and
suck out the fluids of fear. With the other syringe-arm, he would
puncture my chest and in would flow the antidote. My father
was no southpaw. Straight up, classical boxer. Jab, jab, overhand
right. Jab, double left hook, K.O. right hook. He was a good
boxer. He taught me what I had to know. I learned how to take
and throw a man-sized punch. I was never the surgeon that he
was, though, never as calculating and controlled. But at the end I
was better, stronger, faster, younger, crazier. There comes a point
in combat when you realize you are willing to give up your life
to win. Nothing else matters. You see death for a better fate than
defeat.

I suppose an example of a jab from my father was when he
threw me into the ocean when I was about three. I didn't know
how to swim, hated the water, and he threw me right in. "Eh,
you betta learn fo' swim arready. We live by da beach, what if you
drown?"

I refused to go in. How the fuck could I drown when I
wouldn't even go near the water? In the tub? Why wasn't he
concerned about my drowning as he forced me into the waves?
I learned at an early age to keep my questions to myself. He

wouldn't have it, a scaredy-cat kid afraid of the water. For him, my death would be better. He picked me up, lifted me over his head, and threw me about seven feet in. He hadn't checked the tide. The water was about two feet deep. I fell softly on the hard, rock surface, like only kids can, no torn ligaments from the landing, no sprained ankles. It was the closest to cat-like I ever got. My father was furious. I don't really know why, but I was no longer afraid of the water. Now it was just deep water that petrified me.

This was one of his jabs. It sucked a little fear out, and I don't think I hated him for it. Shit, I can imagine some of the haoles on the mainland. "Oh, it was so traumatic! I'm scarred for the rest of my life! Oh, I won't go near the water!" Fucking haoles. Spoiled-rotten, easy living, sick suburbia, white-picket fence mother-fuckers. I can't believe these are the same people we worship in the movies. The heroes! Gibson, Costner, Ford, Cruise. White men who can outrun explosions and fire, the Devil himself: "Oh, I do most of my own stunts, until it gets a little too dangerous."

Fuck you! My whole life has been one stunt after another, fight sequences, car chases, run-for-your-life action. They should cast someone like me in their high-budget action movies. A crazy Japanee who doesn't give a fuck. A guy ready to stop running, turn around, and face the red. A guy that's his own man, his own shrink.

■ ■ ■

My second bout with the ocean happened a year later. When I was about four, my family went camping at Kualoa Beach Park. This was before there was that huge parking lot, before you needed a permit to pitch your tents. This stretch of yellow sand, the left cheek of the mouth of Kaneohe Bay, was open to all. My father and uncles, with their sons, captained their little flat-bottom boats from Kahaluu, which was a few miles away, while my mother,

the daughters, and the aunties made the short drive from Kaʻaʻawa with most of the camping supplies. I was a son, and despite my mother's arguments with my father, her saying, "He's too young," my father still demanded that I go on the boat.

I stood in front of the boat ramp. The concrete slab inclining into the water was cracked and broken. There was moss on the lower part of the ramp, and I was afraid I'd slip and fall. My father held on to the bow of the fiberglass boat and waved me toward him. My father's friend from the army, Sonny Fernandez, and his son, Junior Boy, were already onboard. Uncle Sonny was showing Junior Boy how to pull the cord to start the outboard engine. I walked toward the brown water. When I took my first step off the ramp, my foot sank into a thick patch of mud. When I managed to pull my foot out, everyone laughed because I had lost a slipper. My father shook his head, picked me up by the shirt, and lifted me into the boat.

It amazes me now that I think about it that I was never afraid of being on the boat. Yes, the thought of being in the water petrified me, but somehow the small fiberglass craft always seemed like land to me. My father, controlling the twenty-five horsepower Johnson outboard engine, fearlessly charged the small waves of Kaneohe Bay. The bow rose above the surface and when it descended and slapped a wave, the salty water sprayed up and showered our hot faces. It was refreshing and it felt safe. It was strange that I didn't feel fear.

By the time we got to the campsite, the women and their daughters had much of the gear set up. The thin stretch of sand turned into a sparse forest of pine trees and dirt. Thousands of little poky acorns about the size of marbles were spread across the ground. Not knowing any better, I jumped out of the boat and charged the campsite to look for my mother. I stepped on one of the acorns and my knee buckled. I cried out. The older kids, the daughters included, laughed and said I had "haole feet."

As the older kids and adults pitched the tents, the younger children held in their pain and trained their feet to endure the acorns like the older kids and parents did. After the tents were up and the blue tarp was roofing the make-shift kitchen and dining area, the men, along with an older son or two, prepared to take the two boats out and lay their monofilament fish nets. Before they went to wall off a section of the Bay, they said they'd return for dinner.

Junior Boy was depressed because his father didn't let him go with them. He was about a year older than me, chubbier, but Uncle Sonny just told him he'd get in the way. Both of us were left on the beach watching the boats get smaller. "Was that your first time on a boat?" I asked.

He laughed. "No way, I was on boats choke times. Shit, I went help my fadda pull up da nets jus' last week."

"Yeah," I said, "I think my dad took me plenty times before when I was real young. Even before he taught me how to swim."

"Me too, me too."

Just then a sand crab scurried in front of us. It ran to the edge of the water. It was smaller than a marble. Junior Boy ran after it. He slapped his hand over the crab and grabbed a handful of sand. He walked back to me with his dark fist clenched and I watched as he sifted out the crab. It was hard to find because the color of its tiny shell was the same color as the sand. Finally its two eyes protruded. Junior Boy grinned. "Hey Kenji, go get one cup from your madda so we can keep 'um."

I ran to my mother. She was squatting in front of the shore, rinsing off cooking utensils. I told her I needed a cup so that I could catch crabs with Junior Boy. She grabbed my hand and we walked back toward the campsite. Uncle Sonny's wife, Aunty Jana, said, "Hey no bodda your madda too much." My mother told Aunty Jana not to worry and when the sand ended and the acorns began, she lifted me into her arms. Her bare feet squashed down on the poky acorns. Aunty Jana shook her head.

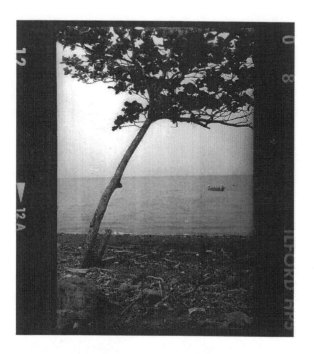

Instead of giving me a cup, my mother gave me an empty glass gallon jar. She patted me on the butt and said, "Don't wander too far." I smiled and ran towards the beach. When I reached the acorns, I slowed down and looked back. My mother smiled and waved me forward. My face flinched with each step, but I made it through.

Junior Boy and I caught about ten crabs that day. When our fathers returned, Junior Boy proudly presented the gallon bottle to Uncle Sonny. Uncle Sonny rubbed Junior Boy's curly brown hair. "Ken helped, too," Junior Boy said. My father looked at me and said, "Right on." I walked back to the campsite to see what my mother was doing.

When I found her, she was sitting on a lawn chair reading a book. She had a blanket wrapped around her. It was getting dark, so she had a lantern by her. She looked up from her book and called me over. She pulled me toward her and sat me on her lap. She wrapped the blanket around us. "What are you doing?" I asked.

"I'm reading a play by a man named William Shakespeare."

"What is it called?"

"It's titled, *Macbeth*."

"What is it about?"

"Oh, nothing. I'm reading it for school. My students are going to have to read it, so I have to brush up."

I crinkled my brow. "But you're the teacher."

She laughed. "Even high school teachers have to study."

"But you're smart."

My father came and stood in front of us. His face was turning red from the mixture of sunlight and Miller Lite. "How you feeling, Shar?"

"Better than yesterday, hopefully better tomorrow," she answered.

He bent down and kissed her on the cheek. "Don't baby da kid too much. He gotta be tough. You know dat. Right, Ken? You goin' be tough."

I nodded. My mother smiled. "He's right," she said, "you gotta be tough."

I flexed my arm at them and they both laughed. "I goin' pick up da net," he said. "So what, you goin' let me take da kid too?"

My mother's arms wrapped tighter around me. "Hell no."

■ ■ ■

My father shook his head and sighed. He and Uncle Sonny picked up a cooler filled with beer and walked toward the boat.

Through the hours they were gone, I spent half the time listening to my mother read me parts of *Treasure Island*, and when I got restless, I spent the other half looking for crabs with Junior Boy. We got flashlights from our mothers and scoured the beach. The crabs were harder to catch at night. Whenever they saw our lights, they charged into the small shore break. The white water washed over them and most of the time, when the water washed back out, the crabs were gone. Junior Boy and I were at it for hours, though. We weren't satisfied until we had twenty crabs.

After we'd caught our twentieth crab, Junior Boy and I saw the lanterns on the bows of the boat get closer. We shined our flashlights toward the water and waited. As the hum of the outboard engines grew louder, Junior Boy said, "I hope dey caught sharks." I shivered. I hated sharks.

My father and uncles brought the boat into shore. It was very late, early morning in fact, when we heard the boat buzzing in from the darkness. A couple of seconds after the engine was killed, the boat's nose slid up the sand. My father and two uncles jumped out of the craft and pushed the boat further up the beach. I heard the grains of sand rub against the fiberglass hull. I waited farther back on shore than Junior Boy, afraid of the water, especially at night. Gone was the transparency of the ocean surface, it was now black where the lantern light didn't touch it.

After the boat was secured, the men began to throw their catch out onto the sand, showing the children their trophies, showing their children what men they were. All sorts of fish were caught in the net. Mullet, *weke, awa'awa, omaka, papio* and *lai* were thrown into a pile. A separate pile was made for the biggest rubbish fish in the ocean — sharks.

When my father began throwing the baby hammerheads out of the boat, I took a step back. They weren't big, ranging maybe from one foot to two, but I hated their mutated heads and I associated them with their much larger parents. The last thing my father threw out of the fiberglass boat was a tiger shark, about three feet long and still alive, flapping as soon as it landed on the sand. Though it wasn't as ugly as the hammerheads, it looked more dangerous, with its large mouth and its hydrodynamic body. There was a lot of kick to it and, with each jump, its entire body cleared the ground. My father stepped out of the boat with a small bat in his hand. I looked back toward the tents and was comforted when I saw my mother walking toward us.

The next thing I knew, my father scooped me in one of his arms and was walking toward the baby tiger, which, after its first several leaps, had stopped moving. My father put me down a couple of feet away from the shark. "Touch it," he said.

I shook my head violently and took a step back.

"Touch it," he repeated, beer fumes shooting toward my face.

Again I looked back for my mother. She was still far away, and I looked up at my father. I felt like one of those sand crabs Junior Boy and I had caught. I felt like I was scurrying in the palm of my father's hand. "It's still alive," I said. "It might bite me."

My father shook his head. He took a step toward the shark. He leaned over and hit the shark on the head twice with the bat. It lay still. He stepped toward me. "Now touch it."

I refused again and again looked back. Mom was getting really close.

Then I felt my father's thick fingers wrap around my forearm. He squeezed hard and it hurt. He stepped me up to the tiger and forced my hand on its back, right above the dorsal. It felt cold. It felt like a flexible layer of rubber, like a slightly flattened basketball. I began to cry. The shark jumped and my father pulled me back. I was hyperventilating. I heard the laughter of my uncles and cousins in the background. Junior Boy's chubby face was scrunched up in laughter. My father began to howl loudly, too.

As my mother got close, I lifted both my arms and ran to her. She scooped me up and I felt a little better. She stepped toward my father, who faced her and giggled. She responded with a vicious slap, which landed on my father's left cheek.

It was a loud slap, like the sound of the bottom of the bow striking a big wave. He stopped laughing, everybody stopped laughing. He gazed at her, first in shock, then in rage. When my father was mad, nobody I ever met looked meaner. Mom stood her ground. My father slowly worked up a laugh again. The others in the back began to put their best efforts into a phony chuckle. My mother turned around and carried me to the tent. Only the two of us slept in the Hideyoshi tent that night.

When my father made me touch the shark, it was the first double left hook, overhand right combination he had given me. His syringe arms were working, pumping furiously that night. I've had a difficult time not looking over my shoulder ever since. All of this happened before my mother started to get really sick, about two years before she died.

<div align="center">✤ ✤ ✤</div>

When your mother dies and you're six years old, there isn't much you remember. I don't care how good your memory is.

Like most young memories, scenes flash but dialogue is forgotten. Sometimes when you're up late at night, out of the blue, you suddenly realize that you've forgotten what your mother looked like. You jump out of bed and search frantically for old photo albums. When you find an old picture of her, it's like, "Oh, yeah." It's like when you suddenly forget how to spell a simple word, and you look for it in the dictionary, find it, and tell yourself what an idiot you are for forgetting it. Unlike the spell search, however, when you forget what your mother looked like and you have to rediscover the image with a damn photograph, you take back to bed the guilt of an ungrateful child. I do not need the album now.

Mom was a tall Japanese woman. A school teacher. She was young when she died, twenty-seven, and as I think back on what she looked like, the image now seems more like that of a long-lost sister. I look like her. She had that long, angular face, thick black hair, unusually dark eyes. She was pretty. She and my father made an interesting-looking couple with their clashing features. My father, with his short but broad body, his Toshiro Mifune-like face. My mother, who was about an inch taller, with her thin features and her thoughtful disposition. She loved to read, books were his kryptonite. He always looked angry, even when he wasn't, while she looked like she was constantly thinking about something. He was local, born and raised in Hawai'i, she was a katonk mainlander, sansei, born in internment. He spoke pidgin, her English was impeccable, stone white.

I hate hospitals. Dignity dies in them. Cold rooms, plastic curtains, ugly gowns, prodding doctors. No comfort, no sympathy. The gowns are the worst. Easy access. Almost naked. I'm surprised there are patients who walk out of a hospital feeling healed and not violated. I'm shocked that families don't more often spirit their loved ones away from this house of sickness, whose neighbor is the cemetery. As patient and visitor, I have always exited with

a fresh wound. Purgatory. A soul waiting. Maybe I was indeed born here.

I missed school regularly my first-grade year. I spent these absent days in the hospital waiting. Waiting to go home. Waiting to see if Mom was going to live or die. Sometimes friends or relatives waited with us. These were the best times. I played with Junior Boy and the waiting passed more quickly. The friends and relatives were nice. But watching somebody die of cancer is to watch them starve to death. Slowly the flesh peels off the body, the spirit evaporates through the pores. After a couple of months you realize that you're looking at half of what that person once was. Yellow, skinny, weak. Glassy-eyed. Vacant-eyed. Ugly. Waiting.

I was six, but I did not cry. Practically everyone else did. I was too young. One of the amazing things about children is that they're like little beasts. They only howl when they aren't getting something they want. Adults cry because of anger, guilt, joy, love, and especially sorrow. There is no sorrow for children. For me, the sorrow came later.

The day before she died, my Aunty Jana had picked me up from school. I was attending school depending on my mother's condition. If she improved, I went to school, and if she worsened, I was at the hospital. For the last two months of her life, I only saw the worst of her.

It was still morning, before recess, when Aunty Jana entered the classroom. She whispered in the teacher's ear and the teacher called me: "Kenji, could you come here?"

The rest of the class laughed as a couple of my male peers mimicked the teacher with a nasal voice. "Kennjii," they sneered.

Humiliated, I stepped toward Aunty Jana and Mrs. Wright. "Kenji," Mrs. Wright said, "your aunty is here to take you to the hospital. She says your mother is getting worse and that you should be there."

Aunty Jana gave my teacher a quick glance. Then she turned her head down to me and said, "Let's go."

As we walked out the open door, I heard Mrs. Wright scold the class. "You kids better learn to be more respectful. His mother is very sick." Her statement resonated in the hall. As I stepped out to the parking lot, the only thing on my mind was the hatred I felt for Mom. It was the day before she died.

I was standing at her bedside in the frigid room which I loathed so much. I didn't want to look at her, I didn't want to see that yellow face, to look into those weary dark eyes. Instead of looking at her, I stared at a white vase stationed by her bedside. The vase was vigilant, but lent no comfort. It was a tall and slender vessel, subtly curved outward at the top. I gazed and listened as a weak, rough sound started. As my eyes worked their way up, I saw the vase transformed to thorned stems, leaved here and there. I began counting the leaves. One... Two... Three... Some were caramelizing on their spined edges. More sound. My eyes reached the top of the stems and saw green crowns, the hands of the flowers holding up their bulbs of crimson bloom. The hands looked fuzzy, little hairs responding to the electricity of the room. The sound wouldn't stop. I counted the bulbs. One... Two... Three... It was hard to see them all because some were hidden behind others. If I were taller I could've counted better. I noticed how a rose on the right had petals that spread outward, while others on the left still cocooned their pollen. The sound droned on. I looked at the flowers and thought about how I'd left school that morning. I grew angry, furious. I hated those kids. I hated that sound. Sound and fury not signifying nothing but working together in an orchestra. Woodwinds and reeds. Soft-spoken opera. Tragedy. The sound stopped, but the fury didn't. I looked up at Mom. She was sleeping. The aria was over.

The guilt was overwhelming. I knew that sound was her voice, but I didn't listen. I even knew those were her last words

to me, but I just drowned out the sound of her voice with the flowers in the vase.

She left me little. A face, an asshole father, a shit-load of books. Fucking father went loony after she died. Flashbacks. Of Mom or Nam? The funeral. The lacquered coffin was set high in the front of the mortuary. I gripped the edge, felt the satin on my fingertips, stretched my body as high as it would go, and caught a glimpse. Her face was as white as the language she spoke except for the artificial, rosy cheeks. She wore a frilly white dress. She even had shoes on. She looked like a porcelain doll in her new lacquered doll house. I turned my head back and looked toward the pews. The dozens of faces wore humbled looks. Some I had seen before, some I hadn't. My grandfather, my father's father, picked me up and took me outside.

I think it was a beautiful day. Cool, temperate, no clouds in the Kaneohe sky. Uncharacteristic of the Windward side. Grandpa told me I'd be staying with him for a while because my father needed time alone. I wouldn't see my father for two months.

■ ■ ■

Grandpa lived in Kaneohe. He lived alone since my grandmother had passed away before I was born. As he drove me through the winding roads behind the Kaneohe Police Station, he talked with enthusiasm about the time we would spend together. "We talked to da school, an you can stay out fo' couple weeks. By den goin' be summa vacation. We can go fishing. We can go movies. Goin' be fun." I wasn't really listening, just looking out my open window and feeling the sun and wind weather my child face.

We pulled up Grandpa's loose gravel driveway and he turned off the engine of his old Toyota Corona. He waited until I got out of the car, then gently put his hands on my shoulders, turned me around and followed me up the three wooden steps that led

to his front screen door. As we walked into the living room, I saw the familiar glass case on the other side of the room. "Kenji," he said, "you can take your fadda's old room. Arready get some clothes inside. He went drop 'um off yestaday when he went ask if I can take you for awhile."

But I was in a sudden daze. I couldn't take my eyes off the case, or off the sheathed swords within it. When he tapped the back of my shoulder, I vacantly nodded. Suddenly, his voice rose. "You like see da swords?"

I nodded vigorously and Grandpa walked me toward the case. After opening the lid, he reached down in the glass box and carefully lifted out the larger sword, the katana. He began speaking again. "My fadda, your great-grand fadda, he brought dis wit him from Japan. Dis sword, he told me, was in our family for yeas. One day I goin' give 'um to your fadda, an den he goin' give 'um to you. Dese two swords, dey da only tings we get from Japan, da only tings we get from our ancestas. So when you get um, you betta take care."

He unsheathed the katana. I could hear the blade sliding out. It was shiny. The setting sun poured rays in through the window, touching the metal. The reflection made my eyes squint. He turned the handle toward me. "Hold 'um," he whispered.

I grabbed the hilt and felt the crimson threading wrapped around it. My palms were sweating. When Grandpa released his grip from the katana, I did not expect the weight. The tip crashed down on the floor, puncturing the carpet. He laughed. "Be careful, da sword heavy."

I raised the tip above the ground, looking at the blade, excited by the danger of its sharpness. I turned around and faced the window, lifting the sword up and letting it stand before the bleeding sky. My skinny arms began to shake.

"Hea," he said, as he gently took the katana from my hands. He carefully put the decorated sheath back on. "One day dis

goin' be yours," he repeated as he placed the sword back in its fragile case.

Sleeping in my father's old room that night, I had a terrifying dream. I was underwater, naked, armed with my family sword. A big tiger shark was circling me, patiently waiting for me to drop my guard. It kept going around and around as I frantically spun in circles trying to keep the sword between me and it. I was running out of breath, but I refused to rise to the surface. I was getting dizzy. The shark sensed my weakening condition and moved in. It bumped me hard, then quickly retreated and began circling again. Every time I would begin losing consciousness, the shark would bump me and wake me up. This seemed to go on for hours, and in frustration I yelled for my mother. My own cowardly chill woke me.

<div align="center">✛ ✛ ✛</div>

The Tripmaster Monkey said of the first Japanese immigrants: "They didn't come wretched to this country looking for something to eat. They'd been banished by the emperor or Amaterasu herself after taking the losing but honorable side in a lordly duel."

That was when my great-grandfather came to Hawai'i. Meiji Restoration. After over two-and-a-half centuries of Tokugawa rule, the emperor got his Japan back. Too bad. The Tokugawas had the right idea. Keep the West out. Keep the white man's god out.

My great history lesson began the day after my mother's funeral. After my grandfather cooked us up some apple and cinnamon oatmeal, he said, "You know, it's time I told you about your history, not da kine haole history you goin' learn in school, but our history. Japanese history."

We sat there and he told me about the Shogun Tokugawa Ieyasu's son. "You know why Japan da best? Cause afta Ieyasu's

son became Shogun, he told all da haoles to leave. When dey went try come back da son told his samurai to chop off da heads of half da crew, put da heads on sticks on da beach, and he told da res' of da haoles, 'Dis what goin' happen if you try come back.' Shit, if da Filipinos and Hawaiians did da same, who knows?"

Grandpa, the World War II veteran, the member of the Go for Broke 442nd, paused. I looked into his wrinkled face, into his old eyes that always looked watery. When men get old, it seems life is such a strain for them that the tears involuntarily flow. He continued. "You look at da Japanese. Was like da Middle Ages when da Tokugawas ruled. Da emperor take ova, fifty yeas lata, da Japanese one major world force. Fifty yeas, Japan not only catch up to everybody, but in da top four."

He paused again. You had to be patient when you listened to Grandpa. His mind was still sharp, but it was like his mouth couldn't work in sync with it. "You heard of da Kamikazes, yeah?"

I took in a spoonful of oatmeal and nodded.

"You see, Japanese, dey die befo' dey accept defeat. Took one atomic bomb to beat da Japanese."

I scraped the last spoonful of oatmeal from my bowl. It tasted sweet. My grandfather took the empty bowls to the sink and brought back two glasses of milk. "You know," he said, "da Chinese could neva beat Japan. Dey went try. Kublai Khan went try. But da wind, da Kamikaze, sent 'um back. Das da closest dey got. But Japan went beat China. You can imagine, one small island went beat up one big country? But was no fair. Da haoles went arready suck da spirit out of China." Again, there was a pause. "You know, da opium." He stopped to gaze at me. "You betta neva do drugs, boy. Goin' kill da samurai spirit."

Late that night, we started a tradition which lasted throughout my stay. We stayed up till ten o'clock and watched his favorite show, *Abarenbo Shogun*. I watched the subtitles flash on the bottom of the screen. It was toward the end when the

Shogun, Yoshitsune, starts beating the hell out of an army of traitor samurai. It always ended the same. The treacherous daimyo of the week, recognizing the Shogun by the now visible Chrysanthemum crest on his kimono, bowed down to Yoshitsune. Yoshitsune, the ruler of the whole country, throughout the show had been assuming another identity to personally infiltrate the shady dealings going on in his kingdom. The daimyo never recognized him until the end, though. The subtitles read something like, "You have betrayed me. I order you to commit suicide right now." The daimyo responded with, "He's an imposter, kill him!" They never even came close. Before the treasonous attack ensued, the Shogun flicked his wrist and prepared to fight with the blunt, unbladed side of his katana. He mowed them down, knocking them unconscious with the power of his blows, without even sustaining a scratch. His blade remained unsoiled. His two assassins finished the job, killing the traitor daimyo.

After the show was over, I went to bed. I spent the night dreaming I was Yoshitsune, except I saw myself using the sharp side of the katana blade. I killed hundreds of samurai that night.

My stay with Grandpa was filled with trips to the Honolulu Zoo and Sea Life Park. He also took me to matinees at the Kaneohe Twins. The theaters were conveniently close, but the movies we saw were always released later than the movies which played in town. Sometimes we'd even drive all the way to the North Shore, to Haleiwa, just to eat the best shave ice on the island.

Wherever we'd drive, he'd tell me old stories of the places we passed. When we went to the Zoo, we always took the Pali Highway up through the Koolau Mountains. The first time he took me, as we neared the tunnels at the top, he told me, "You see dese cliffs? Dis is where King Kamehameha da First pushed da *ali'i*, da chiefs of Oahu, off when had one big war. Kamehameha went chase da army all da way up da Honolulu side of da mountain and finally da *ali'i* got stuck ova hea."

I looked over the cliffs from the moving car and felt the goosebumps rise on my arms. It was so high. I imagined hundreds of ancient Hawaiians pouring down the side of the cliff like a human waterfall.

"You know, boy, neva have da Pali Highway when I was young. Instead we had fo' take da Old Pali Road if we wanted to go town. We couldn't go through da mountain, we had fo' go around."

When the car entered the first tunnel, I heard everything outside get louder. My grandfather had to speak up. "You know, get all kind ghosts around hea. Das why, I tell you now, neva take pork ova through dis tunnel. The ghosts goin' get mad and bad stuff goin' happen to you."

I nodded. I wondered if my mother had become one of these ghosts. I hoped she had. It seemed like if she was a ghost on this mountain, at least it meant she wasn't gone. I looked out the window hoping to see her. Then I realized it was daytime, and I probably wouldn't. Everyone knew ghosts came out only at night.

Except when we took the Pali to town, staying with grandfather that summer really kept my mind off my mother. I wonder if that's part of the reason why he told me all those stories. It was always about things that had passed. Olden times, from feudal Japan to World War II. Or maybe he knew he'd be passing soon, too. History was important to him. "It's who we are," he'd say. While other children dreamed of fighting dragons and saving princesses, I dreamed of sharks and the killing of men. Their dreams were fake, mine were real.

■ ■ ■

Two months later, Grandpa packed my bags and my father drove to Kaneohe to pick me up. It saddened me to leave. I stood in front of the glass case which held the two swords as I

heard the tires of my father's truck roll across the gravel. I felt like reaching into the case and taking the swords with me. My father's footsteps approached and Grandpa opened the door. Suddenly I heard my father's deep, aggressive voice, a voice I'd thought I wouldn't recognize, coming from outside the door. "Hey, kid, you ready to go home?"

I turned around and looked at Grandpa, who stepped toward me, put his hand on my head, and gently guided me toward my father. My father grabbed my bags and paced toward the truck. He came back. "Tanks, Dad," he said, "I hope da kid wasn't too much trouble."

"Eh, was great having him. In fact, maybe on weekends you should bring him ova." My grandfather looked at me and gave me a wink.

"Maybe, maybe," my father said.

The ride to Ka'a'awa was a quiet one. I rolled down the window and let the wind blow my hair back. I looked at each familiar thing we whizzed past: the Hygienic Store, the brown shoreline of Kaneohe Bay, the mangroves, the Hawaiian boys riding their bicycles on Kamehameha Highway. We passed Tang Store, Coral Kingdom, Kualoa Beach Park, and Chinaman's Hat, my favorite little island off the coast. "Hey," my father asked, "so what? Grandpa went spoil you plenty?"

I shrugged.

"Shit, you should've seen when he was raising me. Da fucka used to beat me like one drum."

I didn't believe him.

After a couple more minutes on the highway, we reached the house. As we pulled up, I said, "Wow, da house no look different." My father pulled the keys out of the ignition, then turned to me. "Listen," he said, "I no like you talking like one fuckin' moke. Drop da pidgin. Talk like how your madda talked." He got out of the truck and walked to the door, not looking

back. This is how I spent the remainder of my summer vacation, seeing the back of my father's head.

I thought he was okay at first. Just quiet, just distant. He was on vacation too, and as the last summer month waned, Hayashi Contracting Company waited for his return. This was what we did, both of us waiting, hoping, afraid of the specter of continuity. He spent most of his time on the beach. Every morning he gathered his fishing pole and tackle box, walked across the street, and stuck the sand spike on the beach. He sat there for hours, every so often looking at the erect fiberglass rod, checking whether the bell was ringing. Every evening I would look out the window, across the street, wanting to hear the bell ring. Instead I'd just see his silhouette sitting against the setting auburn sun. I wondered if he was actually fishing for fish, or something else that he seemed to lose.

During this time, most nights he would drink. On the third night I came back, I sat on the picnic table with him and watched him drink a bottle of J&B. He talked for hours. Like me, my father was an only child. He had grown up in a Hawaiian community and raised hell. He boxed, he surfed. He went to Vietnam right after I was conceived, enlisted the year after the Tet Offensive. Long Range Recon Patrol. Bronze Star. Purple Heart. Didn't finish his tour due to a bullet he took in the leg. He and I were actually in Tripler during the same time. "I had to get shot to see you born," he said.

He didn't tell me about the men he had killed, his stories about war were happy tales. The big haoles he had knocked out, the officers he wanted to kill, the friends he made. "Some of the best days of my life," he said. My father told me how much he hated the chopper pilots. Often because of some heavy fire, the pilots would not make their pickups. "Fucking haoles," he said. "Only haoles flew." He told me about the huge snakes he sometimes saw. Dangerous reptiles that supposedly devoured children.

He told me about a nerdy-looking Japanee in his platoon, thick coke-bottle glasses, skinny, weak. This guy who nobody liked or respected jumped on a live grenade and saved the whole bunch. "Bravest fuckin' guy I eva seen," he said, as the fumes of alcohol floated from his wet lips. He handed me his empty glass. "Go refill dis. Put ice, put half J&B and half wata."

I ran into the kitchen, put fresh ice in the glass and filled it half empty with scotch. Then I filled the glass with tap water. I mixed the drink with a chopstick, then ran back outside. He took a long sip and put down his glass. "I eva told you about da time one fuckin' Navy guy went grab your madda's ass?"

I shook my head.

"We was at one bar, me, your mom, Uncle Sonny and Aunty Jana. Was when you was about one. We was at dis bar and one fuckin' haole sailor went grab your madda's ass. She tried to ignore him. I turned around and dis fuckin' Navy guy, wit' his faggy white dress uniform was cracking up wit' da rest of his buddies. Dis fuckin' guy was on one fuckin' boat when I was in Vietnam."

He stopped to take a sip of his drink. "I turned around and I could tell what his eyes was saying. 'What, Jap?' Ho, I went fuckin' unload. Nex ting I knew, fuckin' haoles jumping all ova me and Uncle Sonny. We went take 'um. Dis fuckin' haole, da one dat went grab your madda's ass, I had 'um on da ground. Fuckin' pounding him. Nex ting, his eyes went roll in da back of his head. I taut, 'Ho, I killed him.' Uncle Sonny looked down, and he went grab me. All four of us ran out of da bar."

He stopped again and looked at me. After the pause his voice rose louder. "When we was driving away, your madda was giving me da silent treatment, so I was still kinda piss off. Fuck, I went clean da guy cause of her. I looked down at my hand cause was kinda sore. 'Ho shit!' I went yell. My hand had blood all ova it, and at first I taut might of been da odda guy's blood, but den I seen da teet. We all had to go hospital to get da teet outta my hand."

He let out a thunder laugh. I squirmed on the bench. I licked the front of my own teeth. I looked at his hands. His knuckles looked funny. Some stuck out a lot while others looked pushed in. As I looked closer, I saw several pale lines on both hands, right across his crooked knuckles. My father sighed. He got up and stumbled toward the house. After I heard the door shut, I picked up his glass and took it to the sink.

This went on for about a week. I'd watch him fish all day and drink after dark. Then one evening, or early morning, I think, my eyes suddenly opened. And for the first time in my short life, I remember feeling comfortable in the darkness. Almost untouchable. I felt adventurous. I quietly got out of bed and walked toward the hall. I wanted to see if I could move without making a sound. I peered through the open doorway of my father's room. The bed was empty. Curiosity urged me on.

Carefully I walked through the rest of the house, peeking around each corner I passed before moving forward. The house was empty. I suspected that he might be on the beach, maybe night fishing. I peered through the window, but the street lights weren't strong enough to illuminate the sand. I went to the front door and slowly pulled it open. I saw him.

He was naked, crouching low to the ground and mumbling to himself. I squinted to focus in the darkness, and saw something shiny protruding from his clenched fingers. It was the barrel of a handgun, and it was resting on the tip of his nose. He looked like he was praying. I moved my head slightly forward, focusing on the sound he was making. He was mumbling something like, "Fuckin' gooks... fuckin' gooks... C'mon, you fuckas... Take my wife, you fuckas? C'mon, you fuckin' gooks..."

I felt my body tremble. For some reason he looked like a snake to me, the kind he told me about that devoured children whole. I cautiously shut the door and made my way back to bed.

❖ ❖ ❖

It was two in the morning when Cal rolled off a wad of toilet paper and wiped the dripping blood and ink off Ken's back. Ken got up and stretched. He walked over to the faucet, took a long drink of water, then went to the toilet. Cal cleaned the needle while he heard Ken's piss strike the water in the toilet bowl. He thought about Ken's story and smiled. The alcoholic father, the death of family, these were images of his past, too. Just because he was white didn't mean he didn't experience similar things.

Cal remembered his father used to take him hunting for deer in Texas. Cal had been afraid of guns, trees, and darkness. The chirping of robins and the wind against leaves were the only comforts for him. The explosion of his father's rifle deadened the soothing sounds and made his ears ring. They walked toward the kill.

It wasn't a shark he was forced to touch, instead it was the hot red flesh of venison that his father had forced his hand on. The flesh spread on his hand, turning his skin red. He wiped his hand on his olive-green jacket. "Probably redder den a nigger's blood," his father told him.

Yes, Cal thought, I'd been a student of hate, too. He looked at the soiled napkin he'd wiped Ken's back with, seeing the red and black mixed together. He remembered earlier that day when Ken had said, "We all have tattoos we regret." It was certainly true.

When Ken sat back down in front of him, Cal inspected his work so far. He finished outlining the big symbol which was about eight inches long and six inches wide. He also finished half of the outlining for the smaller characters on the left. Cal wondered if he should do the conventional thing and color all the characters in after he was done outlining it all out, or if he should color in as he went along. He thought about Ken's story and decided that he would do like Ken did, and add the color from the beginning.

"Finished for the night?" Ken asked.

Cal nodded. He wiped more blood and ink off Ken's back then took the gun apart. He cleaned the needle and put the gun back in his mattress.

■ ■ ■

Waking up for breakfast was a pain. There wasn't much for the mute Cal to do in prison, so over the years while being locked up, Cal became a master of sleep. He had been there for years, so unlike the rookies, who slept restlessly and often woke up screaming when they remembered where they were, Cal's sleep was usually deep and about ten hours long. Because he'd stayed up until two in the morning, he woke up exhausted.

Ken, on the other hand, looked well-rested. He was standing in front of the stainless steel mirror when Cal opened his eyes. The outlined symbol on his back was slightly swollen. Ken turned around and smiled. "It's good to come out of special holdings and have someone to talk to."

The buzzer sounded and the doors opened. Cal and Ken walked out and up the stairs, and waited for the second buzz to open the door of Quad Two. Nu'u walked up to Cal from behind and put his arm around him. Nu'u's arm was so large, it felt like Cal was carrying a dead animal on his shoulders.

"Hungry?" Nu'u asked.

Cal shook his head. Nu'u turned to Ken and smiled. "California Joe neva hungry in da morning. He give half his breakfast to me. What about you, Japanee boy? You hungry?"

"Fuckin' starving."

As the buzz sounded off and the prisoners of Quad Two walked through the door, Nu'u said, "Well, if you not hungry, give 'um to me."

The guards led them to the cafeteria. Cal, Nu'u and Ken sat together with their trays at the same stainless steel table. Without Ken asking, Nu'u began telling him the stories of the rest of the prisoners in Quad Two. "You see him," Nu'u said, pointing to a skinny Filipino kid who couldn't have been more than twenty and a hundred forty pounds.

"*Dat's Johnny Lazario. You read about him in da papers? Fucka raped dat chick on da Big Island right afta he went kill her boyfriend. First week he wuz hea, I made him my bitch just on principle.*"

Nu'u looked at Cal. Cal knew what he was looking for, so he nodded. Nu'u smiled. "*Imagine if dat wuz your sista he went rape? Fuckin' dog-eata asshole. Look ova dea, da guy sitting next to Johnny. Das Edwin Geranimo.*"

Cal looked at Edwin. He was another young Filipino kid, also skinny, only he looked tough and had a shaved head. Cal could see the jagged scars on his scalp from a table away. Cal liked Edwin. He did the tattoo of the Indian Geronimo on Edwin's shoulder. He had copied it from a picture Edwin had found in National Geographic. Cal liked him because he knew Edwin shouldn't be here.

"*Fuckin' Geranimo,*" *Nu'u said,* "*typical gang banga from Waipahu. All he did was drive one car wit' da wrong people in it. See da fat Hawaiian ova dea?*"

Nu'u was talking about Sean Alani. Cal felt sorry for Sean. Tavares gave him a beating on a regular basis. "*That fucka, child molesta. Das why he hea. Put him in middle security down da hill, those fuckas would fuck him up. He lucky he in protective custody wit' us.*"

Nu'u pointed to the rest of the group one by one. There were other Hawaiians, a couple more Filipinos, two Samoans, not counting Nu'u, and a Korean and Vietnamese. There was even an ex-cop. Cal knew all of them. He'd tattooed them and listened to their stories.

After Nu'u was finished telling Ken about the others in Quad Two, he asked, "*So what? Wea you from?*"

Ken put down his spoon in his still full bowl of oatmeal. He had eaten only a couple of bites. "*Ka'a'awa.*"

"*Why you hea?*"

"*None of your fuckin' business.*"

Cal's muscles tensed as he readied himself to jump away from the table. He'd seen Nu'u go off before, and was surprised this Japanee had the balls to piss him off. Ken just stared at Nu'u while Nu'u's giant

hands tightly gripped the table. The stand-off lasted only a few seconds. Then Nu'u smiled and laughed. "You get balls, ah boy?"

Ken smiled. "You don't know it, but I know you."

"How you know? I not from da Windward side. I from Kalihi."

"I had a brotha a lot like you."

Nu'u released his grip from the table. "And what?"

"Keep your sense of humor. My brotha died because he couldn't."

To Cal's surprise, breakfast ended without violence. Cal dug into his half empty bowl of oatmeal and pulled out a rubber glove left for him by one of the kitchen workers. He stuffed a twenty in what Nu'u had left in his bowl. He reached his hand down in his pants and carefully put the glove with two cigarettes up his ass.

Before they were let back in Quad Two, one by one, all the prisoners stripped naked at the door as Sergeant Miranda and Officer Tavares watched. When it was Ken's turn, and Tavares saw the unfinished tattoo, he said, "Eh, Hideyoshi, you get contraband in your cell?"

Ken didn't say anything. "Cal," Tavares said as he grabbed Ken by the neck and led him through the door of Quad Two, "you get your ass in here, too."

Ken and Cal stood in their cell as Tavares searched through their belongings. "You madda fuckas. You try piss me off. I working ova-time all da way until two in da morning, and you fuckas like pull dis shit."

Tavares stopped looking and towered in front of the two prisoners. He was even bigger than Nu'u. He looked like a professional wrestler. Cal stared at his tattooed forearms, waiting for a response. The python that Cal did coiled around Tavares' right forearm. Tavares smiled. "Jus' because you did a couple of mine, no mean you get free reign, you haole fucka. You tell me, befo' you do dis. And you, you Japanee fucka, I read your file. Fucka tink jus' because you grew up country you tough? I grew up Waianae, fucka. I tough. But I not one fuckin' criminal like you."

Ken smiled and said, "Dad?"

Cal closed his eyes. He'd been surprised that Nu'u took Ken's wise mouthing, but he knew Tavares wouldn't. He didn't even have to

open his eyes to know it was Ken's body that hit the wall across the room. *Tavares' words crashed together like clouds. "You fuckin' Jap. Feel sorry fo' yourself. My fuckin' fadda beat me probably worse den you, but I neva use 'um as one excuse. I get one job. I get one family. I neva get sucked in. You fuckin' weak ass madda fucka. I see you fuckas every day. Local fuckas dat get all da excuses in da world. Fuck you. Get one legit job. I neva turn out one criminal."*

Ken laughed. Cal kept his eyes closed. *"Yeah,"* Ken said, *"beating on prisoners is real legit."*

Ken flew again. It was like hearing a giant wet rag hit the wall. *"You fuckas deserve it,"* Tavares said. Then he whispered in Cal's ear. *"You betta finish da tattoo quick, cause pretty soon, he eida goin' be back in solitary, or dead on dis floor."*

The door buzzed and Tavares stomped out. Cal opened his eyes. Ken was sitting against the wall, smiling. *"Well, you heard the man. Let's get this tattoo finished. I refuse to die without it."*

Cal took the gun out of his mattress as Ken checked his back for broken ribs. When both were ready, Cal began filling in the symbol. Ken cleared his throat and continued his life story. It would be another three hours before Cal would remember that he left a rubber glove up his ass.

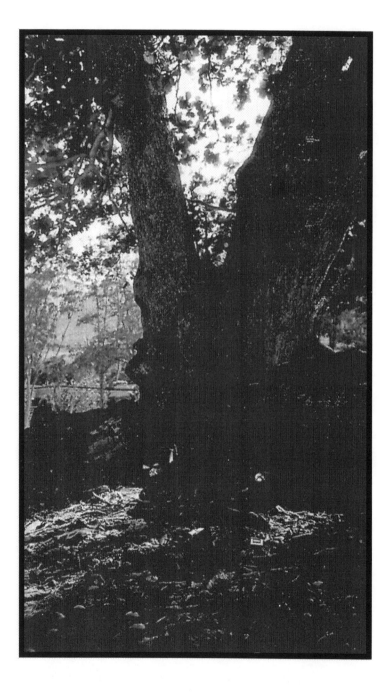

chapter two

"Last night I dreamt I was returning,
and my heart called out to you.
But I fear I won't be like I left you,
me ke aloha ku'u home o Kahalu'u."

Ku'u Home O Kahalu'u
Olomana

Sitting in a fucking box for the last two years has given me a lot of time to think about the past. Hell, sometimes I get so lost in those past images, I forget where I am now. For hours I'll be swimming in the pool of my imagination, basking in the light, eyes squinted, back-stroking in the chlorinated water. Sometimes I'll open my eyes wide at the sun, see nothing, see everything. When the bright blinding haze passes, I'll see the rectangular light shine through the door of the cell. The toilet, the sink, the stainless steel mirror. The slippers on my feet which cost three packs of cigarettes, the customized hem on my state government-issued trousers which cost me four. Sometimes I'll look out the window and stare at the two rows of high fence which surround Halawa. The coiled razor wire on the top of the first. Reality. I figure it's healthy, though, the escape, to look at your mind instead of your fence and your cell, as long as you open your eyes every once in a while no matter how much it hurts.

Most of the guys in here remember well enough. They remember why they're here, the death, the theft, the violence, the distribution of drugs, but I don't think too many of them ever ask themselves what went wrong. When it went wrong. Break down their lives and find out how all of this shit happened. A lot of them only remember in order to escape from reality. They concentrate on the "good things" in life and they can't wait to

get out. Wine, women, and song. Fucking stupid. It's like thinking about food when you're starving to death.

I figure when you break down a young life like mine, twenty-eight years of existence, you've lived through three stages of your life. In each stage, the thing that your life revolves around changes. I suppose if you were writing a book on it, you'd call each stage, in the order that they occur: family-centric, peer-centric, mate-centric. Here, you call them your madda an' fadda, your boyz, and your chick. All three of these suns in your life can fuck you up forever. I figure if all three screw you, there's an almost absolute chance you end up in here for life or in a fucking hole in the ground. If only two fuck you over, you got a slim chance, but it's hard for just one to save your ass. And if just one screws you up, chances are you're joe-schmoe out there, fucking dragging your ass through life. Low-pro, one in the herd.

I was in junior high when I met Koa Kauhi Puana at King Intermediate School or, as we used to call it, "King Zoo." The Puana family was legendary on the Windward side of the island, a huge Hawaiian clan, most of whom were concentrated within walking distance of each other in Kahaluu. Even though Kahaluu occupies a small area, it's really easy to find. All anyone has to do is drive up Kamehameha Highway, the main coastal road on the east side of the island, and look out the window at the ocean. When the brilliant blue and green patterns of the waters of Kaneohe Bay suddenly turn shit-brown, it's like a sign reading, "Welcome to Kahaluu." As you continue to drive north, and the brown water returns to blue, you know you've made it out.

The Puanas lived about two miles in the shit. They occupied five or six houses in the area, but the main house, the one owned by the eldest son of each generation, sat on a big, weed-infested hill overlooking Kamehameha Highway. From its height, one could survey the landscape below; the shack-houses on both sides of the black Highway, the slimy-mud beach, the polluted brown

ocean. Some of these houses were roofed with rusted corrugated sheet metal, the rest with cheap, dried-out wooden shingles. Within twenty-five yards of the shoreline, old flat-bottomed boats were scattered about. They were tied to rusted poles protruding from the ocean surface. Some of them were half-sunk, others looked as if the barnacles were one bite away from devouring the vessel whole.

The view was better if you turned around and faced the mountains. The Koolau Range rose about a mile or two away. The range was the barrier between Honolulu and the Windward side. The mountains were pure green. It was wet up there. Mosquito country, rain country. Those of us who knew the area knew that the mountains were veined by little streams, streams that became more contaminated as they neared the sea. Plumbing. Prawns, *medaka* and *talapia* swam in it, unleashed poi dogs, mixed-breeds drank from it. I used to look at the mountains from atop the hill and wonder what I would have to do to get to the other side.

The Kahaluu sounds resonated atop the hill. The fighting chickens crowed every morning. The daily traffic whizzed by on the Highway. Hungry dogs barked, some in cages, others tied to about ten feet of rope. Pigs squealed, sensing their demise. And as day turned into night, the drinking began. Laughing. Brawling. The same Hawaiians strummed the same Hawaiian songs every night. I could live two lifetimes, never hear "Sweet Lady of Waiahole" again, and die a happy man. At dawn, when the last alcoholic had passed out, the roosters crowed, and the cycle began all over again. Sometimes I think Pandora's box exploded in Kahaluu.

Puana Castle, like the kingdom below it, was hardly impressive. It was a one-story, five-bedroom, two-bathroom house. White lead paint. Wooden. Bed sheets hung in doorways instead of doors. Old, stained linoleum lined the floor. Screens, no

windows. In both bathrooms the wood along the tubs was soft and swollen. Leaks, cracks that you couldn't even see. The water that made it through the pipes travelled to a cesspool. The waste in Kahaluu stays in Kahaluu, there is no modern sewage system.

Puana Castle's king, Koa's father, was a sight. James Puana was the only man I had ever seen manhandle Koa. Fucking huge. About six-four, maybe three hundred and fifty pounds. He had a huge belly which was solid, not jiggly. His torso was like one of those mountains which rose behind his property. He had a huge head. The kind of head that looked so hard that if you were to hit it with a baseball bat, you'd probably just piss him off. Huge everything. I remember the first time I shook his hand. He had these sandpaper palms and fingers as thick and hard as a broomstick. They squeezed down on my fingers, and I had a hard time keeping a straight face. The old man was all smiles, though. Easy-going, friendly, funny in that sort of "I'll laugh at your lame jokes because you're so fucking huge" way.

Aunty Kanani, his wife, on the other hand, was like a one-hundred-and-fifty-pound Portagee firecracker. Lighter than Uncle James in skin color and body weight, heavier in temperament and voice. Every other word out of her mouth had "fuck" in it. Hell, Koa and I probably got our chronic bad language from her. She was never menacing, though. Her anger came off as comedic, in a way.

"Hey, Japanee boy, you betta fuckin' eat ah you skinny shit. Hea. Go warm up dis roast pork. An you betta eat 'um all or I goin' kick your skinny ass."

"Ma, no bodda Ken. Fuck, we jus' went eat."

"Eh! What da fuck I told you about dat fuckin' swearing. You like one slap, you fuckin' kid? An no try tell me you went jus' eat, Ken. Fuck, look, your waist mo' fuckin' small den mine. You betta eat cause I supposed to be da skinniest one here. You no put some meat on dose bones I goin' fuckin' banish you from da house."

You had to love her. She had six kids and the energy to swear at all of them and their friends on a daily basis. She could call you a "fuckin' little shit," and most of the time it was a term of endearment. Both of them, Uncle James and Aunty Kanani, great people. Generous beyond their means, they took me in from time to time. My closeness with the Puanas, especially Koa, was what made it difficult for me to leave the Windward side. It was also part of the reason I always seemed to return.

Like everyone else in that area of the island's east coast, I had known who Koa was long before I met him. He went to Waiahole Elementary and was the "bull" of the Windward side. He could kick ass, and he was a great football player.

I loved football for the reason that many love their favorite sport. I was good at it. Ever since elementary school, no one could run as fast as me. I remember my speed was realized at first in defense, running from the other kids so I wouldn't get my ass kicked. This running away lasted up until the fourth grade when I finally got caught and had to face my father with a fat lip. They hit me in the nose too, but I was never much of a bleeder.

"What da fuck happened to you?" he asked, while brooding over a scotch on the rocks on the kitchen table.

"Somebody hit me."

"Did you hit dem back?"

"No."

"Listen. You come home beat up, das o.k. But nex time you come home like dis and I hear you neva fight back... You going have to deal wit' me instead of dose little fuckin' punks at school. You see, dis is why I hard on you, even when you was smaller. Life is fuckin' tough and you gotta be tough, too. So wheneva I seem mean to you, rememba I stay building your character. You tough you no need worry about shit. If you can eat bullets and crap thunder, goin' show you respect. Your grandfadda taught me da same ting when I was one kid."

I didn't know the first thing about fighting, so I ran. After my father's threat, however, I knew my tactics had to change. I don't think my change was motivated purely by the fear of what my father would do to me, but some of the stuff he had said to me was making sense as I turned it over in my mind again and again. I wanted to be tough. I envied the confidence that tough people had. I envied the ability of my father to make me fear him. Also, I think, I began growing weary of fear itself. Even prey get tired of running. It seems when both prey and predator are lost in the chase, both have hearts that beat hard and fast. One beats from fear, the other from hunger. I wanted to feel the beat of hunger. I began to willingly let my father inject me with his syringe-like arms, the ones that cured fear and administered hate. In fact, it may have been at this point in my life when I started administering my own injections.

I didn't stop running, though. I'd still run if I sensed someone stalking me. But after a while, I did it more out of fun than fear. In fact, sometimes I'd tease a classmate just so he'd chase me. Eureka, adrenaline. I was slowly getting hooked. My risk-taking in teasing progressed into allowing myself to get caught. I'd take a hit. After taking a few hits, my pain tolerance grew, and I tried my hand at some offense. At first my attacks would come from behind. During recess I would choose my prey, making sure that he was always larger than me, wait until he was at least fifty yards away, and start to sprint full blast at him. With each stride, my heart would pump faster and faster. By the time I was half-way there, I felt hatred toward him. Hate was becoming a light switch which I could easily turn off and on. Right before impact I would thrust my arms out so that my palms slammed into each shoulder blade. Damn, these kids would just fly. I found my horns. One time I did it to an older kid, he fell funny and broke his arm. He cried and cried. Achilles the swift-footed! After a while the other kids stopped fucking with me, and they began calling me,

"Kamikaze." They would say, "Eh, no fuck wit Kamikaze, or he going Pearl Harbor you."

I suppose this is when I contracted that dangerous, sometimes fatally cancerous affliction called pride. It spreads and spreads until not even the strongest poisons can kill it. The chicken began growing his comb. Suddenly I was not the whipping boy at school, I was "Kamikaze," Divine Wind. Even my father noticed the sudden growth of my ego. He liked what he saw. He started paying attention to me, which sucked. Insults to curb my ego and slaps on the back of my head came more regularly than my meals. Sometimes I felt like a dog which had suddenly pulled a neat trick. Like he had ignored me for years, then one day I brought him his slippers, and he was instantaneously amazed at this pet he owned. He'd drag me out fishing on weekends, sometimes pick me up from school. He tried to become a father when I didn't even really want one anymore. On my twelfth birthday, he bought a medicine ball, a jump rope, wraps, gloves, and a brand new heavy bag, which at first felt like it was filled with steel instead of sand. He began training me in boxing.

Every day after school, he watched as I warmed up with my sit-ups, pull-ups, and push-ups. Then I threw combinations at the heavy bag, and worked with the jump rope and medicine ball. Sometimes when he held the bag for me, he held a wooden back-scratcher in his right hand. When I would drop my left hand, he'd whack me upside the head with it. It almost felt like I was fighting him. I'd pretend that the heavy bag was his body and, gripping the iron bar in each glove tightly, I'd jab and hook with enthusiasm. This idea that he was the bag was my muse. Of course, the bag of sand always protected him, so no matter how hard I hit, he never went down. And no matter how much I watched out for his back-scratcher jab, he'd always get me at least once. It's surprising the right side of my head isn't flat from all the nights I spent avoiding the pillow with my left side. I can't really

say that I hated it, though, since with each day my comb grew bigger and bigger. Meanwhile my father would say, "You one fuckin' natural. I was wrong. You must have Hideyoshi blood." So by the time I started at King Zoo, I had my own reputation.

■ ■ ■

Koa was my brother. In football, when we played for Kahaluu Broncos and in high school, the Castle Knights, he was my primary blocker. Fucking best offensive tackle in the state. I'd just follow in the wake he would create. He'd just mow them down and wait for me to pass him. During games I'd sometimes call him Moses. With him blocking, I always felt safe, like I could run wherever I wanted. All I had to do was follow the big "78" on his jersey, and he'd show me where to go.

I remember, during practice, sometimes he'd play defensive tackle. As a defensive lineman in a scrimmage, he was my worst enemy. Fucking guy hit so hard, you'd feel your skeleton shake.

When I think back now, it seems that every time I did something for the first time, he was with me. He taught me how to do most of it. Surf. Dive. Hunt. Gamble at the cock derbies. Smoke weed, smoke rock. Some of the best days of my life.

I met him in English. The thing about somebody like Koa is, he was born a rascal. A real trouble-maker. I used to tell him that when he came out of the womb he probably played dead just to scare the shit out of his mom and pops. Different from me, born not giving a shit. Loud and funny. Emotional. The only emotions he ever revealed regularly, however, were humor and rage. He was a magnet of excitement, blind to consequence. Immune to self-analysis, guilt, and fear from birth. All id. Unstable. Some people would consider him stupid, but that would be inaccurate. He had wit, he had a sharp mind.

So there he was in class. Fucker could almost pass as a man already in the seventh grade. He was sitting in the back, yucking

it up with some of the other guys. The teacher was trying to explain the myth of Sisyphus to us. Without raising his hand, Koa suddenly spoke. "What a dummy. Shit, I would tell da boss of hell latas fo' dat."

The class laughed. The teacher was silent. Koa swore and got away with it. My first impression was, "What a fuckin' asshole. Thinks he's hot shit." I looked back and his eyes met mine. We shared that moment, that moment when two guys who think they're hot shit mentally communicate to each other: "What the fuck are you looking at? You better turn your eyes away before I kick your fuckin' ass." We were two complete strangers ready to kill each other because one wouldn't look away. I was scared shitless, but potent pride can always overcome fear. He smiled this "I don't believe you have the audacity to keep staring at me you little Japanee shit" smile. I looked away. I had won. A smile like that is a tactical retreat, an attempt to step back with pride intact.

Of course he tracked me down after school that day. Him and his lackeys. That's another thing about the stand-off, sometimes you regret backing down so much, the anger snowballs as you dwell on it over and over again. Koa was pissed. The only reason he had backed down was probably because no one had ever challenged him before. Shocked into submission. So there I was at the bus stop, waiting for my "Kaneohe-Circle Island" piece of shit white, yellow, and black city bus. I was reading my book of Greek myths, a book my mother left me, when I glanced off the page and saw them coming from pretty far away. I could've run, but refused. The three of them stopped in front of me. Koa, John Makena, and Michael Pacheco.

John was skinny like me. Dark as hell. He had a sparse patch of hair across his upper lip. Michael was fat, big, but fat. His forearms were covered with hair. Koa was tall, and his body was still laced with baby fat. Mean-looking. I looked at his hands and saw that

they were bigger than my father's. All three of them had their fists clenched. They all looked down on me as I stood in front of the wooden bus stop bench.

"Hey, what you fucka?" Koa said. "You look at me like dat, you betta be ready fo' trow down."

As I felt my body begin to quiver, I looked him in the eyes. I knew I'd lose badly, but I knew I couldn't run.

"What you little fuckin' Jap," Mike said, as he grabbed my book and tossed it in the dirt. Confidence oozed out of him.

It's funny how I unloaded on that fat fucker Mike. I didn't say shit. Just sighed, then hooked him in the ribs, then in the head. My father had always made sure I worked on my double left hook. To him it was the most devastating two-punch combination. When you hook the body, the other guy's hands instinctively drop. Before his hands even reach his gut, the other left lands on the right side of the chin. This leaves the guy defenseless for the overhand right. "Think of your waist as a swivel," he used to say. "Befo' you trow your shoulder completely left, get da second hook to da head in quick. Less den one second lata, your waist should snap back fo' da right. Jus' make sure you keep your balance."

Mike couldn't fight and he was slow. But he was bigger and stronger than me. After each combination I'd quickly jump back out of his reach and look at him. In a split second I'd decide what combination I'd throw next. Then I'd jump in for another flurry. It took three combos to drop him. Suddenly I felt arms wrap around me. My feet were dangling from the ground. No matter how much I struggled I couldn't even come close to breaking free. More than anything in the world, I'd come to hate the feeling of helplessness the worst. Pride hates nothing more than the inevitability of failure. Finally I heard Koa whisper to me, "Enough arready."

I stopped struggling and he put me down. Then Koa helped Mike up. John stood there in shock. Koa turned to me. "No

worry," he said, "I not into mobbing people. But you know what? If you still like beef, I go wit' you. I tell you one ting though, I no care how crazy you stay, if we go, I goin' kick your fuckin' ass. I no like, but I will. So up to you, we can beef, or we can wait fo' da bus and talk story."

I thought about it and knew he was right. He could kick my ass, but he was giving me an opportunity to walk away with my pride intact. I extended my hand and said, "My name is Ken."

Koa shook my hand, picked up my book of Greek myths, and dusted it off. He handed it to me and we all waited for the bus together.

The next day, they were sitting by me in class. Even Mike. We ate lunch together. Caught the bus home together. In the years to follow, we'd sleep over at each others' houses. My father loved Koa. You could tell because from day one he teased him, chased him around, punched his arm all the time. Koa, the natural wise-ass, would ask my father stuff like, "Hey, Uncle, where da bird stay?"

My father, not knowing what he was talking about, but knowing something was coming, played along and asked, "What da hell you talking about?"

Then Koa said, "Oh, you stay getting bolo head. I thought you was trying to make your head into one bird's nest."

The chase would begin. My father would catch him and either punch him in the arm or pin him and yank out some of his leg hairs. Koa would be laughing and yelling, "Nah, nah!" at the same time. It's funny, people like Koa who don't give a fuck, sometimes they're the most charismatic people around. There's a quality in them that is attractive to others. It never surprised me too much that my father loved a natural like Koa, but it shocked the hell out of me that he trusted him.

"Hey Dad," I'd say, putting down my book, "I goin' out K-point, surf. Be back tonight."

"Das what you tink. Today we goin' clean yard. And what I always tell you about talking like one fuckin' moke."

"Aww, c'mon Dad. I'm supposed to meet Koa pretty soon."

"Koa? Ahh, o.k. den. Tomorrow we go clean yard."

"Koa" was like the magic word. It was one of those weird things that, no matter how much I thought about it, I couldn't come up with an answer. Little did he know that we only went surfing or diving half the time, and almost never at K-point. When we did surf, we'd catch the bus to Sandy's or the North Shore, looking for big waves, and on the ride over, I'd try to read while Koa teased me about reading. "Eh, you nerd motha-fucka, why you read so much?"

"Betta den looking at your sorry ass."

"Fuckin' Poindexta."

"Fuck you."

When we'd get to the beach, we'd ride waves way too big for us. My fear of water was overcome, like most of my other fears, through anger and pride. Age and confidence. Besides, when you're pissed off half the day every day, it's easy to say, "fuck it."

Whenever you hear or read anything about surfing, all of this "soul" and "zen" crap appears. For me, surfing is athletic. All the zen in the world won't get you past fifteen-foot breakers when you're paddling out. Only skill, athleticism, and a demented mind will get you through that. It's a rush because of the fear factor. When I have thousands of pounds of water nipping at my heels, longing to smash me down into coral, I am not feeling "one with the ocean." Instead, I'm running away from it, not really trying to escape it, but teasing it with every cut, showing Neptune that I'm too fast, too smart for him. I'm briefly transformed into a modern-day Ulysses.

I remember one day Koa and I were sitting out on our boards at Sunset Beach. No sets were coming in and he caught me looking over my shoulder. "What you looking at?" he asked.

"Just looking back at the beach, seeing if get any chicks."

He looked over his shoulder. "Yeah right. If all da chicks was wearing surf shorts and was topless, you couldn't even tell if dey was girls or guys from here. You was looking in da water. Why you scared of sharks?"

"Nah, I was just lookin'. Figure if I see one I can hit 'um on da nose befo' da thing try bite me. You hit 'um on da nose and da fucka goin' bug out."

Koa laughed. "You think if you hit one thirteen-foot tiger on da nose da thing goin' cry and run away? Fuck dat. Fucka would laugh if he could. Da only way he goin' away is if you taste shitty."

I involuntarily looked back again and was pissed at myself for it. He laughed again. "Look," he said, "you no need worry. Sharks, das my aumakua. Das all my great-great aunties and uncles swimming around. You my bradda, dey not goin' fuck wit' you. When I die, das what I goin' become. But hey, if I die before you and you surf without me, I goin' come and eat your sorry ass."

He laughed. I called him a superstitious mother-fucker and asked him if he prayed to tikis, too. He put hands by his mouth and yelled, "You heard dat, aunty, uncle? Come eat da fuckin' Japanee!"

We both laughed, then looked at each other, and began racing back to shore. As we paddled in, I saw a tour bus stop in front of the beach. A file of tourists exited. I couldn't make out any faces, but I saw a group of ugly aloha shirts and white limbs congregate in front of the bus. I slowed my paddling and waited for Koa to catch up. Koa stopped beside me. "I cannot see," he said, "fuckin' Japs or haoles?"

"Eh, neva mind saying 'Jap' ah. I Japanee, rememba?"

"Yeah, but you not dat kine Jap. You local. Hey, you tol' me about da samurai befo'. What da fuck happened to Japan? Only get skinny pussies now, ah?"

"Eh, no blame dem," I said. "Fuck, imagine if you got two atomic bombs dropped on you. You would act like one pussy, too."

Koa shook his head. "Fuck dat. Eh, Hawaiians got mo' fucked by da haoles. You know, my grandfadda used to tell me about Kahaluu and Kaneohe Bay when he was small kid time."

"I see some wit' blond hair, must be haoles," I said.

"Eh," Koa said, splashing water at me, "listen you fucka, I trying fo' educate you. Fuckin' Kahaluu used to be mean. Had pig all ova da place. Had taro. Kaneohe Bay had all kine fish swimming close to shore. You could trow net from da beach. But da best, and I know you not goin' believe, but da best is you could drink da wata from da streams coming down da mountains."

I laughed. "Fuck dat. No way you could eva drink from dat. You fuckin' die in seconds. I would radda drink my own piss den da wata from da stream behind your house."

"Serious. Could, you know. My grandfadda told me dey always used to drink from da stream. And you know what's even mo' mean? Da beach in front Kahaluu neva used to have shit-brown wata."

"No fuckin' way."

"Yes, and you know what else?"

"What?"

"My great-great-grandfadda used to be da chief."

"Fuck you."

"Yup. So you betta call me 'Chief Koa' from now on cause I da rightful chief of Kahaluu."

I smiled and shook my head. "Yeah, nice your kingdom now. Fuck rememba da last time we was on your brown beach? Had fuckin' dead fish washing on your shore. Hey, what dose fuckin' haoles doing now? We go paddle more in."

As we got further in, we saw the tourists taking off their socks and shoes on the beach. Most of the men and women were

fat, and some of them wore matching aloha shirts. I looked at the legs of some of the men and saw their tan lines. Their ankles and feet were pure white, while their upper calves and thighs were red. Even some of the children had this tan line. I laughed. "Look at dose fuckas. Fuck, dey no shame or what, half sunburn, half white?"

"Das nothing," Koa said, "look dose fuckin' shirts. Can be any brighter or what?"

When we got to shore and picked up our boards, the tourists were walking past us towards the water. "No fuckin' way," Koa said. "No tell me dese fuckin' haoles goin' put dea stink-ass haole feet in da wata."

We walked further up the beach, put down our boards, and sat down. We watched the tourists. They were standing knee-deep in the water, laughing and splashing. "Eh," I said, "maybe dat's why da fish stay dying in Kahaluu. When you sleeping, get haoles sneaking ova dea putting dea feet in your wata."

"Fuck, das not even funny. Hey, look at dat kid. What da fuck he doing?"

One of the tourists, a blond boy who looked about our age, ran up the beach from the water and began undressing. He unbuttoned his bright blue aloha shirt. The shirt had the Hawaiian Islands drawn all over it, and under each island its name was written in cursive pink letters. He took off the shirt and began unbuttoning his pants.

"Whoa," Koa said, "what da fuck he doing? Eh, what da fuck is dat he wearing?"

"Das fuckin' speedos," I said.

"Fuck you, das bebeddies. Look at dat fucka, he no shame or what. Can see his balls sticking through dat."

"What da fuck you doing looking at his balls?"

"Fuck you. Eh, what is dat he get now? No tell me das one fuckin' mask."

The boy pulled a pair of swimming goggles out of his pants pocket. I smiled. "Das da style in da mainland."

Koa stood up and put his hands by his mouth. "Eh, haole boy, you crazy or what? You look like one faggot insect. Put your clothes back on befo' we go blind."

The boy was too far away to hear what Koa was saying. I was laughing, then I felt Koa's hand grab my arm. I stood up. "Hey Ken," he said, "what da fuck haole boy doing now?"

I watched the boy swimming in the water. "Dey call dat da buttafly or someting," I said.

"Da buttafly? I taut buttaflys was pretty. Fucka look like he having one seizure out dea. The fucka like drown or what?"

I shook my head, smiled, and sat back down. Koa looked over his shoulder. "Hey, look up dea." He pointed toward the front of the tour bus. "We go steal dea shoes."

"How can? Still get da tour guide in da bus. Besides, what about our boards?"

"Fuck da boards. No one goin' take 'um. And no tell me you cannot outrun dat tour guide fucka. You da fastest guy I know."

"What about you, fat ass? You cannot run dat fast."

"Yeah, but you forget someting."

"What?"

"I no give a fuck."

We stole the shoes and ran away laughing our asses off. The tour guide only chased us about ten feet before he stopped and the tourists just stood on the beach in a state of shock. We waited for the bus to leave, then went back and grabbed our shirts, slippers, and my book from the bushes. Luckily, no one stole our boards, too. I didn't know it at the time, but Koa's personal war against haoles was to escalate in high school. But until then, we did more surfing and harmless stealing. Sometimes we avoided the tourists, the landmark beaches, and went diving or hunting instead.

✤ ✤ ✤

I always felt safer in the water while diving. At least I had my three-pronged spear, and I could see under the water. I was still a little paranoid, though, because I knew the spear would be about as effective as a stick would be in warding off a hungry lion if a shark were to attack, and the tempered glass sucked onto my face by a rubber frame gave me limited sight into the ocean. I saw only about twenty feet in any direction. Sometimes I felt like I was walking into a huge, dark room armed with a flickering candle, moving in a tenuous bubble of light. I loved to dive, though. Taking the boat out to Chinaman's Hat and diving the deep end behind the island. Spitting in the mask and wiping the glass to prevent fogging. Sitting on the edge of the boat, holding my mask down on my face, leaning back, and entering the ocean like I'd seen Jacques Cousteau do. The rush of cold water, the surfacing, spitting water out through my snorkel, acting like I'm a whale, the snorkel my blow hole. The sound of my breathing resonating in the plastic tube. Sounding like Darth Vader. Trying to talk like him. "The circle is now complete, I was once the student, but now I am the master." The searching for prey under dark crevasses, the feel of the surgical rubber squeezing the knuckle of the index finger right before I released to take a shot. Nothing can compare to the feeling of going down about forty feet, holding my breath, seeing an *uhu* just before I have to resurface, deciding to stay down for just a half a minute longer, feeling my body shake from lack of oxygen, knowing that I have only one shot at him, knowing I'm risking a lot just to catch one stupid fish. Nothing around you matters, not even thinking about sharks, just struggling to get a clean shot at the fish before you pass out. It was like therapy.

Hunting on land was always shitty to me in comparison. Even though Koa loved it, I complained that it was like a long,

fucking walk up a mountain just to get a few rounds off. We used to hunt illegally up at Kualoa Ranch, the only place left on the Windward side with a significant wild boar population. We always had to watch our back for ranchers who would bust us for trespassing. Carrying that damn thirty-thirty up a mountain, feeling it get heavier, feeling the moistness of your palms accidentally touch the metal, knowing that when you get down you'll have to give it a thorough cleaning because of the mixture of sweat and salt. And God forbid if you actually shoot a boar and have to carry it on your shoulders down the whole damn mountain. Pig blood matting the hair on the back of your head. The huffing and puffing, the strain and stain on your back. It was like work. One trip I'll never forget, or remember fully for that matter.

The sun was setting and I wanted to go home. Just as Koa and I started our descent, I saw one lying down under a tree. Like an idiot, without even thinking, I raised the barrel and fired. Like the unlucky asshole that I am, I hit it. I heard Koa cheer and I sighed. We walked down the ridge to the tree. I handed my rifle to Koa, put the boar on my shoulders, and we began to walk down.

It was getting dark. Suddenly we heard voices. Someone yelled "Hey, stop!" When someone yells this in your direction, it's usually a good idea to haul ass. For me, it was like hearing someone fire a starting gun. Koa and I blazed. He was ahead of me because of the boar on my back, the biggest pigskin I ever had to carry. I watched as he ran straight through branches and tall bushes, much like a wild mountain boar does when it's running. He was blocking, I ran through his wake. The blood was pumping and I began feeling like the hunted animal, fleeing with all of my strength, the adrenaline bravely fighting off exhaustion. Suddenly I noticed we were running down like a sixty-degree incline.

Every fifty yards or so, we'd fall flat on our faces and roll down about fifteen feet. For some reason, each time I got up, I'd

re-secure the dead pig on my shoulders, refusing to leave it. Sweating with that weight on my shoulders, dropping it once in a while, scrambling for it like it was my arm I'd dropped or something, sniffing the wild smell of the dead animal, feeling my fingers dig into its coarse hair. We were determined to escape. It was a clumsy flee, but finally the voices faded with the sun. We kept on running just in case, not slowing down in the blinding dark. It was at least a mile. We were lucky we didn't run straight off a cliff. Finally I saw the light of Kam Highway. Relieved, we slowed down.

When I reached the side of the street, I let the boar drop from my shoulders and paced with my hands on my hips, trying to catch my breath. Koa threw the guns to the ground, sat down, and leaned back. Every few seconds, his panting would be interrupted as he turned his head and spit. Suddenly, out of the blue, we both started laughing.

"Holy shit," he said. "Fuckin' ranchers was right on our ass."

I laughed. "You fuckin' nuts or what? You could see where you was goin'?"

His eyes got big. "Fuck no! I taut we was goin' fall right off da mountain."

We laughed so hard the tears rolled down our beet-red cheeks. As the laughter subsided, once more I said, "You fuckin' crazy."

We decided to clean the pig at my house because it was closer. I picked it up, Koa grabbed the guns, and we began walking home. This is where the trouble started.

When we got to my house, I hung up the pig while Koa went inside to wash up and grab a knife. I smelled the wild stench on me, crinkled my nose, and began taking my hunting clothes off. When Koa came back out, I finally noticed. His face was covered with lacerations made by the branches he'd run straight through. He read my shock and laughed. "You neva see?" he asked. "Shit, I neva even know too until I went in da house and looked in da mirror."

I laughed, laughed in the cold, my underwear and some pig blood my only coverings, but then I saw he was holding the unsheathed katana in his hand, the sword my father inherited after his father's death, and another kind of shiver emerged. I saw the crimson threads above and below his clenched fingers. The blade shone even though it was dark, greedily grabbing at any light it could reach. Moon, stars, distant street lights. It shone with its cleanness, its flawlessness. He sensed my nervousness. "Shit, I was goin' grab da small one," he said, "but I figured would be more fun wit' da big one."

He handed me the sword. It felt so much lighter than before, when my grandfather had first put it in my hand. But in a way, heavier, too. "Gut 'um," Koa whispered.

I looked around. My father's truck was gone. I looked at the boar, smelled it, hated it for making me shoot it, making me carry it all the way down that mountain. I pretended it was my father. I let out a loud "Yahhh!" and lifted the blade over my head and swung down with a quick slice. Before I could even step back, the intestines dropped out of the boar's belly and splattered on my bare feet. Steam rose from the bloody mess. I heard Koa yell, "Holy shit! Lemme try."

I handed the katana to Koa, and without hesitation he swung at the neck of the pig. The whole pig fell from the force, and the head rolled a few feet away. I couldn't believe it sliced cleanly through the thick spine. He began to laugh. "This fuckin' sword is so cool."

That's when we heard the truck pull up the driveway. We were the deer in the headlights, unmoved, maybe longing to hear a loud cry of warning, a "Hey, stop!"

I heard the bloody blade drop from Koa's hand.

No explanation attempted, no questions asked. He walked straight up to me and said, "Koa, get your ass home."

I looked over and saw Koa take several steps back. Then before I could look back at my father, I already felt the fist hit the

side of my jaw. My body spun, but I didn't drop. Then I heard his voice. "You fuckin' kid! You disrespect da sword, you make me hit you!" Bam, another fist to the head, this one on the temple. "And now you no drop! Who da fuck you tink you are!" Another one hit me on the jaw.

After I spun from that one, I looked up at his face and saw the crinkle in his forehead, the devilish arch of his eyebrows, and the enlarged whites of his eyes. I smiled. Gave him my best sixteen-year-old smile, and spit out fragments of teeth at him. Another hit. "So you lifting weights now, tink you hot shit, " he yelled. "C'mon give me one shot! I fuckin' kill you, you fucka!" I stood there with my hands down and stared at him. Finally he said, "Get da fuck outta here before I fuckin' kill you!"

Actually, I don't really remember any of this. It's what Koa told me had happened the next day when I woke up in his room. I figured that was the way it went, though, considering I couldn't talk for a week, and when I slid my tongue across my teeth, I cut it. I had to drink Slim Fasts all week long. I didn't go home, I didn't go to school. Koa picked up some clothes for me. His parents let him stay home for a couple of days to keep me company, and when he went to school I just read more because I couldn't talk. After I got a little better, Aunty Nani stopped giving me pitying looks, and began teasing. "You betta start fuckin' eating cause I not going give you any mo' Slim Fasts. Bumbye you get even mo' skinny."

Uncle James stayed out of it. I suppose it's a code that exists around the world: Never interfere with the raising of someone else's child. You have no right. A week and a half later, my father picked me up and took me to an oral surgeon. Uncle James and Aunty Kanani stayed in the house while Koa shook my hand outside by the truck. My father nodded to Koa and drove off. Puana Castle got smaller and smaller. It was a quiet ride. The quiet rides I had in that truck. They always occurred, it seemed,

when he was picking me up from someplace else and taking me home. I guess most quiet rides occur when you're heading for someplace you don't want to go. I looked toward the Koolaus and again thought that I had to get over the mountains, out of the Windward side.

This thing with the sword, it was the worst beating I ever got. That sword never did seem to do me any good. My beating was bad because I didn't fight back, didn't demand respect, a presence, but there was always something in me that refused to hit him back. I was trained well. On the bright side, to this day I have whiter teeth than anyone else I know.

The memory loss bothered me more than the physical discomfort. It was like losing a cursed heirloom that I didn't want but felt I needed to have. I hate that frantic feeling when you lose something, know it's somewhere around, but can never find it. He'd hit me before, but it was the first time I couldn't remember. It scared the shit out of me. For days I tried to dig deep down in my mind and search for a shred of memory. It seemed even further away from my conscience than my mother's last words to me.

My father and I never discussed what had happened, even when I returned home. I hid in the cradle of books my mother left me. I read about foreign places, places I wanted to go to, but didn't think I'd ever see. Sometimes I'd put a book down and wonder why my great memory was not able to dig up such a huge corpse. I thought, if I blanked out once, I could blank out again. How could I lack control to such a degree? I probably wanted to find the memory because I didn't want to believe it. How could I get so crazy that I didn't care anymore whether I lived or died? It concerned me greatly that I could get to the point where I just didn't care anymore, that I'd just give up, crawl under a rock and accept death. I wanted to be a fighter, to go out in a blaze if necessary. I did not want to be the kind of person who just accepts his fate with a defiant grin. I knew the grin was

just a feeble attempt to save face. My behavior, the accepted futility that Koa had told me about, scared me. My attachment to memory is strong, but perhaps my desire to never go out quietly is even stronger. I like to slam the door.

✢ ✢ ✢

When Koa and I didn't go surfing, diving, or hunting, we got into more trouble. We gambled, fought, drank, got high, sometimes all in the same day. We used to steal chickens and take them to the derbies. Koa always had good knives, those clean, razor-sharp, sickle-shaped blades you tie on to both legs of the chicken, lending each gladiator bird the power to kill with one stroke. We, the Romans, low-income degenerate gambling mother-fuckers, looking down into the colosseum, watching the feathers fly with each furious charge. It was amazing to watch a usually timid and weak creature suddenly turn blood-thirsty, angrily leaping up at its opponent. Both would be suspended in mid-air for just a second or two, wings flapping violently, claws extending in quick offense. When both landed back onto the pit surface, their stay ended in a flash because they'd leap back up as soon as they possibly could, unsatisfied until one yielded. In this case, surrender and death were the same.

The first time Koa took me to a derby, before the first contest began, he leaned over to me. "Watch dis. You rememba when you went drop Mike? Da way you went beef reminded me of one chicken. Attack fast. Land. Attack fast." I thought, if this was true, then it was my father who'd tied the knives to me, he who'd made sure they always stayed sharp.

Koa looked around. "Look at dis place, Ken, you gotta love it. My kind of place."

I looked and saw boys and men of all ages drinking, smoking weed, anticipating the next fight. "See," Koa said, "on dis side of

da island, we no fuck around when we break da law. Look at dis. Gambling, smoking out. And you know no one goin' call da cops. Nobody like cops come."

I watched as two men let their birds go, one had white feathers, while the other wore brown. The roosters charged each other. They were moving so fast and flapping their wings so hard that their feet seemed to barely touch the ground. Right before they met each other in the center of the ring, they lept foward and led with their claws. Koa leaned over to me. "Fuck, good ting still get places dat da tourists no see. Good ting we keep most of dose fuckas in Waikiki."

The two birds landed on the ground, seemingly unharmed. They jumped up again. White and brown feathers fell like leaves below them. "You know why it's good dat da tourists no see dis?" Koa asked. "Because if dey did, da fuckin' cops would crack down on dis shit." The birds landed and jumped again, but this time the white rooster jumped higher and the brown one was forced into a defensive position. One of the white bird's knives pierced the breast of the brown one.

After the derby, which was held in Waiahole Valley, the valley which sits between Koa's Kahaluu and my Ka'a'awa, we went to Freddie's place. Koa had won a hundred bucks, so he wanted to celebrate. He told me about Freddie, this guy he knew, who always had stuff. We hopped on our stolen bicycles and I followed him deep into the valley. When we got there, we dropped our bikes in the front yard. I looked at the house briefly, it was this audacious pink, but other than that it was nothing different. Screen door, wooden-planked walls, shingled roof. Old. I followed Koa as he walked toward the backyard. The yard was pretty big. Two plumeria trees dropped wilted flowers on the bermuda grass. I stepped on them as I followed Koa. Before he turned the corner, Koa stopped. "Ken, no talk too much. Da fucka stay kind of mental. Jus' let me talk to him."

In the backyard sat a big square shed, walled and roofed with smoky corrugated fiberglass. It must have been about twenty feet wide and fifteen feet tall. On the way to the front, I saw a few little patches of fur sticking up from the ground. Then I smelled the good smell and knew someone was burning. Suddenly I heard a loud blast of music from inside. It was some hard rock group, maybe Slayer or something, one of those groups whose music never makes it on the radio or MTV. I followed Koa as he stepped inside.

It was like a thick, reefer jungle inside. Dozens of potted cannabis plants were spread out, many of them growing to the ceiling. In the middle of the hothouse was a workbench with paraphernalia scattered all over it. Scales, mirrors, plastic, ashtrays, tweezers, scissors, spoons. A boom box blasted in the right-hand corner. Next to it I saw a high-caliber revolver, a three-fifty-seven, I think. Freddie's back was to us, as he was concentrating on something on the middle of the bench. It was a broad, well-muscled back, a twenty-five-year-old back, dark and lumpy. A huge tattoo stretched across his shoulder blades. In jailhouse calligraphy letters it read, *Lunatic Click*. He wasn't that tall, about five-eight, but he was wide, carrying the kind of frame that can be achieved only with heavy weights. Below his shirtless torso, he wore dark-blue Levi's, which drooped down so his tan line and the top of his ass crack were visible. I looked up at the back of his head and saw the outrageous bushel of hair. It was the kind of wavy hair that grew out, not down, defying the laws of gravity. Clouds of smoke billowed from the front of his mane and hung there just long enough that he looked like he was wearing a twisted halo. I was scared of him before I'd even seen his face.

"Hey, Freddie!" Koa yelled, attempting to be heard over the rapid guitar solo that screamed from the tape player.

Freddie put his hand on the gun and slowly turned around. A joint dangled from his lips. He smiled and waved Koa over.

"Hey," Koa yelled, "no shoot me ah, you fucka!"

We both walked to the bench. Freddie was sealing ounces. After he finished packaging the one he was working on, he grabbed a bud and a Zig Zag, and began rolling a joint. About thirty seconds later, he passed it over to Koa.

We got stoned. I looked at Koa and laughed. His glassy, blood-shot eyes peered at me, squinting as his mouth broadened. Suddenly we heard Freddie say sharply, "Hey, shut up." We froze and it looked as if he was trying to hear something. He held his hand up at us and remained still. After a few seconds, he reached for the volume knob. The screaming music dulled to silence. I thought he was having some kind of bad trip. He reached under his workbench and pulled out a handful of cat food.

I was tripping. I was fascinated, though, especially because I was so stoned. I looked over at Koa, and he was just as captivated. Freddie quietly stepped out of the shed. He began to make clicking noises, calling noises. Koa and I walked out and saw him crouched down, beckoning, sometimes pausing to throw a dried gem of cat food into the thick bushes.

Sure enough, after a few minutes, a cat reluctantly emerged. It was a gray one, one of those short-haired gray felines that have squiggly black stripes running all over its body. A real stray, ugly and skinny. Freddie patiently called. It was a sweet call, full of calming emotion, like a soothing song. The cat wasn't immediately taken by it. At first it was smart, paranoid, like most cats are, but soon the food and call harmonized together, making the cat come closer and closer. I was amazed at how patient Freddie was, his rhythm never became strained or anxious. He just crouched there, motionless, singing his call. Finally the cat rubbed against his leg and purred. Freddie gave it a gentle stoke down its spine, then suddenly clamped his hand around its tail.

The cat tried to run, but Freddie just stood up and let the cat dangle from his grip. It went crazy, contorted its body in

violent spasms, scratched at his hand, but Freddie unflinchingly strolled back into the shed with a big smile. He motioned for us to follow him. I knew the cat was in deep shit.

Freddie swung the cat over his head, spun it around and around like it was a sling and a stone. He let go and it crashed onto his workbench. Before it could recover, he quickly ran over and grabbed it by the neck. "Hey Puana," he yelled, "go grab me dat rope in da corner ova dea."

Koa looked at me with this "holy shit" look, walked over to the corner and picked up the rope. It was a short, thin nylon cord that already had a noose tied to the end of it. Koa threw it over to Freddie, probably not wanting to get too close. "Hea, you crazy fucka."

We watched as Freddie tied the rope to a high, thick branch. He put the cat's neck through the noose, and lowered it until the rope tightened around its neck. He let go of the cat. The branch bent down from the cat's weight so that it swung at our eye level. At first the cat went crazy, clawing and kicking the air. But soon it settled down, exhausted and defeated. Freddie rolled another joint, lit it up, and passed it over to us. When we took our hits and handed it back, he pushed it in the cat's mouth, clamped his hand down on the cat's muzzle, and we watched it get stoned. After several hits, the cat began to make this low, pitiful, meowing sound.

He let it hang there while he talked to us. "So what, Koa, who dis?"

"Dis my bradda, Ken. Ken, dis Freddie."

We shook hands and smiled at each other. Our eyes met, then suddenly I looked away, looked over his shoulder, and involuntarily looked at the cat which let out another pitiful meow. He put his arm around my shoulder, led me to the cat, and slapped it in the face. "We go paint 'um," he said.

Koa and I watched as he meticulously sprayed blue paint on the cat. The cat meowed as it became more and more blue. I

looked at Freddie's face. It lacked emotion. The joint dangled from his lips and he squinted so the smoke wouldn't tear his eyes. He looked like a carpenter painting a chair or something. Patient, crafty, like he just wanted to make sure that he got all of the empty gray spots with smooth stokes.

I looked over at Koa. He smiled and shook his head. Freddie yelled over the blasting music. "Eh! Let's go in da house and grab one beer!" We left the hanging cat out to dry and walked in Freddie's house to have a cold one.

When we returned outside to the shed, the cat was still alive. It was making this violent, gasping sound. Freddie rolled another joint and put a Metallica tape in his radio. *The Four Horsemen* blared through the speakers.

"Koa," Freddie said, "run in front of da house and grab my shovel."

Koa shook his head and stepped out of the shed. Freddie lit the joint and held it with his lips. He lifted the cat and loosened the noose. He grabbed the cat by the skin of its neck and took off the rope. He stepped out of the shed and said, "C'mon."

I followed him out. When we got behind the shed, Koa met us there with the shovel. "Koa," Freddie said, "give da shovel to Ken. Ken, dig one quick hole."

I dug a small hole about a foot and a half deep. "Kay, nuff arready," Freddie said.

He handed the joint to Koa and got down on his knees. He wrapped his hand around the cat's neck and put it in the hole. "Ken," he said, "hurry up and bury da fucka."

I looked at Koa. He shrugged. I shoveled dirt on the cat. "Koa," Freddie said, "put your foot on da cat."

Koa put his foot on the cat and Freddie let go. The cat started scrambling. Koa tried to keep it in the hole with his foot, but he was having a hard time. He had to hop around on his free foot so the cat wouldn't get away. He looked like he was dancing

to the fast beat of the Metallica tape. I tried to help him by shoveling the dirt quickly on the cat.

Suddenly I heard Freddie laughing. Koa lost his balance and fell down. The cat jumped from its grave and shot away. Freddie fell down, laughing. "Hard, ah," he said. "Fuck, imagine doing 'um by yourself."

❖ ❖ ❖

So after that Freddie was our source. We used his stuff, and sold some for him. When he graduated to coke, we walked with him. I used to blame the coke for the beginning and end of my separation from Koa. He stayed hooked, I didn't. As we got older, the surfing turned into going to Sandy's, smoking joints in our cars, blowing a few lines, getting stoned out of our minds, and looking for fights. Not in the surf, not even really looking at it, we just blasted the stereo, drowned out the sound of the crashing waves, and sat in cars bought with money we made with Freddie. The hunting became taking coke and beer chasers up to the mountains with our guns in tow, getting drunk, and shooting at trees like a couple of drunken hillbillies. Soon Koa saw hunting as a long, boring walk, too. We still went to the cock derbies, not to watch or gamble, but to sell. Sometimes we'd over-charge just to cover what we skimmed. The dumb ones would still buy, some of the others needed persuading. The threat of violence is sometimes the most convincing form of discourse.

During the football seasons, we told each other we'd clean up our acts. And at first we did. I made First Team All O.I.A. my junior year, Koa made All State. But by the summer before our senior year, Koa was a coke fiend. "The hell with football," he said, "not even fun anymore."

I'd had enough. Coke wasn't for me, at least as a user. I began to think about what my grandfather had told me about

the Chinese, how they were broken by the drugs the haoles gave them. I figured I didn't want to be broken. I looked at the powder and began thinking, "Jeez, it's pure white." I also began looking at Koa and seeing in his place a hanging blue cat with a joint crammed in his mouth. I quit coke that summer. Funny, it wasn't hard, really. Even though I really liked coke, I guess my body never embraced it. Genetics, I guess. My father never turned out to be a great alcoholic. He drank a few days a week, what is that? Social drinking.

Koa didn't quit. I can't really blame him. It had nothing to do with strength or willpower — Koa had a lot of both. Instead it just always came down to the fact that he did not give a fuck. "Where da fuck am I going?" he'd say. Where I would see my future beyond the Koolau mountains, always looking for a tunnel of escape, he never even really looked toward them. I had something to run from, he always felt he had what he needed and all that he was going to get. Kahaluu, Puana Castle, it was his kingdom to inherit, his land to rule. It was what the haoles had left him, and he was going to make sure that the haoles would never snatch a piece of it while he still breathed.

Koa, it was kind of strange, how cool he was until it came to haoles. I mean, he was a nice guy, a guy who, like his parents, had this tremendous heart. Sure, he was a born trouble-maker, a fucking rascal, but this guy loved people unconditionally. This was the guy that took me in and made me, an otherwise outsider, a knight in his kingdom. He would do anything for me and anyone else he called friend. He'd give his last dollar with a smile. He was always smiling. Anything he had was for the giving when it came to those he cared about. But, man, when it came to haoles, he became a fucking blood-thirsty animal. He hated all of them. I never asked him why. It always seemed obvious. They'd taken his land. They killed his culture and therefore they'd taken his humanity. Well, if they wanted an animal, Koa was going to give

them one they'd never forget. A fucking Grendel, a Skylla and Charybdis all rolled up in one.

So sometimes we'd drive to Kailua, the closest place where there was a guarantee that some haoles were around. The Marine base was in Kailua, so there was always some fucking jarhead walking around Kailua town. We'd hunt at night, cruise around some of the Kailua bars, stalking with patience. Half the time we wouldn't see anyone worth fighting, so we'd kill time with some beer, some coke. That's one of the things about coke, why I figure it's so addicting to most. The feeling it gives you, it's like heightened awareness. Your body feels awake, primed. Sometimes you feel like your eyes can see farther, that your ears can grasp sounds out of the air with lightning quickness. You feel like a rubberband, stretched out at maximum. The tension, the band is thin and smooth, the rubber is suspended to the point where just pulling a centimeter more will cause cracks to surface, lesions to appear. But it feels like it's not hard to keep the rubberband steady. You feel in control, like forcing the band to snap is a conscious decision which only you can make. I still can't believe how easy it was for me to quit.

So we'd wait. Most of the time it wasn't just me and Koa. Most of the time we went on the hunt with six or seven. The last thing we wanted was to get mobbed by a group of haoles too big for us to handle. We were a regular posse, a bunch of teenagers looking for white faces to punch. We were just a bunch of poor kids from the Windward side with the abbreviation SYN tattooed on our hands. We hoped we'd send the haoles packing back home. Like my grandpa told me the Tokugawas did: chop off their heads, spike them on the beach, and tell the others never to come back.

To our credit, we never picked easy fights. We never hunted old men or people who walked alone. We made sure that it was a group of tough haoles (actually it was good enough if they walked around thinking they were tough), usually Marines, jarheads with

their shirt sleeves rolled up, often revealing tattoos. We wanted the craziest fucking semper fi mother-fuckers, a group of them about equal in number to ours. We wanted to show the haoles that these guys can't protect them from us. They aren't as tough. Hell, these were adults, we were just teenagers with "SYN" tattooed on our hands. I was about seventeen when I had started, not even full grown, but five years of boxing, two years of weights, and about ten years of hate had me prepared. Some of the others weren't much help at times, but there was always Koa leading the charge, all two hundred and eighty pounds of him, and there I was following in his wake.

The first time I hit a haole, I broke my left hand. The second time, I broke my right. Both of them went down, but at a price. The second time I broke my hand was during my senior year, my last season of football. I missed half the season, blew any chance of making All-State and receiving a scholarship from the University of Hawai'i. So by the third time, I was pissed. This time it was only me and Koa. We had started losing confidence in the others, thought sometimes they didn't pull their weight. We cruised the main road, didn't see anything, so we went to Kailua Beach Park.

When we got there, it seemed like a typical Friday night, some guys drinking, others with boyfriends or girlfriends walking on the beach. Just about all of them were locals, Kailua High School people, just cruising at midnight. It seemed all of the Marines had decided to stay on base that night, and we were getting anxious. It's funny how when you expect something and it doesn't materialize, you want that thing even more.

Suddenly a red Camaro pulled up in the beach parking lot. I saw it in the rear view mirror, then looked over at Koa, who smiled. We sat quietly in my car, sipping beers, waiting to see what they would do. They jumped out of the car, two of them, one blond, the other with black hair. Both were shirtless, revealing the dog tags hanging from their necks.

"Hey, I neva even taut about dat before," Koa whispered. "Fuck, when we kick dea ass, we go fuckin' take da dog tags, you know, like one trophy."

I looked over at Koa and saw this huge grin on his face. His eyes were red from the beer, and I could see that he was probably having delusions of grandeur, thinking something like if we did this every weekend for the next two years, we'd have over a hundred dog tags. The fucking Marine Corps would go absolutely nuts having to re-issue all these dog tags to these black-eyed, busted lip Marines who'd come walking in, quietly saying, "I lost my tags." I think Koa was probably figuring that he could single-handedly get the Marines to leave Kaneohe Bay. He never said it, but I laughed out loud anyway.

He just looked at me and whispered, "We go get dose dog tags."

I looked out my window and watched as the two Marines threw their empty beer bottles into the bushes. I could feel Koa burning. Then the improbable happened. They came walking toward my car. Before I could get out, the blond leaned over with a cigarette hanging from his lips and asked in a Southern drawl, "Hey, you gotta light?"

I pressed in my car lighter. "Hold on," I said, "it'll be a minute." While I held the knob of the lighter, I saw the other marine walk to Koa's side. When he looked in, his head involuntarily jerked back. He was probably surprised at Koa's size. I saw both of the Marines looking at each other through both open windows and my hand started to shake.

The blond one broke the stare and asked me, "Hey, you got a couple of extra beers?"

I looked at Koa, who held the rest of the cold pack in his lap, and turned to the blond and said, "No."

They looked at each other again, then the other one said, "What's that in your lap?"

Before Koa could say anything, the blond added, "Hey, you guys are a little young, yeah? Maybe you should hand the beer over to us before you get busted by the cops."

We were at an extreme disadvantage because we were sitting in the car. They could get clean shots at us, while trying to hit them while sitting down would have been stupid. We couldn't believe it. These guys were starting shit with us. The car lighter popped out. I pulled it out and looked at the orange glow of the coils. I told the Marine, "Here, I'll light it for you."

When he leaned in I shoved the lighter right into his left cheek. He screamed and jumped back. His partner on Koa's side of the car froze in shock. Both of us quickly jumped out of the car. I heard hitting on Koa's side of the car, but didn't look back. The Marine on my side was holding his burnt cheek and yelling, "You fuckin' Jap! You mother-fuckin' Jap!"

The moment he dropped his hand from his cheek, I hit him with a right hook. I was relieved that my hand didn't break. After a few more hits, he went down, and I looked over at Koa and saw that he was slamming the car door on the drooping body of the black-haired Marine.

I yelled, "Let's get da fuck out of here!" He pulled the dog tags off, and threw the Marine to one side.

As I reversed out, I felt my sweaty hands shake on the steering wheel. I shifted into first, peeled out on the loose gravel, and made tracks to the street. Just as I started to feel like we'd made it out, I heard the siren and saw the glow of the blue light flashing in my rear view mirror. I heard Koa say, "Ditch 'um," so I pressed the gas down as far as it would go and started mapping out a possible escape from a town whose roads I wasn't that familiar with.

It was the first time I was arrested for something scary. I'd got busted once for shop-lifting, and twice for violating curfew. But this time around, in one fell swoop, I was charged with assault,

driving under the influence, underage drinking, driving with an open container, reckless driving, and resisting arrest. Koa got assault and possession of narcotics. Since we were seventeen, we were not tried as adults. In juvenile court, my school record helped me, so I was sentenced to only eighty hours of community service. Koa's school record sucked. In fact his grades were so bad that it didn't look like he was going to graduate, so he got twice as much. All in all, it was a good deal, but to this day what burns me up is that those fucking Marines probably didn't get shit. This "who threw the first punch" idea is bullshit. They would've hit us first if we hadn't hit them, and I've always refused to wait for someone to punch me. Koa was happy, though. He managed to hide the tags under my seat, and nobody said anything about them. They probably thought the tags simply got lost in the fight.

I knew I had to slow down after this one. Koa seemed to know it, too. He started to spend more time with his girlfriend, Kahala, and we started to surf and dive again. As we neared graduation, things seemed to be smoothing out, but then I began thinking it would be safer on the other side of the mountain. So I started looking for that tunnel even harder, and my father seemed quite willing to lend me a magnifying glass.

When he picked me up from the Kailua police station that night, he wasn't happy. It was about three in the morning when I had finally finished getting processed, and when I walked out to the main office, and saw my father standing there with his devil eyebrows hovering over blood-shot eyes, I turned to the sergeant and said, "I don't suppose there's any chance of letting me back into the cell."

It wasn't a quiet ride home. For twenty minutes he screamed. "What da fuck is dis fuckin' shit! You like die? Fuckin' drinkin' and drivin', das pretty stupid, but trying fo' outrun one cop? You mus' be da biggest fuckin' dummy in da world! You lucky you neva had drugs on you, too. If you had drugs, I would've fuckin'

walked right into dat cell an I would've fucked you up! Mother-fuckin' kid. What your madda would say?"

This one slowed him down. He rarely mentioned her, but when he did, he always seemed to get calm. After a long pause his voice had calmed from lunacy to anger. "You lucky she no stay around. You would make her so fuckin' sick. She would probably disown you, you fuckin' fuck up. Fuck, I taught you fo' box not so you can be one fuckin' punk, but so when somebody fuck wit' you, you can defend yourself."

Before I could seal my lips, the sarcastic chuckle escaped. I felt a hard slap on my head, and looked over. The devil arch was going crazy, it seemed that if it got any sharper, his eyebrows would have pushed up and put two parts in his hair. He looked over at me. "So you tough now, ah? Get wise wit' me. You lick one fuckin' haole so you tink you can get fuckin' wise wit' me. O.k. When we get home, we goin' find out how tough you stay."

I wanted to laugh again. I couldn't believe that he had the audacity to say that his "training" of me was motivated by this idea of defense. Maybe I'd bought it as a kid, but after a while I realized that he didn't teach me shit when I was getting picked on, he had just told me, threatened me to fight back. That first day I came home with a fat lip, he didn't teach me shit. By the time he began to teach me how to fight, I had already become someone who didn't have any problems at school. I was already someone respected by my classmates. The boxing, all that did was turn me into a more dangerous animal, an animal who was conscious of this new weapon, a cock quite aware that these were lethal knives being tied on me. Defense, please. I heard what he was saying and noticed that he never even mentioned the assault charge in his initial verbal attack. He hated haoles too, especially haole military guys. He only mentioned it when he brought up my mother, not because he disapproved of the charge but because he knew she would. He was more pissed about having to pick

me up at three in the morning than anything else. Sure the running away from the cop was stupid, and the drinking and driving, too. I could accept his gripes about those things. But never did he disapprove of my fighting. He would only disapprove if I lost. Even though the sword was still in his care, he was the one who had taught me how to use it. And nothing as razor sharp as a katana is used for defense.

I thought about the sword on the ride home, thought about how it was kept in a glass case. I realized the purpose of the glass wasn't to keep people from touching it. Fragile glass was the wrong material for that purpose. Glass was used for display purposes. The Hideyoshis wanted people to see it in all its glory, especially family. It represented strength and danger, it was to be passed down from father to son. This prideful display was also bait. They wanted the sons to gaze at it, long to hold it, desire it enough to break the glass, unsheathe it, and wield it. Not for defense; defense, how silly, but for offense.

While the truck neared the house, I thought about that night when my father caught me and Koa with the sword. I realized that he wasn't angered because I took the sword out, or let it be taken out. He was enraged because I'd used the sword to butcher a dead animal when I should have known that the sword was only meant to be used on live humans. My temptation was pure, but my action was blasphemy. After thinking about it, I knew the glass display was a mistake, and that my father would pay for it, as would the entire Hideyoshi ancestry. I knew that if it ever became mine, and I still had the strength, I would conceal it.

When we got home, nothing happened. He told me to get to bed. He was tired. I waited until his bedroom light was off, then I walked outside and looked at the heavy bag hanging from a wooden beam in the garage. For the first time I noticed how old it had gotten. I saw stains that I had never seen before, I saw tiny threads sticking out at the seams. It was weathered from the

salt air, beige from the canvas material absorbing highway exhaust and time. I hit it with my bare hand and it felt soft.

I walked back into the house and found myself standing in front of the glass case. How easy it would be to blast my hand right through the glass and grab the sword. I concentrated on the katana, like I always did, then found myself looking at the short sword, the one the samurai used for seppuku, the one they used to gut themselves in ceremonial suicide. I opened the case and grabbed the katana first. I unsheathed it and examined the blade. I noticed a small speck of dried blood on it. The long sword felt good in my hands, light and easy. I replaced the sheath and put the sword back. I grabbed the much smaller one. For some reason it felt heavier. I took off the sheath. Suddenly my stomach turned and I felt an urge to throw up. I quickly put the smaller one back and closed the case. Standing there, I felt myself shiver. After it passed, I walked back to my room and closed the door. I didn't sleep that night.

<center>✛ ✛ ✛</center>

So a month before I graduated, I planned to get out. I had decided I'd had enough of the Windward side, and I wanted to try town out. The problem was I didn't know how I was going to do this. Sure, I had a couple of thousand dollars hidden in my room from selling coke. Like an idiot, it amazed me how much more money I was making when I stopped using. I figured I could go to Kapiolani Community College or something. U.H. was out because I'd never bothered to apply. But tuition would cost money, and if I were really going to leave, I'd have to start paying rent and stuff. I figured I could get a job, but the thought of the kind of job I would end up getting depressed me. High school diploma, no experience. I'd probably end up washing dishes at some low-grade restaurant. I thought about selling drugs, but

that felt unsavory, too. The last brush I'd had with the law had spooked me, and besides, all of my connections, my customers, were on the Windward side.

For a while, I felt stuck, and I just tried to take my mind off it. I'd enjoy surfing and diving with Koa once a week. As we came closer and closer to graduation, I didn't see him very often. It was cool, though, I liked Kahala, cool chick, fine. I tried to talk about my situation with him once or twice, but he just kept telling me I should stay on this side. He'd say, "Why da fuck you like move town for? Only get townies and haoles on dat side. Stay dis side wit da boys. Everybody know you dis side. Da chicks dig you, in fact Kahala like set you up wit Cheryl. Fuck, she mean. You should rush."

He was right, Cheryl was fine. But I was tired of just about everything on the Windward side. For the first time I examined my life and saw the obvious. This place was no good for me. So, knowing that, I figured it would be easy to leave, but it wasn't. It was tempting to stay because he was right, all I knew was on the Windward side. It's hard to leave home no matter how fucked up home is. Home is your comfort zone. It's the place where you can walk the street with your head up. It's where you're somebody, it's where all the things that you hate and love exist together. Once your roots dig deep within the hard soil and wrap themselves around underground rocks, they are difficult to unearth.

This was when Koa told me how both B.Y.U. and U.H. had offered him football scholarships even though he hadn't played his senior year. He told me, "No sense, unless you can turn pro." I knew why he'd turned down B.Y.U. — Koa would never live in the mainland. But his rejection of U.H. seemed odd. That's when it hit me that Kahala was probably pregnant.

The thought of having a kid, even back then, scared the shit out of me. What the hell could I give a kid? My wisdom? What a laugh. My Hideyoshi legacy? Even worse. What if I turned out to

like my father? Even if I didn't, me having a kid, where else would I take it? It would end up in Ka'a'awa. Fathers are usually not good about taking in their pregnant daughters, and they hate the thought of a younger man, the same one who they imagined raped their daughter, coming in and taking over. So we'd probably be in Ka'a'awa — me, my father, and its mother, all sitting there looking at the swords in the glass case, all probably staring at them, waiting for another to make the first move. I figured a couple of us would race for the katana to kill the rest, the other would rush toward the short sword wanting to kill themselves first. Fuck that, I wouldn't have it. I was probably the only guy in Castle High who religiously used condoms. The fucking irony of all of this is that with age, I got more stupid. Because all of this shit ended up happening, and that's why I am where I am today.

But back then, it would never have happened to me. Throughout high school I had only three girlfriends, and none of the relationships lasted for over two months. I was too busy being an asshole to make anything work. Besides, deep down inside I never wanted it to work, anyway. It's an inevitable conclusion — the more you fuck, the more likely you'll end up with kids. I'd seen it all around me, the results of teenage pregnancy.

Hell, no, I used to think, it's not for me. The thought gave me a shovel powerful enough to dig up and sever my own roots. At school, I'd ignore Cheryl, not even wanting to look at her, knowing that I might succumb. She and Kahala were best friends, both grew up together in Ahuimanu, the hills of the suburban upper middle class. Ahuimanu sits right outside of Kahaluu, on the border between Kaneohe and Kahaluu, by the Valley of the Temples graveyard, you know, where they put Ferdinand Marcos' corpse on ice. They were both beautiful. Kahala was taller, thinner, with the body of a sprite, Cheryl was shorter, thicker, more voluptuous. Kahala was Hawaiian-Chinese-haole, her bone structure Chinese, her dark features Hawaiian, and her green eyes

haole. Her dad was an architect or something. Cheryl was *hapa*, Japanese-haole, beautiful light-brown hair, and hazel eyes. I think her dad was an attorney. Man, I wanted her, and I thought she was crazy for wanting me, thinking her dad would sue me on sight. Kahala's dad must've been overjoyed at the sight of Koa. Fucking rich chicks, what were they thinking?

So Koa and I graduated, walked together, and decided that we would throw a graduation party at his house on graduation night. We wanted the party to end all parties. Uncle James bought ten kegs of beer, made the *imu* for the pig, put up the tent, and rented the tables and chairs. Aunty Kanani cooked the food, along with Koa's other aunties, the basics: chicken long rice, squid luau, cake noodles with char siu and vegetables, sushi, macaroni salad, *lomi* salmon, and *lumpia*. Koa's uncles brought sashimi and *poke*, cut from the *aku* and *ahi* they caught themselves. Others brought poi or bottles of Popov Vodka, Quervo Gold, Bacardi Rum, and Chivas Regal. Even my father contributed, though he hated going to social events. He gathered the coolers for water and punch. He even dropped a net into the ocean, bringing from the Bay mullet, *awa 'awa*, and *papio*. He steamed mullet, pounded the *awa 'awa* into fish cake, and fried the *papio*. The party mood was contagious and, as I stood in the sun, waiting to get my diploma, I couldn't wait to step down and head to Koa's house to tap the first keg.

Before Koa and I made it to his house, we stayed at the ceremony, receiving leis from family and friends. We let them stack around our necks. The mixing smell of plumeria, ginger, carnation, and *maile* tickled our noses. With each lei came a congratulatory handshake or a proud hug. I started feeling like people were suddenly expecting great things from me, or they were amused by my ignorance while welcoming me to the "real world." The leis were like a series of nooses, stacked up so high that they rose up to my chin, and I felt my neck sweat under the weight. We had to take pictures and find our friends who also

graduated to congratulate them. We wandered endlessly through the sea of faces, trying to make sure that we got to everybody we were supposed to.

Finally I found my father in the crowd, and walked toward him. He was conspicuous, standing there alone, wearing an aloha shirt I hadn't seen in years. His head was turning to and fro, looking for me. His face wore that signature angry look, the one which never eased, the one that only got sharper as anger rose. When he finally saw me, he straightened out his shirt and coughed into his hand. He had no lei, instead he held out his hand. When I shook it, I felt a piece of cold metal in his palm being passed over to me. I looked at it. It was his Bronze Star from Vietnam. He told me, "No lose 'um, ah."

I said, "Thanks, Dad," and looked at it again before I put it in my pocket. He looked around again. "Okay, congratulations," he said, "I guess I see you at Koa's house. Ova dea I give you your odda present." I said thanks and watched him walk into the crowd.

I pulled the Bronze Star out of my pocket and looked at it again. What the hell kind of grad present is this? I thought. I knew that the medal was important to him, and I was honored to receive it, but I didn't get what I was supposed to do with it, what it meant. I put it back in my pocket and thought about the other present he said he was going to give me. I didn't have a clue what it would be. I mean, I didn't think he had anything I really wanted. So I departed from the futile brainstorm and looked for Koa in the crowd.

When I finally found him, his parents weren't with him. Instead I saw Kahala holding his hand, and I laughed as I noticed that he wore so many leis that his mouth and nostrils were completely submerged in a sea of stringed flowers. I walked up to them, kissed Kahala on the cheek, and shook Koa's hand. Aunty Kanani appeared and told us, "Hey, you three, stand togedda so I can take pickcha." Kahala stood between us and I put my arm

around her waist while Koa put his arm around her shoulder. All three of us smiled into the camera. I still have that picture of the three of us.

After the picture was taken, we all decided to ride to Koa's house together for the party. We looked forward to the celebration, and wanted to get off the campus as soon as possible. We were all happy in the knowledge that we never had to put one foot on it again.

It was a helluva night! Saturated with food, drink, friends, and surprise announcements, it was everything a party is supposed to be. Hundreds of people showed up. They crowded underneath the huge blue tarp Uncle James had put up. It was so big it looked like a wrinkled sky. Some mingled underneath it, while others hid in the unroofed darkness. Cherries glowed from lighted joints. I saw Mike and John smoking and laughed, thinking how far we'd come from the day they threatened me at the bus stop. John was as skinny and dark as ever, tall and emaciated, looking like he hadn't slept for days. His mustache was still sparse, like the day I had met him. Mike, on the other hand, was a Hardy to John's Laurel, round to the point where the bottom of his t-shirt failed to touch his jeans. Both didn't graduate with us. John already had two kids and Mike spent a great deal of his teenage years in Olomana, the boys home. I walked up to them and shook their hands. Mike laughed. "Sorry ah, graduate. You too smart fo' me."

The three of us laughed. "So now what?" John said, "I heard you like move town. Why you like be one townie? You should hang wit' us. Shit, you get 'um good wit' Freddie, you set." He raised his hand and showed me his SYN tattoo, reminding me of that night we all put the needle in our skin.

I laughed and showed him mine. "Look, mine stay all green arready." We all laughed and walked together to the keg.

After leaving Mike and John, I ran into Freddie. He was talking to one of Koa's little brothers at the side of the house.

Ikaika, the second oldest in the Puana clan, stepped back as I approached Freddie's back. I put my finger on my mouth, telling Kaika not to say anything, and I slapped a full nelson on Freddie. He began to buck like crazy. Even though I was taller, my feet were off the ground, and he swung around violently until I finally said, "Hey, you mental fucka, calm down, it's me."

He put me down and I released my grip. We began to playfully box each other, and Kaika laughed. We stopped. "Hey," Freddie said, "what's dis about you moving town?"

I shrugged my shoulders. "I don't know. Fuck, I figure I stay hea, I only goin' get into trouble, end up getting someone pregnant or goin' jail or something. I cannot even get one job down hea."

He laughed, looked at Kaika, and motioned for the kid to take off. When Kaika left, he said, "Shit, you know you get one job. Besides jail, you shouldn't be scared. I get some boys in Halawa Corrections, no worry, you end up dea, you do easy time."

I shrugged again. "Fuck, I no like do anykine time."

He laughed. "None of us do, bradda, none of us do. But fo' some of us, no matta what, we goin' do time. I no care you live Ka'a'awa, Waiahole, Kahaluu, town. Some of us, we was destined to go."

"Fuck dat," I said, "I ain't going."

He laughed. "Too bad you like go town. I lived town befo'. Fuckin' worse den ova hea. But I know you set on goin' so I cannot say anyting. Too bad, too. Out of all da braddas I do business wit', I trust you da most, especially since you quit blowing. Fuckin' Koa ova dea, dat fucka like one vacuum cleana. Fuck, I hope his bradda not like dat."

We laughed. Suddenly he turned serious, put his hand in his pocket, and pulled out a wad of bills. He handed it to me. "Hea, your grad present," he said.

I counted the bills. It came out to fifteen hundred. I shook my head. "No fuckin' way. You crazy? I not going take dis from you."

When I tried to hand the wad back to him, he pushed my hand away. "Bradda," he said, "you try give dat back to me and we trowing blows. Jus' keep 'um. I like you have 'um. You need money you go town. Fuck, what you goin' do wit' out money?"

We began throwing the money at each other. When I threw it for the third time, he didn't catch it. Instead he let it bounce off his chest and fall to the ground. He attacked me. He wrapped his arm around my head. I put my hands against him and tried to squeeze my head out. His grip was too strong, so I went for his leg. I grabbed the one closest to me and lifted it off the ground. I heard him laugh. I pulled the leg up as high as I could. I felt his arm squeeze my head harder as he lost his balance. We spilt on the ground. I still couldn't get my head out. I was beginning to feel suffocated, beginning to lose my cool. I think Freddie sensed I was beginning to take this little play seriously. "You going take da money?" he said.

"Fuck you."

He laughed. "Take da money or I neva goin' let you go."

I tried to struggle out of it, but I felt him adjust his grip. What was once a playful headlock was now a choke hold. I was stuck. I was enraged. I wanted to struggle out of it, but I knew it was too late. "I give," I said.

We hugged each other and he walked away. I think he was pissed that I was getting pissed. I picked the money off the ground and buried it in my pocket. I dusted off my pants and walked back toward the keg. I stretched my neck.

The next familiar face I ran into was Aunty Jana's. She was standing right outside the tarp, her hand resting on one of the poles which held it up. Several metallic colored balloons which read, "Congratulations" in cartoon letters, were tied to the pole. The wind blew and the balloons attacked her. She tried to box them away.

I had only seen her a few times over the last several years. Though Uncle Sonny still came around to drink with my father,

Aunty Jana had stopped coming around after my mother died. She smiled when she saw me and we kissed each other on the cheek. She held me at arm's length and said, "Wow, you one man, ah? I still remember when you was one little kid, and we used to take you camping."

I smiled. "How you doing, Aunty Jana?"

"O.k., o.k., but neva mind dat. How you? What you goin' do now?"

"I don't know," I said, "I was thinking about moving to town. Maybe go school or something."

This brought a big smile to her face. The balloons blew in front of her. For a moment she looked like she had a shiny metal head. After the wind died and her fake head disappeared, she spoke. "Wow, right on. Would be good to see at least someone go college from dis side of da island. I know your mom always wanted you to go. She used to say, 'I wonder where I should send Kenji to college? Berkeley or Stanford.' She used to think you were so smart. She used to smile every time she saw you reading because you always read and no one ever had to tell you to."

I began to feel uncomfortable, like a failure, thinking how if I went to school anywhere, it would be Kapiolani Community College. I thought about Freddie, who I had just talked to, and said to myself, "Yeah, Mom would be proud." I thanked Aunty Jana for coming, kissed her on the cheek again, and made an awkward exit toward the tarp.

As I walked around looking for Koa under the covered area, I noticed that a crowd was forming. I approached it and saw Koa's father and mine drinking together. They were calling people to them, saying they had things to announce. When they saw me, they waved me forward. As we stood there in the middle of the crowd, the sun was setting, and we waited for Koa.

About ten minutes later Koa and Kahala arrived and they were also called up. My father, by now drunk and happy, put his

hand up, indicating that he wanted to speak. The crowd quieted. "Today, my son graduated from high school," he said. "I feel so... surprised, really." The crowd laughed. He continued, "Just think, about two, three months ago, I had to pick dis kid up from jail." Again laughter. "Well, I'm here talking because I have a present to give my only son." He pulled a piece of paper out from his pocket. "My son, da one always reading books, here, I give you your pass out of Ka'a'awa and your pass into school."

I grabbed the paper from him. It was a check in my name for three thousand dollars. I was shocked. "Wow," I mumbled. The crowd laughed. "I'm rich!" I said. "It's three thousand dollars." Everybody laughed. I shook my father's hand and he smiled. People took pictures of us as we stood under the tarp, the crumpled artificial sky.

Next it was Uncle James' turn. "Koa," he said, "come hea." He took a piece of paper from his pocket. He handed the document to Koa, and Koa began reading it. After several minutes of quiet, Koa stepped to his father and hugged him. They just stood there, hugging each other. After Koa finally broke the embrace, he said, "Dis is one deed in my name. My fadda gave me one quarta acre in Waiahole."

Everyone clapped. Uncle James spoke. "Your great grandfadda used to own a lot of land dis side. Our family no more too much left, but I figure, one quarta acre, das good. You can build one house on top. Ken's fadda arready said he was going help."

Everyone laughed as my father put on an exaggerated look of surprise. Then he smiled and put his arm around Koa. "Nah, no worry, I help you. But no expect you goin' get one mansion or swimming pool or anyting." Everyone laughed. As the voices quieted, I heard a strong gust blow against the blue tarp. Violent wrinkles rode through the blue material like waves.

Then Koa spoke. "You know what, I get one announcement, too."

He called Kahala over. She walked to his side and held his hand. He cleared his throat, whispered in Kahala's ear, then spoke to everyone. "Me and Kahala, we goin' get married."

The place was silent. The wind blew harder. Everyone knew she was probably pregnant. I looked at poor Koa and Kahala squirming up there and I wanted to laugh. Not laugh at them, but just laugh to ease the tension.

Finally Koa's father broke the stillness. He walked up to Kahala and gave her a big bear hug. Next, Koa's mother walked up to her husband and daughter-in-law-to-be, pushed her husband away, who outweighed her by almost two hundred pounds, and hugged Kahala. Everyone laughed. I couldn't believe it, I looked over at Koa, and he began to cry. He was so fucking happy, he started crying. I walked up to him and gave him a hug.

He wiped his eyes and asked, "So what? You going be my best man, yeah?"

"You know dat," I said.

Suddenly the wind blew harder, so hard that the blue tarp lifted like an opened parachute. The poles holding it up were ripped out of the ground and I heard laughter as the tarp fell down on everyone who was standing under it. I thought, the sky is falling. After I got out from under it, I looked up to the real sky and saw darkness. Suddenly balloons crossed my vision. Those metallic balloons with the cartoon letters were floating high in the sky.

■ ■ ■

Before the night was over I had a chance to talk to Kahala. I was drunk by then, not only from alcohol, but with the thought of my six-thousand five-hundred dollars. The two I had stashed at home, the fifteen hundred from Freddie, and the three from my father. Actually, the next day, I found out I had altogether collected nine thousand. I opened dozens of congratulation cards

filled with twenties and fifties. But that night there I was, grinning with happiness, looking for the next person to toast with. That was when I saw Kahala sitting alone at one of the empty tables, shrouded by the night.

I sat down next to her. "Congratulations," I said, "on the engagement, I mean."

She smiled. "Thanks. You too, on your ticket out of here."

I took a sip from my beer, and I don't know, I guess I was feeling frank. "Your dad must be having a stroke over this."

She laughed. "Yeah, he isn't too happy. He told me I'm on my own if I marry Koa. He was especially mad because I told him I'd have to wait a couple of years on college. I was supposed to go to the University of Washington, but I turned it down. Jeez, he was acting like if I didn't go this August, I'd never go."

"Well, at least you guys got that land you can build on," I remarked, trying to lift her enthusiasm.

She sighed. "Yeah, that was totally cool of Mr. Puana. I'm stoked. But you know, even though I'm going to do this, I still feel scared. You know, eighteen and getting married. Don't get me wrong, I love Koa. And I would never get an abortion. But, you know."

I knew. She was scared shitless. She felt like her life was ending. Like all of us had thought when we were young, that when you get married, have kids, that's it. It's over. I suddenly realized that she probably envied my "ticket."

"I'll tell you what," I said, "if it ever gets really bad, give me a call. Not that it'll ever get bad, you and Koa, you guys will be happy together, but if it ever really gets terrible, give me a call and I'll send you a ticket."

She laughed again. "Thanks. Hopefully I'll never have to take you up on that, but thanks for offering. I'm sure it'll be great. We'll build a house, one that we can design. It's going to be a killer house. That I'm looking forward to."

I decided I liked her even more. She worried about the future, and it made me feel like I had a partner, like I wasn't the only one. "Yeah, that should be cool," I said, "making your own house."

She looked at me and smiled. "So I guess I should tell Cheryl that you're not interested."

"I don't believe I lasted this long," I said. "I dig her, but I gotta get out of here. Besides, I wouldn't be good for her, anyway. What are you Ahuimanu chicks doing? Chasing us delinquents around?"

"You know what it is? You guys, you're real. You know, no bullshit. You guys do what you want, be yourselves with no apology. Like, 'This is me, take it or eat shit and die.' There's no hiding with you guys. Girls like that, you know."

Suddenly I felt an arm resting on my shoulder. Koa stuck his face between me and Kahala and then he turned his head toward me. "Eh, neva mind trying to steal my fewtcha wife, ah." He turned to Kahala and kissed her.

She crinkled her brow and laughed. "Ill, you drunk."

Koa turned back to me. "C'mon, get up, we gotta take more shots."

I sighed. "Let's go." I smiled at Kahala, kissed her on the cheek, and said, "Bye."

Koa and I left her at the table and headed toward the tequila, determined to get even drunker. By the end of the night, we were so drunk we passed out in the yard. The next day, when the harsh sun woke us up, we stood up and brushed the grass and dirt off our clothes. We looked at each other and laughed until the tears came out of our eyes. I felt my head pounding and tasted the cotton feeling in my mouth, but I laughed anyway. Koa turned away to puke. I laughed even harder. We spent the morning laughing, crying, and puking all at the same time.

What a fucking night that was! Fucking beautiful. There are some experiences so pure, so deep, that flowery descriptions

and metaphors don't do them justice. When you remember them, you have to use expletives. There's no other way.

■ ■ ■

I think back on it now, all of it, this entire chapter in my life, and I trip on how this part of my life was much like that day in the mountains, how I shot the pig without even thinking, how the ranchers chased us, and how we ran down the mountain, not looking, not caring where we were going as long as we were going down. Koa taking the point, the position of lead blocker, and me following, trying to keep up. I don't believe that I kept picking that boar up every time I dropped it. I often ask myself why I couldn't just let it go and leave it, but I can't really come up with any concrete answers. All I know is that it was almost like I needed to, like if I didn't, the entire bad experience was a waste, like it was just senseless running into oblivion. Dropping that pig would have been like surfing straight down a wave, not juicing the ocean for a long ride. It would have been like diving in the ocean, not to catch fish, but to swim around aimlessly, dangling on a hook like shark bait. The pig was a load I didn't want, but felt I needed to carry.

It's like my imprisonment. I can't think of it as a senseless end, even though I can't remember carrying out the specific crime, the one act that brought me here. As if it were just one event. I stopped believing in one events. Sure, the first drag from a pipe, the pulling of a trigger, the whispering of a lie, these at times can be monumental events, but there is always history behind them. They can't be picked apart standing alone. It'd be like trying to split an atom with a machete.

The other thing I think about when I remember that night with the pig is what happened after. The beating I took. How I escaped the clutches of one threat, and how I ran straight into the arms of another. I figure that's how life is sometimes. Just when

you think you're out of the shit, when you're running, looking back, and laughing, you run right into another pile, slip, and fall on your ass. You never even see it coming, but the only thing you can do is pick yourself up and head for the next pile. I felt like staying down once, but never again. Life is gonna have to hold me down and drown me in it.

<div align="center">✛ ✛ ✛</div>

They had missed lunch and had Cal's two cigarettes for a meal instead. Cal was almost finished filling in the symbol when he tapped Ken's shoulder. Ken stood up and stretched. It was time for dinner. "Okay, let's take a break."

Cal put down his gun and plopped down on his mattress. He cracked his knuckles. Ken laughed. "That's the only sound I've heard you make, besides the buzzing of your gun."

Cal shrugged and scratched his head. He looked at his hand and saw dandruff flakes underneath his fingernails. He smiled. This place is breaking me up piece by piece, he thought.

Cal lifted his arm and stuck his thumb up. He closed his eyes and pictured the Windward side. He had been through there years before. He remembered the dark green of the mountains and the hot sticky air. The coastal waters of Kahaluu had been brown even back then, but Cal thought it was because the mountain streams mixed with the ocean, bringing fertile soil into the sea. He never attributed it to pollution. Evidently things changed, because Cal remembered the Windward side as a beautiful place.

Cal opened his eyes. Ken was staring out the rectangular window of the door. "I hate the fact that they can hear us from that box whenever they want," Ken said.

Cal was surprised that Ken wanted to limit his audience. Cal knew that Ken took pride in his story, and that it probably irritated him that no one would read over it or make a movie out of it. Sure, if you take all the pidgin out, exchange Ken with some white guy from West Virginia, then

there'd be an audience. But Ken was Japanese and brought up in "paradise."
Paradise was never the compelling setting unless it was falling or lost.

Cal knew part of the reason why local guys hated white guys so much was because white guys got all of the attention. He smiled. But then nobody will hear my story, too, he thought.

"Claudia's coming to visit me the day after tomorrow," Ken whispered. "She's bringing the kid."

This stung Cal. He thought of his children, a daughter about Ken's age and a son a couple of years younger. He took their mother away from them in one act of jealous rage. Cal shook his head.

"You got kids?" Ken asked.

Cal shook his head again. He was not their father. What kind of father would take away their mother?

"You should see Claude," Ken said. "Beautiful."

Cal walked to Ken and tapped him on the shoulder. "Yeah, I'm ready," Ken said. Cal looked at Ken's back and noticed the blood and ink were beginning to dry. There were also a couple of big bruises where Ken's back had hit the wall that morning. Fuckin' Tavares. Cal wet a wad of toilet paper and wiped Ken's back when the door buzzed for dinner. Cal did not want to see Ken interact with Nu'u or Tavares.

When they got to the cafeteria, Ken and Cal sat alone at a table. Nu'u was sitting with Johnny and a few of the others. He was harassing Johnny while the others laughed. Ken was quiet. He picked at his food, but did not eat.

Cal wondered why he was so vocal in the cell, but quiet in public. Public, Cal would laugh if he could. Halawa was definitely more private than public. His longing for laughter ended as he saw Tavares' giant ink-covered forearms underneath the hands which now gripped the table.

Tavares sat next to Ken, ignoring Cal. "You knew Koa Puana?"

Ken nodded. "He was my cousin," Tavares said.

Hawaiians. Everybody was related to somebody. Cal then knew that Tavares had been in the control box listening to Ken's story all day, too.

"He was my brother," Ken said.

Tavares nodded, then stood up. He wiped his hands vigorously against the legs of his blue jumpsuit.

As he walked off, Ken smiled. "Cleanliness is godliness."

Cal looked at Ken, puzzled. "It's prison guard syndrome," Ken said. "I heard about it before. If you were to go to Tavares' house, you would see. A perfectly cut lawn. An impeccably clean house. They're around prison so much, and feel so dirty that they become obsessed with cleanliness. You know, they try to wash that locker room, animal smell of prison off themselves. I heard some of their wives hear it if the house isn't kept perfectly clean. In other words, they always hear it. There's no such thing as a perfectly clean house."

Cal nodded. "Cops aren't that different," Ken said. "Cops feel like college professors trying to teach a class full of ten-year-old retards who look like men. Sooner or later, you're either going to beat the retards and take their lunch money because you know you can get away with it, or go home and beat your wife out of frustration. I ran into a couple of corrupt, pig mother-fuckers. At the time I probably wanted them to go home and fuck with their wives like most good cops do. But now...Ah. Women, they should know, but they can't be blamed. Stay away from any man involved with the law. Either side of it."

Ken dumped his spoon in his tray of mashed potatoes. Cal dug in his tray for the rubber glove and cigarettes. Just then, Nu'u sat by Ken. "Hey, tough guy," he said.

Cal wanted to close his eyes again, but just before he did, he saw Nu'u's face screw up in pain. He seemed to be trying to get something off his lap under the table. He was acting like there was a tarantula on his lap or something.

Ken smiled and leaned towards Nu'u's ear. He grabbed the spoon and held it handle up. "You keep fucking wit' me," he whispered, "and you'll be talking about as much as Cal does." He showed Nu'u the handle of the spoon. "It would take me less than one fuckin' second."

Cal didn't doubt at that moment that Ken could bury the blunt handle of a spoon in Nu'u's throat. Every ounce of Ken's face said he

could. But instead, Ken let Nu'u's balls go. Cal could see that Nu'u was wondering if he should hit Ken. But he paused. Ken didn't take his eyes off him.

Tavares walked to the table. "Problems, gentlemen?" he said. Nu'u stood up and gingerly walked away.

Ken put down the spoon. "He ain't no Koa."

Tavares smiled as he walked away. "There was only one of him."

"How's Uncle James and Aunty Kanani?"

Without stopping or turning around, Tavares said, "Good, good. I heard."

Ken picked up his tray and looked at Cal. "It's like Musashi said. 'When you appreciate the power of nature, knowing the rhythm of any situation, you will be able to hit the enemy naturally and strike naturally. All this is the 'Way of the Void.' Nu'u is ignorant of this."

Cal smiled. This pycho thought he was living in feudal Japan. But then again, jail did seem like a more primitive place. Maybe Ken was approaching it with a healthy attitude.

Before Ken walked away, he said, "I thought I knew all of Koa's cousins. I guess not."

Cal knew that that was about all the friendliness Ken could expect from Tavares. Tavares was a guard, Ken was a felon. But at least it probably meant that Tavares would stay off of Ken's back. Cal hated Tavares. He was the kind of guard who took it in his own hands to make sure prisoners were doing hard time. Even Cal almost got beat when Tavares had found out that the state government was buying computers for the prisoners down the hill in middle security. "What about my fuckin' kids!" he'd yelled. "Das my money, da taxpayas money buying dat!" He was anti-rehab, pro-punishment. And having Sergeant Miranda as the supervisor was both a good and bad thing. The smaller but tightly built Portagee-Hawaiian did not get emotionally involved with the issues. This job was just a paycheck to him. This meant he never abused prisoners, but it also meant that he didn't care if guards like Tavares did. But Tavares had a connection with Ken now. He wouldn't beat his dead cousin's best friend.

Cal and Ken dumped their food and made it through the strip search without any problems. They went to their cell. As Cal readied the gun, Ken started his story again. His voice carried more enthusiasm. He looked toward the control box. He knew he probably had an audience of two now. Cal cracked his knuckles and started on another moonlight session which would take them to early morning.

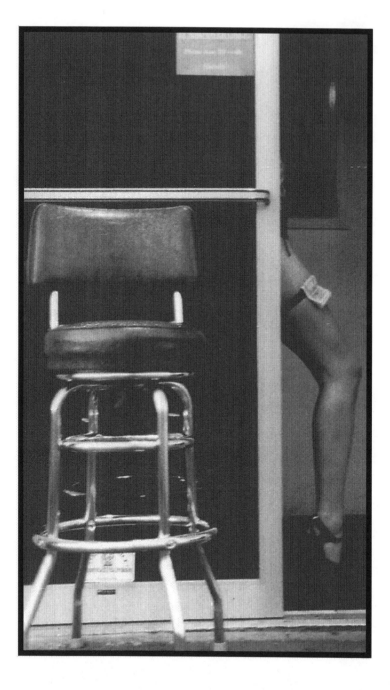

chapter three

"Each time Honolulu city lights,
stirs up memories in me.
Each time Honolulu city lights,
will bring me back again."

Honolulu City Lights
Beamer Brothers

*H*onolulu. Town. It was the place I took refuge in when I was eighteen years old. The day I left, I took the uphill drive with my suped-up eighty-three Toyota Celica. It was designed with oxidized black paint, bondo patches, and surface rust corroding the bottom of both doors. I drove up the Pali with an old twin mattress and a surfboard, a Town and Country gun strapped to the roof. Boxes of clothes and books were stuffed into the back seat, oozing socks, long flannel sleeves and denim pant legs. My diving equipment, thirty-thirty and twenty-inch television were riding shotgun. I had nine-thousand dollars folded in my pocket. Connected to the rear view mirror dangled my Bronze Star, the one my father had given me. Every time I looked in back of me, I saw it there. It was dark compared to the light which shined through the windshield.

I looked ahead and saw the winding asphalt in front of me. It looked almost like the road was poured down from the top of the mountain, winding down like a cooled stream of lava. As I drove, one hand was on the vibrating wheel, the other was holding a greasy roast pork sandwich. I listened to the whine of my engine in fourth gear. My exhaust system was letting out a loud, sputtering sound as I climbed the mountain range.

My great escape was a half-an-hour drive through the Koolau Mountains. The climb started with a steep, uphill drive on the Pali Highway. I took the hairpin turn. I saw the green

mountains on the left, the cliff on the right. Looking over the cliff, I saw all of Kaneohe and its Bay. The suburbia spread under overcast skies. The atmosphere bled shades of gray. Looking down into the Bay, I saw the breaking waves, which looked like suspended white brush strokes on a blue canvas.

These were the cliffs where King Kamehameha the First drove his enemies into free fall. He pushed the *ali'i*, the chiefs of Oahu, into oblivion. Using guns and cannons brought from the West, conquering, killing. I thought about the blood that must've run down the mountains that day. The people, the blood, pouring down the cliffs like waterfalls, emptying into a pool of death below, perhaps running so far, perhaps reaching the Bay itself. But it was all gone. In that place where the pool was, instead sat a golf course. The path of the river of blood was covered with houses and asphalt roads. History dried up, and in its place rose an imported way of life. A new history, a foreign one. I never fooled myself, my ancestry was a part of this new history, too. I looked over the short cement railing and waved goodbye, taking a bite from my roast pork sandwich before I entered the first tunnel through the mountain.

After I passed through the second tunnel and began my gentle descent down the mountains, I was greeted with rain. Heavy showers, which the Koolaus are known for. I turned on my wipers and the blades squeaked against the windshield, the sound of children jumping on a box-spring mattress. The rain was really falling and, although my wipers were at max, visibility was becoming a problem. I scooted my face closer to the windshield, squinted my eyes, and saw the brake lights of a car rapidly approach in front of me. I down-shifted, then pressed down on my brake with a nervous foot. The car hydroplaned for a couple of seconds and my hands, dropping the pork sandwich, worked on the wheel. Finally the tires grabbed the asphalt, jerking my body forward. The gun was fired. I saw the surfboard fly

ahead of me, almost hitting the car ahead. It cracked on the road. Regaining control of the car, I sped up and ran over it. I felt the tires leap. Well, I thought, since I'm going to town, a gun's no good anyway. I needed a longboard to surf the small waves in town. Then I wondered if this was a warning from my mother. Waving away the absurd, child-notion that my mother's spirit drifted in these mountains, I picked up the sandwich from the floorboard. My eyes remained squinted until I reached the bottom of the gentle downhill ride.

I found myself in Makiki, home of the high-rise condominiums and ugly three-story apartment complexes. My crummy studio apartment was directly north of Ala Moana Shopping Center and Keeaumoku Street. It was close enough to the mountains so that vegetation blossomed, close enough to the Ala Moana district so that the green looked out of place. For almost two years I had bled my nine grand, paying for tuition at Kapiolani Community College, paying six hundred dollars a month in rent for my studio in one of those crummy three-story apartment complexes. When I first got to town, the only two costly things I ended up spending my money on were my paulowina tattoo and this framed Otsuka print of Miyamoto Musashi, the most legendary samurai of feudal Japan.

I found him in some gallery at Ala Moana Shopping Center. There he was, covered with a glass sheet, hanging on the wall, looking like he was about to shatter the glass. The lights were on him. The glass absorbed the fluorescent glow of the bulb which hung above it. This gave the glass a mirror effect, and when I looked at Musashi I saw my reflection. I recognized Musashi immediately, his messy, long black hair, his shaven angular face. I looked into his dark slanty eyes, which somehow coupled both serenity and rage. He had that look, that "I'm going to kick your ass and there's nothing you can do about it" look. The print had this animated, cartoon quality to it. I had read about him before,

read his *A Book of Five Rings*. I liked it even though, at the time, I didn't understand much of it. He was the ronin, who, by the age of thirty won over sixty duels. Shit, the crazy mother-fucker sometimes fought with sticks while his opponents had swords. He'd still kill them. He was the fucking man. I looked up to him, hanging there in the gallery. I had to have him. I walked up to the lady who was working there that day. She was a Chinese-looking lady dressed in a smart-looking lady's suit. I asked her how much. She looked at me skeptically and said, "Framed, five hundred and fifty dollars." I pulled out my wad of cash. "Well," I said, "take it down, I don't have all day."

I loved the print and the tattoo, but together they cost me about seven hundred dollars. Out of fear and guilt, I immediately got a library job at K.C.C., shelving books. Got paid five-something an hour, pulling twenty-hour weeks. I spent hours in that library, hiding in the cubicles, reading novels instead of my assigned textbooks. Slowly what was left of the nine grand bled, and through those two years I attended classes which I hated. But I was determined to make it to the University of Hawai'i at Manoa, determined to do it without any help or returning home.

Sitting in those one hundred level courses is what killed me. No, paying to sit in those one hundred level courses is what killed me. I took courses on subjects I had no interest in, courses which I was forced to take in order to meet requirements. Classes like logic, classes which were a pain to sit through, classes which forced your eyes on the clock above the professor's head. It seemed every time I eyed the clock, I'd think, I can't fucking believe I'm paying for this.

Suddenly, I found my life very boring and tedious. Besides, I was sitting side by side with some of the most uninteresting people in the world — college students. I began to long for something real, something threatening, something that made me feel alive again. I longed to make stories, do things that were

interesting, new things I could tell the people back home. Every time I got back to my shitty apartment and saw the ronin Musashi look at me, I'd say to him, "Yeah, I'd like to roam the country and look for trouble like you did, make my life legendary, but I gotta do this college thing." For almost two years I didn't roam, though, I just did what I thought I was supposed to do. I managed to muddle through two years of school, two years I'll never get back. I might have made it to U.H. Majoring in what or doing what, I have no idea. But two months before my fourth semester ended, opportunity knocked. At first, I thought of it as a way to continue my education, but some of the things you get yourself into, they're not only jobs, they're lifestyles. Sometimes when you open the knocking door, you have to step through it, too. This doorway led to Keeaumoku Street, the main road which led to the heart of Ala Moana Shopping Center, the road peppered with hostess bars, massage parlors, and strip bars. These were places owned by first-generation Koreans and Vietnamese immigrants, bars which were always changing their names.

I was nineteen, having beers one night by myself at Club Mirage. Over those two years I was in school, it had changed names three times. First it was Club Oasis, then Club Fancy Dream. Finally, Mama-san settled on Club Mirage. It sounded French to her, and she thought anything French or Italian was just the shit. She was an amazing old Korean lady, all four-ten of her. She was smart and tough as hell. Every night she crammed her one hundred and fifty some-odd pounds into a gaudy, tight, sequined dress. She didn't shop with an eye for style, brand names and price tags determined what she wore. Her thinning hair was always permed, displaying an ineffective attempt at thickness. Her face was always painted heavily, false eyelashes and all. She wore a huge two-carat diamond ring on her left hand, while gold and jade bracelets crawled up both forearms. When I first saw her, oddly enough, she kind of reminded me of my father. It was the

angry look she always wore, the look like one wrong word would send her into a frenzy. She was a genius at running that bar, though. Despite all of the neighboring competition, a river of cash flowed through Club Mirage for years. It became the most famous strip bar in the state of Hawai'i. Hell, guys on Kauai, Maui, and the Big Island knew about Club Mirage, and often on weekends we'd get patrons who'd fly over just to see the show.

So there I was one night, having beers and checking out naked women. The black lights were low, and Prince's *Erotic City* was pulsing in the cheap perfumed air. I was hiding out in one of the booths, nursing a Budweiser. I was watching a Japanese tourist stick his nose in between the naked legs of a tall haole dancer. After every move, she pulled on her garter, signaling her audience to deposit a tip. The tourist folded a bill and added it to the dozens of bills which wrapped around her upper thigh. I smiled as the tourist ran his hand down her leg after depositing the tip. No touching, I thought. I watched for the next two songs, watched the stripper soak the tourist for at least thirty dollars in ones. She made thirty dollars for about seven or eight minutes of work. But work it was. She contorted her body into all sorts of positions, always thrusting her naked crotch a mere inch or two away from the foreign spectator. I wondered if I could ever do it. Then I remembered that I was a guy and laughed at the mental image of me showing some tourist my hairy balls. After thinking about this, I decided it looked like some of the hardest work I ever saw.

As Guns and Roses' *Appetite for Destruction* began, I stepped out of the booth and watched as the stripper gathered her string stars-and-stripes bikini. She walked naked off the stage. A local girl took her place. She took off her panties before Axel Rose even started singing. The tourist sat still with a big wad of bills clenched in his fist.

Just as I was about to walk out, I heard yelling. I looked back and saw a naked Korean girl screaming on stage. She was

being stalked by a big Samoan. He wore a white, v-neck t-shirt, which must have been a double-extra large. His arms filled the sleeves. One of these huge arms shot out. He grabbed her ankle, yanking her off the stage. Her body knocked over a row of chairs, and she hit the thin, gaudy red carpet. Her naked body was still. The Samoan turned around, seemingly expecting what was coming next. Two bouncers pounced on him, while a skinny Korean waiter shot a kick up toward the Samoan's face. The kick hit one of the bouncers instead. On impact both the Korean and the haole bouncer lost their balance and fell to the floor. The last bouncer, an out-of-shape Hawaiian, didn't stand a chance. He took two giant hits to the face and fell to the floor. At this point both the bouncers and the waiter were scrambling on hands and knees, away from the Samoan. They almost looked like a school of fish darting away from a three-pronged spear. I heard Mama-san scream from behind the bar. "I call police! You go now!" The Samoan smiled and strode toward her.

I don't know why I did what I did. I must've been fucking nuts. This solé was huge. But action, for me, was a magnet. Since King Zoo, I guess it always was. I couldn't stay out of it. There I was, acting on instinct while my brain was probably screaming, "Get the fuck out of here!" But once that instinct kicks in, all is quiet. Void. I didn't hear my brain, the music, or Mama-san, who was probably screaming her head off, not showing fear, but showing anger. I ran behind the Samoan and kicked the side of his knee. When his knee buckled, I wrapped my left forearm around the front of his neck and locked on. That's when my ride began. He lifted me off my feet and began swinging. My legs were swinging violently back and forth while he grabbed for my head. He pulled and scratched, but I didn't let go. I hid my face in his hair. It smelled like smoke and cheap shampoo. I almost gagged. Once in a while, I'd release the lock for a second and hit him with my right hand. I don't know how much good it did,

every time I hit him, it seemed like his strength intensified. I knew I couldn't let go, though. If I had let go, this guy would've killed me. Finally, I felt him tire. In a last-ditch effort, he grabbed a beer bottle off the bar and blindly swung it down at my head. He missed and the bottle shattered on his head. This killed more of the fight in him and, finally, while the nearing police sirens blared, I was able to drag him out.

The lights were on when I stepped back inside. Suddenly, I saw a collage of stretch marks and shy men. The men began leaving while the dancers put on their clothes. Mama-san was talking to a couple of cops at the bar. One was short, about five-five, and Japanese. The other was much bigger, Portuguese-looking. He put his big arm around Mama-san, looking like he was trying to calm her down. I looked at his big gut and wondered what kind of physical qualifications the Honolulu Police Department had set for its officers. He looked funny there, with his arm around Mama-san. She almost looked like a child next to him. The Japanese cop whispered something in her ear. She pointed at me. I waited, expecting to get busted or something, but instead the cops walked up to me and said, "You one crazy fucka." They patted me on the back and laughed. When Mama-san approached them, they both went up to her and gave her a polite kiss on the cheek. After spending a moment catching glimpses at the dressing strippers, the cops began walking out. Just as I was about to follow them outside, I heard Mama-san's voice. "You wait! What yaw name?"

I turned around. "Ken, my name's Ken."

She stepped toward me with that angry look on her face. She reached up, grabbed my chin, and turned my head. "You Japanee boy?"

"Yup."

"Japanee boy, you like job? You come tomorrow night, I give you job, okay? You come back."

With that said, she walked away. I headed home and waited for the adrenaline rush to fade. I couldn't believe it, I was going to get to work in a strip bar. When I got home and turned on the light, I gave Musashi a wink as I threw my keys on my table.

I worked for Mama-san for about five years. For five years I had a wad of hundred dollar bills lining my pocket. For five years, I slept with painted and plastic women. I mean, sex with some of those strippers, for them it was like shaking hands or something. If they thought you were cute enough on a given night, they'd want to shake your hand. For five years, the poverty in my life evaporated. I stopped going to Ka'a'awa and Kahaluu. Once in a while I'd talk to my father, Koa, Freddie, or Kahala on the phone, but I never heard shit. I was too wrapped up in my bliss to really listen to any of them. School was no longer on my agenda. I figured, why should I go to school for a few more years, work hard, and end up with a job which paid less than the one I had? For a while, I figured this life was my calling. It was like an epiphany. I wrapped the shroud of the Club tightly over my head, and rolled around happy in it. I felt like the luckiest guy in the world.

I started as a bouncer at Club Mirage. I worked six nights a week, from about nine at night till two in the morning. Mama-san paid me cash. With that, and what the bartenders and strippers tipped me, I walked home with about two hundred and fifty dollars a night. As the months rolled by, Mama-san began giving me more and more responsibilities. Within a year I was running the place when she wasn't around. I couldn't believe it. I was twenty years old, not even old enough to drink, but there I was, helping run the most popular strip bar in the state. And if that wasn't enough, there was the partying I did with the dancers after work. Sex, drugs, and rock and roll! Twosomes, threesomes, drinks till eight in the morning, and always, the music played. I figured I had found my religion, hedonism, and it was led by a

god who didn't answer dreams, but instead drowned them out in a pleasant way.

I remember my first night at work, after the last set, I helped Iris, whose real name I never knew, off the stage. She was one of the prettiest. She was young, about nineteen, local. She was from the suburbs of Moanalua, I think. Her skin was still tight, unscarred. She had this funny streak of white running through her black hair. She smiled and stepped off the stage naked and tired. I looked down at her garter, and saw all sorts of bills hugging against her leg. I remember asking her, "Why do you do this?"

She laughed. "It's all for the money, honey, it's all for the money."

For me, that summed it up nicely.

Mama-san, I came to find out, was into more than the bar business. Besides the two bars she owned, she had a hostess bar a block away on Kapiolani called Club Nouveau. She was into prostitution, loan-sharking, and gambling. She and a partner owned a massage parlor called Happy Hands, where you'd pay fifty at the door, and "tip" your masseuse for any other services rendered. In her loan-sharking, she had lent out money to dozens of Korean immigrants who were starting their own businesses in town, whether they were jewelry and apparel shops in Waikiki or bars along Keeaumoku or Kapiolani. She had two sisters — one ran an illegal casino in downtown, the other ran Club Nouveau. Her partner ran Happy Hands, while she took care of Club Mirage and the loan-sharking, the two most profitable businesses. There she was, this little lady from God-knows-where in Korea, running her own little empire. A real rags-to-riches story. And once again I found myself riding on the coattails of someone bigger than me. Again I was knighted into a kingdom which I was not born into.

It was great for the first several years. Mama-san kept paying me more and more. Besides staying at the bar, sometimes I'd pick

up money for her. The loan-sharking thing, which they called the "Tanomoshi," was great. She did what no bank would, she lent out tens of thousands of dollars to the new-comers who had no credit or collateral, and charged them outrageous interest. Koreans, for some reason, always seemed to want to open their own business, unlike Filipinos who always seemed to work for somebody. The thought of enormous debt seemed something that the Koreans thought of as necessity rather than hardship.

Of course Mama-san, with her Tanomoshi, ran the risk of people not making money and skipping on their loans, and sometimes it got ugly. Sometimes I had to collect for her. After all, new businesses go bankrupt everyday, and sometimes these people had no way of paying. Mama-san was always squeamish about resorting to violence, but you can only reconsolidate a loan so many times. Some of these Koreans would be like a hundred grand in the hole, and sometimes because of this another hole had to be dug. She didn't like to do it, besides she'd rather get at least some money back. But she couldn't survive with the reputation of being somebody that's soft. Who can? Only those who can bear being the jackass among the strong. That sure wasn't her.

So, yeah, I collected, but I left the hole digging to the others, the evil-looking Koreans Mama-san owned. They were the ones way too young to remember the Korean War, but they looked like they remembered anyway. I left the killing to them, while I beat people, people who Mama-san thought would be scared of my violent Japanese looks. She thought I'd remind some, who were old enough, of the Japanese occupation of Korea. These people were usually honorable enough to attempt to fulfill their debts, but nevertheless, these people were sometimes guilty of a heinous crime in this world. They weren't making money. Immigrants from Asia looking for something better, just like my ancestors, instead finding the same damn thing. Embarrassingly,

it wasn't a time in my life when I got tangled up into moral dilemmas. Coke never got me, but money did for a while. It seemed the more I got, the more I wanted. It was my narcotic, my passion, my reason for living. It was my fairy godmother.

I was a sight back then, wearing thick, gaudy gold chains around my neck and wrist, wearing designer shirts which were a size too small on my weight training-induced two-hundred-pound body. I remember this one rope chain I had, half an inch in diameter, which I wore every day. I wore it so much that a pale ring began to form around my neck. It wound tight around my jugular, almost like a dog collar. It screamed, "Hey, look at me, I get my money illegally!" It's kind of scary when I think about it, the first time I saw Mama-san, I wanted to laugh at her gaudy appearance, her jewelry, her overly-painted face. But after a while I became what she was, I became a son who worshiped the same idol.

After a while, after partying with the strippers, I noticed that they did an extraordinary amount of drugs. I didn't ask why, I was just interested in capitalizing. I dug Freddie up and he'd come to town to drop off coke, weed, and the up-and-coming drug of choice, crystal methamphetamine. Freddie, he'd drive anywhere to get his hands on more blue cats.

Sometimes, when I did collections, I'd skim some, telling Mama-san that the portion I gave her was all they had.

I dabbled in sports gambling with a buddy of mine, a silent partner, making about fifteen grand every football season.

I still collected cash from Mama-san, from the regular bouncing and collecting.

Altogether, I must've been making a hundred grand a year, tax free. My crummy one bedroom turned into a two-bedroom condo on the thirtieth floor of the Marco Polo building right outside of Waikiki. It was a real high-class place, with security cameras and a guard at the door. It even had tinted revolving

doors, the kind I'd see on T.V., the kind in places like New York City. I remember the first time I saw the night guy standing by the door. He was this middle-aged Korean guy, his broad face sagged like a bulldog's. His belly hung over his tightly cinched belt. I tried to give him a twenty-dollar tip. For some reason I figured that's what people did. He thanked me, but refused. So every Christmas I gave him a bottle of soju instead. He'd smile, take the bottle and say, "Tank you." He'd bow slightly several times, looking a bit too happy in receiving his gift.

My twenty-inch television grew about forty inches. Leather sofa, glass tables, plush burgundy carpets, my Otsuka framed print of Miyamoto Musashi hung from a cement, not wooden, wall. My piece of shit Celica became a brand new black Porsche Sportster. I kept my money out of the bank, and put it in my books at home. Between the pages of pieces like *Macbeth*, *The Odyssey*, and *Native Son*, thousands of dollars served as hidden bookmarks. I marked my very favorite pages with thousand dollar bills, other good pages I marked with hundreds. It seemed safe at the time, I figured books were like kryptonite to thieves. I thought I was an original, one of a kind. Besides, my thirty-thirty turned into a Glock and a sawed-off shotgun. The shotgun was under my bed, and the Glock was in a case under the seat of my car. So I was confident. I was living large, and my fairy godmother never told me that the clock would strike twelve.

The life was more than entertaining during those years, especially at Mirage. Of course there were the strippers. Iris. Did her. Epiphany. Did her. Crystal. Did her. One time Crystal took me home with Chanel and I did both of them next to a glass table covered with glasses of margaritas, weed, glass pipes, and little plastic bags of crystal meth. The threesome. Everyman's dream. Didn't officially date any of them. Most of them had on-again, off-again boyfriends who were either dealers, surfers, or musicians. These were guys they usually met at work.

Watching the customers was also very entertaining. We had all types walk through the red velvet curtain. College students on a limited income. Japanese tourists brought in by limo from Waikiki. Blue-collar guys dressed in t-shirts and jeans. Drug dealers, with their tight shirts, huge gold necklaces, and wads of hundred dollar bills. Haoles walking in with that "surfer" look; shorts, t-shirts and slippers. Huge Hawaiian strong-arms who collected protection money from all the bars, including ours. Businessmen wearing slacks and aloha shirts. Most were either boyfriends or husbands. A few were of that lonely I-never-get-laid breed. On any given night, every type of thirsty man came crawling to the Mirage.

It's funny, you'd figure that the dealers or strong-arms would give us the most trouble. But the cops were often worse. At least the dealers and strong-arms were big spenders, sometimes dishing out hundreds per night. But some of the cops? They figured once they'd gotten their badges, it was discount city wherever they went. And they were right. Nobody, especially a woman like Mama-san, wanted the cops on her. Even if Mirage was a legitimate business, she had the whorehouse disguised as a massage parlor, the loan-sharking, and the casino. Besides, in the Club itself, drugs flowed in and out every night.

Those two cops who came that night Mama-san offered me the job were always there. The Portagee and the Japanee. It didn't matter, on or off-duty. Both were married. Both were alcoholics. Both were dirty. They weren't dirty in the sense that they stole, murdered, dealt drugs, or even used drugs, instead they were the type of cops who abused power. Everything in Mama-san's kingdom was free to them. Drinks were free, "massages" at the whorehouse were on the house. And in return, they turned their backs on any criminal activities Mama-san was involved with and they served as protection for her. I should've been happy to have them, but something about the whole

arrangement bothered me. Maybe it was because they had too much power and they knew it, or maybe it was just that I didn't like the fact that they were hired to do a job which they didn't really do. I mean, if you're hired on as a strong-arm, kick ass, if you're employed as a cop, catch criminals. Do what you get paid to do.

Cops... It's hard to blame them, though. Their job is to deal with shitty things that happen. If you see enough shit, you want to have some beers and relax. And when bar owners start kissing your ass, what's a man to do? The bar becomes his favorite place. These two, the Portagee and Japanee, loved Club Mirage.

And I loved it, too. We moved with the times. I had an ATM machine brought in. I told Mama-san that she should hire a D.J. During football season, we had Monday Night specials. Cheap beer, free pupus, and a satellite dish bringing in the game live. Other sporting events. Everytime Tyson fought, we made a bundle. A lot of customers would step into the trap and stay well after the satellite spectacle was over, even when beers went back up to five dollars. We ran things smart and professionally. And just as business was hitting its heights, and I was making more money that I ever did before, the clock struck twelve and in came Claudia Choy.

❖ ❖ ❖

I met Claudia Choy, the third sun in my life, four years into my time in town. I never saw her coming, never knew she had even existed. But one night there she was, real, walking through the entrance of Club Mirage. She was looking for her mother. I remember when she first walked in, I was standing behind the bar. Her long, straight black hair was wetted down from rain. Her blue jeans and black t-shirt were equally soaked. The black lights revealed the dots of white lint which decorated

her shirt. I couldn't see her face at first because of the dim lights, but as she neared the bar, I saw the naked tanned skin spread out on her high cheek bones. I saw her roundish eyes which revealed some haole blood. I wasn't too surprised to see a woman here, a few came in every week. But Claudia didn't look like the usual party girl that came once in a while, hanging on the arm of a guy, or a couple of other party girls. She walked in alone with no make up, no jewelry. She just looked around the place in a disinterested manner as she slowly made her way to the bar.

I pulled a book out from under the bar and acted like I was reading it. When she got there, she asked, "Hey, is Kilcha around?"

She smelled like rain and Ivory soap. I put the book down. "Kilcha? Who's that?"

She crinkled her brow. "What do you mean, who's that? She's the short, angry little Korean woman who owns the place."

That's when I smelled the liquor on her breath. I looked at her eyes again and noticed that they were a bit glassy. I reached behind me and opened a bottle of Bud Lite. I put it in front of her. "On the house. What do you want with Mama-san?"

She took a sip from the beer, then smiled. "I need to talk to my mother."

Hell, I never even knew Mama-san's name until now, and I was shocked to find out that this girl was her daughter. She was at least five-six to Mama-san's four-ten. I believed her, but I had to doubt her anyway. "There's no way in hell you're Mama-san's kid. What'd she do, marry one of the two white basketball players in the NBA?"

This earned a laugh, but one that, to my disappointment, rang with more politeness than anything else. It wasn't that funny. "Why?" she asked. "Do you look exactly like your mother?"

She lifted the bottle to her mouth. "Yeah, I do," I said. "She was a gorgeous woman, don't you agree?"

She quickly pulled the bottle out of her mouth. Foam rose in the dark bottle. The laugh forced a few drops of beer from her closed lips. One of the drops rolled down the side of her mouth. She caught it with her pointy tongue. "Yeah," she said, "she must look all right. But I hope she doesn't have that disgusting gold thing growing out of her neck, too. She's risking suffocation, and a green neck among other things. I hope she got hers removed."

I put my hand on my chest and dramatically bowed my head. She turned her head a few times, looking behind her. "Unfortunately, Mom's dead," I said, "but she left me books."

I picked up the book which I was pretending to read and showed it to her. I looked at the title and cringed. "The Bartender's Bible," she said. "Interesting book to leave your child. Was Mom a bartendress?"

"No, unfortunately Dad was a drunk. Nothing more pitiful than seeing your father get blasted on drinks with little umbrellas in them."

Claudia smiled. "Well, a lady as wise as to leave you something to keep your father happy sure must've told you bits of advice before she died. An amateur bartendress to boot? She must've told you stuff like, 'reading in a dark strip bar is bad for your eyes,' or 'too much gold makes you look like a two-bit criminal.'"

That one hurt, so I felt like I had to bite back. "Well," I said, "someone's got to make money in the family, right? Some of us have to break the law to spoil our relatives with whatever their hearts desire."

"You are quite an asshole," she said.

"Are you coming on to me?"

She laughed. That's when Mama-san approached the bar and grabbed her daughter's arm. "What you doing here? I tol' you never come here. Bad place bad." She made an attempt to reach up and put her hand over her daughter's eyes. "Craudia,

you go outside right now. Pabo. You go now." Mama-san gave me a dirty look as they both walked toward the exit.

I took a big gulp from Claudia's beer before I threw it away. I was standing there thinking, I couldn't believe Mama-san gave her daughter a name she couldn't even pronounce. I was curious, so I walked and followed them outside.

When I got out there, Mama-san was telling Claudia, "Aigo. I tol' you never come here. What you doing out dis late, anyway? You, you drink, yeah? Crazy girl! You drive, too?"

Claudia saw me come out of the thick, red velvet curtain, then looked back at her mother. "Ma," she said, "my car got towed. I was at a bar a couple of blocks away. I need money to get my car out. I promise I'll never come back here and I'll pay you back."

Mama-san opened her purse and pulled out a wad of money. "What you doing at bar?"

"Ma, I'm twenty-two years old. I was drinking with a couple of girlfriends from school."

"You no drink too much. Here money. Catch cab. I go back work."

Claudia bent down and hugged her mother. "Thank you, Mom."

Mama-san responded with an "Ackk!" She said something in Korean, then walked back toward the velvet curtain and gave me another dirty look as she passed me.

Just as Claudia turned around, I spoke up. "Hey," I said, "don't catch a cab. I'll take you. Where's your car, Sand Island?"

She stopped and turned round. "Go back to work. I saw you busting your ass in there. The place would fold without you."

I laughed. "Yeah, you saw me working in there all right. But seriously, let me take you. Mama-san won't mind if I split early."

She sighed. "Okay. On one condition. You take off that crazy gold chain."

I nodded and took it off. I put it in my pocket and felt the heavy weight attempt to pull my pants down. I hoped the darkness covered the light ring around my naked neck. When I walked to my kick-ass Porsche, I was kind of ashamed of it. She seemed to be more of a Toyota Celica kind of girl. Not in a trashy way, but in that way that some people born into money are attracted to those that don't have any. I opened the door for her.

We took off to Sand Island, which was about fifteen minutes away. We did some small talk on the way, exchanged names, told each other where we were from. She'd lived in town all her life. After I pulled into the impound lot, which was surrounded by tubular industrial buildings, I peered into the bad lighting. I wondered which car was hers. When I stopped, she quickly got out, not waiting for me to open the door. I followed her up to the attendant.

After the exchange was made, she turned to me. "Thanks for the ride. Don't let me keep you from anything."

I smiled. "Don't worry, I'm free. Besides, I was planning to follow you home. Seeing that you've been drinking, I wouldn't want you to get pulled over."

"Are you my knight in shining armor?"

"No," I said, "actually, I was hoping you'd be mine. I figure since you slayed that gold thing growing around my neck, you could protect me from all the other bad things stalking me."

"Only one rescue a night. Tell you what, give me a call tomorrow."

She pulled a pen and crumpled piece of paper out of her purse and wrote down her number. She handed it to me. "We'll go do something in the afternoon if you wake up in time."

After I secured it in my hand, I resisted the urge to pump victorious fist holes into the sky. Instead, I told her, "Listen, before I leave, I gotta see your ride. I just want to see if you're some kind of hippie or something."

She smiled. "Nope. In some ways, unfortunately, I am my mother's daughter."

She waved good-bye. I watched as she stuck her key into a crimson colored Lexus coupe. She peeled out and drove away.

■ ■ ■

I called her at about eleven the next day. She wanted to surf. We decided to meet at the Waikiki Natatorium. After I hung up, that nervous feeling crept into my body, that feeling of bliss mixed with fear. I laughed to myself, thinking, I was the one who was supposed to lure her to the beach so I could check out her body. Before I left, I strapped my longboard to the roof of my Porsche (this sight always looked ridiculous to me) and set out to Waikiki.

I had beat her there. When she arrived about five minutes later and got out of her car, I was hardly disappointed. She was in a smooth, thick-strapped, black bikini, her body was tanned and hard, probably from surfing. She had long, smooth legs, and cut abs. Her top revealed a small crease of cleavage high on her chest. Several small freckles decorated her below her neck. Her bare face was even more pretty in daylight. Her dark eyes and long, thin lips looked killer on her thin, tanned face. She had those smart, cocky eyes, the kind that always looked like they weren't just looking, but analyzing, too. They were sure eyes. I couldn't believe she was Mama-san's daughter. To me, Mama-san always looked like she carried this giant invisible rock on her shoulders for years, like she could've been tall once, but the rock smashed her body closer to the ground. Claudia, on the other hand, seemed to carry no such burden. Her uncombed hair tangled in the wind as she reached to the roof of her Lexus and unstrapped her longboard.

When she met me at my car, she leaned her board against it and put her hands on her hips. She looked me over and jokingly,

with eye-lashes fluttering, she asked, "Do you work out?" We laughed. I watched her stomach tighten with the laughter. She grabbed her board. I followed her to the water.

The waves were small, near non-existent that day. One to two feet, maybe. But as always, it was packed. About fifteen to twenty surfers drifted with the tide, mostly guys, and we all waited for the next small wave to come. I noticed others were occasionally checking out Claude, and at first it gave me a mixed feeling of pride and jealousy. However, after I thought about it and realized that she wasn't mine, the pride boiled away, and the jealousy turned to rage. She didn't seem like the type to dig caveman ways, so I turned to her and said, "Hey, let's paddle more out." She nodded and we paddled out closer to the horizon.

When we got far enough away from everybody, I stopped. "Shitty today," I said.

She nodded in agreement. "Hey, Claudia," I asked, "what do you do anyway? Do you have to work or something tonight?"

She had stopped and let the incoming tide drift her back to me, while I occasionally paddled in order to stay where I was. When she reached my side, she paddled to keep herself next to me. "Nope," she said, "I don't work. I go to school. Much to my mother's disappointment, I'm here at U.H. getting an Art History degree. I think she was thinking Stanford or Berkeley or something. Thinking pre-medicine or pre-law or something. I'm turning out to be a big disappointment. I would say black sheep, if there were any other sheep to compare me to."

"I hate to take sides, but what the hell can you do with an Art History degree anyway?"

She laughed. "You're telling me. Nah, I don't know, I guess I could work at a museum or something."

"Work in a museum? I've seen the ladies that work in museums. They look one step away from becoming relics themselves."

She laughed her polite, slightly sarcastic laugh and looked over to me. "When the hell have you ever been in a museum, scarface wannabe? What were you doing, looking for paintings to steal?"

I laughed. Then I thought about this conversation we were having, and the other conversation we had the night before. I realized that I'd been laughing like a jackass during the moments I was with her these last twelve hours, laughing more often than I'd ever laughed before. I also realized that Claude didn't fear me. It seemed strange at the time. I figured just about everyone I knew had some reason or another to fear me, but she didn't. She lacked caution. I mean, I knew she was making some attempts to be clever and charming, but she didn't seem afraid to fail or insult. This girl didn't give a fuck, but she didn't give a fuck with grace. I looked up at the sun and squinted. I felt its harsh rays burn the white ring around my neck. I paddled a little closer to her. "Will you marry me?"

She laughed and splashed water on my hot face. I felt the cool ocean drip down to my mouth. I tasted the salt. "Hey, let me ask you something," she said, "you told me last night you grew up in the country. Ka'a'awa, right? Why don't you speak pidgin?"

I looked at her. "Why, sista? You get one problem wit' da way I talk? No ack. Why, you one Korean-haole, how come you talk like one haole and not one Korean?"

She shook her head. "I can speak some Korean. Can't write it, though. I guess I talk the way I do because I learned my English in the classroom. In kindergarten, I could barely speak English, so I had no friends. I learned how to talk from the teachers. So what about you?"

"My father was never into me speaking pidgin. My mom was an English teacher. I read some. Hey, don't look so surprised. I guess you could say I went to kindergarten barely being able to

speak pidgin, so I had no friends. I talked to books and they talked to me. After a while, when I learned how things worked, I got friends and picked up pidgin."

She nodded. I looked toward the shore and noticed that the tide was pulling us further in toward the other surfers. I didn't want to go in. Then I looked to the horizon wishing that I could see beyond it. I looked down in the water which surrounded me and noticed I had forgotten all about my shark phobia. I looked at Claude and saw her looking at the horizon. "Hey," I asked, "what is it that makes you like the ocean?"

She smiled but didn't look at me. Her eyes were still focused on the horizon. "Don't know, really. A lot of things, I guess. The isolation, the danger. The power. I like the feeling of being wet. But then again, that's not all of it, too. I don't necessarily have to be in the ocean to enjoy it. Sometimes I love just being on the beach and looking at it. Somehow it tells me there are endless possibilities." She paused and splashed water on her face. "It makes me feel alive, I guess. Like this is a place where nothing back there," she pointed toward shore, "can touch me." She laughed and pulled her wet hair in front of her face. "I must sound like an idiot."

I was enchanted. "See, you're gonna force me to propose again."

"Why, because you're attracted to idiots? Or because you're an idiot yourself, and you can make some sense of what I just said?"

I brushed her hair away from her face. "Well, I guess it means I'm attracted to idiots."

She splashed water on me and I splashed back. I thought about the laughing again. The humor. I was beginning to realize how it was a shield. All the clever dialogue just kept us from putting ourselves out there. It was like we didn't want to show much of our real selves, because we were afraid we'd be sitting there naked, while the other was fully clothed. This kind of

bothered me. I wanted to be naked with her, but I was unwilling to be the only one without clothes. I realized the big problem, even after just this half a day, was that I was in love with her. How fucking trite! But I didn't think she was in love with me. If she had taken my proposals seriously, damn, I would have married her that day. This was beginning to worry me, too. I did not love. It was something I thought myself incapable of doing. I hated, not loved. I was beginning to feel lost at sea.

A few seconds of silence passed. I said, "For whatever we lose, like a you or a me, it's always ourselves we find in the sea."

She looked at me curiously. "What?"

"e.e. cummings. I told you I read. Impressed yet?"

"Not yet. For all I know, that could be the only line you know. I might have to hang out with you a bit more and see if it's all a sham."

I felt like getting serious. I looked toward the horizon. "You know, it's funny. I know some lines, but none of them are mine. They're owned by dead haoles who I probably have nothing in common with. But sometimes, sometimes for an instant, I feel like they were talking to me. Knew my thoughts. My personal favorite is Macbeth on life. 'It is a tale told by an idiot, full of sound and fury, signifying nothing.' Man, I can think about that one for hours. Nihilism before there was nihilism. Every time I read it in my mind, I think, damn straight."

Right after the words had poured out, my heart cringed as if waiting for a blow. I thought I'd put way too much out there. I knew quoting lit often sounded forced. She was going to give me a crazy look and paddle as fast as she could back to shore. Instead she paddled closer to me. "Yeah, I heard that one before. But here's the thing. I figure if you can hear the symphony in the sound and see the farce in the fury, it's not all pointless. At least it makes it entertaining." She laughed. "Jeez, listen to me, Plato over here. I don't know."

"Look at the big brain on Claudia."

When she smiled, I said, "If my friends could hear me now, they'd probably disown me for talking all this crap."

I felt her grab my arm. "You worry, don't you?" she said. "Worry real hard about what other people think about you. Don't do that with me."

"We all worry, hon. I ain't any different. Let's paddle in. Let me buy you lunch." We paddled in together, side by side, as the gentle surf pushed us toward the beach.

We spent the rest of the day with each other. After dinner, we went to her place. It was one of the many condo apartments which Mama-san owned. The furnishings were minimal. There was a puffy-looking beige sofa which sat in front of the T.V. On the left sat a cheap, do-it-yourself, plyboard desk and a small dining room table with two chairs. The right was virtually empty except for a few of the house plants which were scattered across the room.

She was sitting on her sofa and I was sitting on the carpet in front of her. She had broken off a spiny branch of one of her aloe plants. She rubbed aloe on the burnt ring around my neck. She stopped and touched my shoulder. "Nice tattoo," she said. "What is it?"

She began tracing the lines of the tattoo with her finger. "It's my family crest," I told her, "the paulownia."

She stopped and frowned. "You're just a modern-day samurai, huh. Long hair, family crest. Where's your swords?"

I laughed. "They're not mine yet, but I guess I stand to inherit them."

"Your father has them?"

"Yeah," I said. I grabbed her hand and held it. "He has them."

She began to trace the lines of the tattoo again. "Are they like really old?" she asked. "Passed down from generation to generation?"

"That's what I hear."

"You don't sound like you want them."

"It doesn't really matter. They're gonna be mine."

"You know, if they're that old, you could sell them or something."

I didn't know what to say so I pulled her in and kissed her. Her hand came off my shoulder and she kissed back. It was amazing how fast this love thing grabbed me. Usually with sex, nervousness was virtually absent in me. My feelings were closer to want, to hunger. But with Claudia, it was almost like I didn't want her, like I didn't want to fuck her. My nervous hand shook a little, like I was almost afraid to touch her, like I didn't want to offend her. I remember telling myself, "C'mon dumb ass, it's just sex, it's just sex." It was like a mantra. I got up on my knees and faced her. She squeezed out a gelatinous piece of aloe from the branch and put it on the tip of my nose. I took off her shirt. I gently kissed the back of her ear, digging my nose deep in her hair. She ran her hands through my long, messy hair. I almost froze, as if I didn't know what to do next. She pulled off my shirt and joined me on the floor. We began to kiss, and slowly I felt my back approach the carpet. She was on top of me, her chest pressed against mine. We kissed each other on the lips and all over each other's face. It seemed like we kissed for hours.

An hour later, we made our way back to her bedroom. We both sat on her futon bed cross-legged, naked. We sat there on her ocean blue sheets. She held one pillow in her lap, and I held another. I felt the hard, wooden frame underneath the thin mattress dig into me. She touched my face. Her fingers moved against the grain of my scars. I put my head down and let out a little laugh. Her hand stopped. She tipped my head back up and stared at me. I looked away. "What's wrong?" she asked.

I looked at her. "I don't know, this feels wrong. I don't know why, but it does. Maybe I'm thinking what your mother will think."

She crinkled her brow. "Don't worry about her, I can handle her."

I laughed. "You don't know much about her, do you?"

Her face turned serious. "I know what she is. She's a woman obsessed with money. She's a woman obsessed with me having money. I'm not stupid, I know this makes her dangerous. But you don't really strike me as the kind of person who's afraid of that."

"No, to tell you the truth, nothing much scares me. But this knowledge of myself, me knowing that I'm not scared, scares me a little. And, as corny as this sounds, hurting you scares me, too." I was shocked to hear the words come out of my mouth. Schmaltz City, here I come.

"Look at me," she said. "Really look. Do you see someone fragile? If you do... All I can tell you is you're wrong." She looked me straight in the eye. "I'm tougher than you."

I grabbed her. I roughly pinned her to the bed and smiled. She laughed. I kissed her. We kissed and I felt my body wanting her.

■ ■ ■

As the sun began to rise, she was in my arms. I wasn't sleeping. But for the first time in my life, my insomnia wasn't caused by anxiety, instead it was motivated by calm. In fact it wasn't even insomnia. I was tired, but I forced myself to stay awake and just envelop myself in the calm. I enjoyed it. I revelled in it. I couldn't believe I felt calm. It became a place I didn't want to leave. So this is love, I thought. All good. I felt her stir. She entwined her long thin fingers with mine. I felt her strong hand squeeze her palm into my callused hand. She kept her eyes closed.

From that moment I knew this wasn't a one-night stand. Then suddenly she sat straight up. "Oh, shit," she said, "what time is it?"

I looked over at her clock. "It's about nine."

She jumped out of bed and jumped into her panties. "I gotta go to school."

She grabbed her keys and removed one from her keychain. She threw it to me. "I'll be back in a few hours. I expect you to be here when I get back." I reached over and stuffed it in my jeans pocket.

I wanted to ask her, jokingly, who the hell she thought she was, but instead I simply nodded. After she got all her clothes on, she bent down and kissed me. She ran out of the room and I heard the door shut. I put a pillow over my head and smelled the left-over fragrance of her hair. I laughed and threw the pillow off the bed. What the fuck was happening to me? I didn't want to need. I told myself I wouldn't be here in a few hours. I told myself I didn't need her, but I would if I stayed around here. I began to feel weak and stupid. I thought back on the last couple of days, and asked myself, "Who was that loser, dumb ass hitting on this chick and making all romantic?" I thought about how "touching" the day before was and it made me want to puke. I was definitely in the Schmaltz City Limits. I began to seethe as I stood up and started dressing. I tried to hate her but it was hard. So I began hating myself and it was easy. I walked out of the apartment and told myself I would never return.

Two hours later, it dawned on me. I was sitting in front of my big T.V., vacantly watching some stupid soap, and I realized I had her key. I looked up at Musashi and yelled, "Fuck." I took the key out of my pants pocket and looked at it closely. I rubbed the ridges of it with my finger. I looked at Musashi again and threw the key across the room. Fuck, she'd outsmarted me. I looked at the T.V. screen and saw some haole guy proposing to some haole girl. I turned it off and paced in my living room.

When I began looking for the key, I couldn't find it. For about fifteen minutes I crawled around on my carpet looking for that fucking key. Just as I was about to say, "fuck it," I slapped one of my empty shoes across the room. I saw the key fly out of the shoe and I crawled to it.

When Claudia got back to her apartment a little past noon, I sat waiting for her on the sofa. She opened the door and asked, "So what did you do all morning?"

I was planning to tell her that I wouldn't be able to see her again, but when I saw her I heard myself say, "Nothing. Just waiting for you."

She sat down next to me and sighed. "Let's go in the bedroom."

✤ ✤ ✤

It went on like this for a couple of months. Every time I felt strong enough to leave, she'd make me stay just by being in the same room. It drove me fucking crazy. We'd surf, dive, eat, make love. She began talking to the night security man at my building and somehow pulled some kind of deal where we were able to get another copy of my set of apartment keys. Not to mention she seemed to be that type of girl who could easily give her friends the shaft when she got involved. It was easy for me, too, considering my friends were on the other side of the mountains.

After she got the key she was around even more, and I'd be into it whenever she was near me, but once she left, I would begin to plot my escape. I don't think she was on to this, at least for a while, but sometimes my absences would last a few days. No phone call, no messages. Sometimes I found myself avoiding my own apartment. During these separations, I tried to immerse myself in work. I would spend hours at Mirage, looking at the

strippers, hoping one would seduce and save me, in turn saving Claudia, too. But to be honest, it was all getting old. You spend enough time in a strip bar and sooner or later you find women more attractive clothed than unclothed.

So I tried to turn my mind to the actual business side of the Club. I suggested to Mama-san that we build a kind of back room, a private party room for bachelor parties and stuff. She liked the idea, so this kept me busy for a while. But it was my only idea. Bouncing, collecting, it wasn't brain surgery. It allowed time for my mind to drift. I'd debate whether I should call Claude (I saw her so often, I had to even shorten her name just to save energy). Sooner or later, I'd give in. I guess school kept her busy. It's funny, she never made the effort to look for me at the Mirage, even though she knew I was there. This would make me hate her sometimes and I'd play this competition with her, this game of "Who can last without whom the longest?" I hated the game and I'd often lose. So I didn't think anything bothered her. But I guess it did. One night, the summer after her graduation, we finally had it out.

We took her Lexus and went night-diving out at Black Point. Behind the houses of the wealthy, we walked across the black lava rocks that separated the road from the ocean.

When we got to the edge, we dove into the cold water with our dive lights. I felt the water pierce through my wet suit. I turned on my light and saw the particles of the sea drift with the ebb and flow of the ocean. I raised my head above the surface of the water and heard the wind whistle against the hollow of my snorkel. I looked out towards the black ocean and saw an orbit of light moving further out beneath the surface. Claude was getting ahead of me and herself. I dove back down and kicked hard to catch up with her.

We scoured the water for spiny lobster even though it wasn't in season. As we swam further and further out, I kept a closer eye on Claude, making sure she stayed close. I pointed my light down

into the darkness and saw a lobster coasting slowly on the rocky, sand-colored surface. I signaled for her to dive down and grab it. I watched as she took the shallow ten-foot dive down and chased the lobster. She reached out and grabbed for it, but she was too slow and missed. She chased after it clumsily, but it was too late. The lobster kicked up a cloud of sand and disappeared into the darkness. We rose to the surface and took our snorkels out of our mouths. "You gotta be quicker then that, hon," I said. "You gotta be sneakier. Try again, I know you can do it."

She nodded and put her snorkel back in her mouth. We swam on. She missed a couple more. I laughed, but she didn't hear me underwater. I decided to take a dive down. I reached the bottom and swam further on. I looked under a rocky ledge and saw a huge lobster.

Automatically, my arm shot out and I wrapped my hand around its kicking tail. I dropped my light to get a better grip on it. I put it in my netted dive bag and retrieved the light. Just as I was running out of breath, I flashed my light through the yellow mesh of the bag. The lobster was a big, ugly thing. It looked like a large prehistoric insect with its segmented, spiny armor, and its long, protruding antennas. It was an ugly, tasty scavenger. Finally I rushed to the surface, spit the water out of my snorkel, and took in a deep breath. I looked around and didn't see Claude's light. I spit out my snorkel and tread water in circles. I didn't see her. I hadn't swum very far chasing the lobster, so I figured the tide had probably pulled me even farther away from her. I flashed my light toward the shore and realized that if I didn't have the light, I wouldn't have known which direction the shore was. I called out for her. No answer. I called louder. When I heard splashing farther out, I swam toward it. Finally I heard her voice. "Ken!"

When I got to her, she was crying. I flashed the light in her face and saw her face mashed up with tears flowing from her eyes. I hugged her. "What's wrong?"

"You left me, you fucking left me."

I hugged her harder. Then I felt the bump on my leg. I resisted the urge to swim toward the shore as fast as I could. I held her hand and moved my head and light below water. I waited and listened to my quick breathing resonate in my snorkel. I flashed the light in every direction. Suddenly I saw it glide out of the darkness like a spaceship. When you see a shark underwater, you know it's a killer, and on a whim, it could kill you. I looked at its sharp, ugly teeth which stuck out of its mouth. I looked at its eye, its dull black nothingness, and watched it grow bigger and bigger. It was an expanding black disk growing closer and closer to me. I floated still. It was a tiger. Suddenly I saw my hand flash toward the eye. The ten-footer jerked its head away and in a split second it disappeared again into the darkness.

I shot my head to the surface. I asked her if she was okay. No answer. I asked her what had happened to her light.

"I dropped it when the shark came. It went off."

I felt for her. Being stuck in the ocean without light was a scary experience. Sometimes, when I'd dive, I'd turn the light out momentarily to check my courage. The darkness would envelop me, and I'd end up turning it on sooner then I'd planned. For a second, I thought about searching for her light. Instead I grabbed Claude's hand and we swam back to shore. We had a hard time getting back because it's difficult for two people to share the same light. One leads while the other blindly follows. It takes trust.

We lifted ourselves on the rocks. I suddenly realized that I'd dropped my bag with the lobster. I turned to Claude. "Don't worry, that was my friend's great uncle. But, just in case, remind me to buy a bang stick tomorrow."

Tears rolled down her cheeks. Suddenly I felt jealous of her ability to cry. I felt like if I could cry, it would make me feel a lot better, it would make my heart grow calmer, the heart that still

felt like it was going to beat right out of my chest. "You fucking left me out there," she said.

I looked at her through the darkness. I couldn't really see her. "I saw a lobster and went for it. I couldn't have been gone for more than a minute."

She threw her mask at me. It hit me on my face. I guess she could see fine. I stepped toward her, my fear suddenly transformed to rage. She stood there waiting for me. Her tears had stopped, and she looked at me defiantly. I stopped in front of her, wanting to fucking pound the shit out of her. I wondered why she was so scared of that fucking shark but totally unafraid of me. "I cannot be wit' you every fuckin' second of da day," I said.

"I don't expect you to. But I expect you to be there when I need you."

I shook my head. I began to get calm. "How da fuck was I supposed to know what was happening? And besides, when we first got here, you took off without me."

She shook her head. "You never should have left. But you know what? Fuck it. You want out, fine. Fuck you. Fuck off." She walked toward her car.

I followed her and grabbed her arm. She turned around shivering. It was funny, I didn't know what to tell her. It seemed like I had nothing good to say. I mean, I really believed she was being stupid about the whole thing. Sure, she had every right to be scared out of her fucking mind, but to hold me accountable? It seemed ridiculous. Besides, at the time, the way she was acting, it was pissing me off. But I didn't want to tell her that. I stopped myself from saying anything. When she turned around, I just kind of looked at her in silence. When she tried to pull her arm away my grip tightened.

"I never would have left," she said.

"You're leaving now."

She tried to twist her arm away but I wouldn't let go. "You're hurting me," she said.

"You're hurting me."

"Deep down inside you want me to leave."

"Deep down inside I want you to stay."

When she laughed, I let go of her arm. My eyes were adjusting better to the night and I saw her smile. "We gotta put this out here right now," she said. "What are we doing?"

My thoughts flashed to my mother and father and I wondered if they went through a moment like this. I thought about how it might have been better if I let her go. I wanted to let her go. I wanted never to see her again. But I didn't. I had made her stay when I grabbed her arm. I made her stay and I didn't know what to say to her. It was like I was forcing a moment, a situation that I did not want to be in. I felt like she threw a net over me. The more I struggled against it, the more I was entangled. I looked at her car. I looked at the tinted driver's side window. I tried to force my vision through the night, through the dark glass. I couldn't see inside. In a moment, I decided to tell her the truth. "Fuck it," I told myself, "she wants it out. I'll tell her."

I looked at her. She was waiting for me to say something. So finally I said, "I feel like you own me. Like you control me. Like I'm bad for you, but you got me, anyway. It's fucked up. When I'm with you, I'm happy. When I'm not with you, I feel like I should never see you again. What are we doing? I don't know. Not thinking, I guess."

I looked away, back at her car. I was getting angry because I couldn't see through the tint. I heard her voice. At first I didn't want to listen, I just wanted to look at the window. I didn't want to listen and this not wanting to listen felt familiar. Suddenly I remembered my mother and how I didn't listen to her as she was dying. I remembered regretting it. I forced my eyes off the car and looked at Claude. Her lips were moving. I forced myself to listen for the sounds. To break them down and distinguish the words. Finally, I started to hear the words. She was saying

something about love, how she loved me, and something about how we can't let our pasts control the present. I started to hear more and more. I heard, "...and you make me happy, too."

Then I heard myself say, "I don't love."

She looked at me. "But you love me."

I turned my head away from her. "You'll hate me in a year."

"No, I won't."

I looked back at her and smiled. "You're going to want to leave."

"But I won't."

I'd run out of things to say. I guess I didn't really want to say anymore, anyway. I opened my arms. She walked to them and I hugged her. I leaned my mouth to her ear. I listened to the wind and waited for a strong gust. When one came whistling through the air, shaking the leaves and branches of trees, I whispered, "I love you."

And so I started my residence in Schmaltz City.

<div align="center">❖ ❖ ❖</div>

And happily ever after. Suddenly it seemed we had no obstacles. We were together and happy to be so. It was the first time I fell in love, so I figured that was that. But that wasn't that. It should've been, but it wasn't. It should've been, I mean she didn't try to change me, she accepted me, and I accepted her. We were happy with each other. But the world wasn't happy with us. It didn't seem to like us very much, and it seemed to hate us being together. It was like that treacherous run down the mountains while being chased by the ranchers. Instead of Koa, this time it was Claudia who led me down the mountain, down into momentary safety and bliss, but down to something else too. Except Claudia and I didn't run down completely blind, like with Koa. Claudia and I shared a dive light and jumped into the water. Sometimes I think darkness is better than partial light.

Mama-san wasn't happy about our relationship. She didn't really know how serious we were, in fact we tried to keep it from her, but she knew something was going on. She didn't do anything too drastic at first, though. She cut me out of some work, but I didn't mind. I had enough money in my books to last me a long time. Besides, she didn't cut me completely out, I still ran around town collecting for her, I just didn't pull any hours at Mirage anymore, which was fine with Claude. No, at first Mama-san was not happy, but she wasn't unhappy enough to really do anything. Claude finished school and I didn't seem to be ruining her life. I wasn't the doctor or lawyer Mama-san wanted to see with Claude, but I wasn't ruining her life.

It was funny how me and Claude were. Most people when they hook up, it's like the future suddenly becomes overly important to them, it's like a weight a couple decides to lift and bear together. Claude and I didn't care. We looked at this boulder called "the future," and let it lie. We liked the present too much. We'd eat out constantly. Surf, dive. It was funny, she was less hesitant to get back in the water than I was. Sometimes we'd just stay at my apartment. She'd do her homework in the living room while I'd read in bed. She'd join me when she was done, tease me about the print of Miyamoto Musashi hanging in my living room. She'd say, "That's not art, this is art," and point to some page in one of her texts, some painting or sculpture made by some dead white guy. I'd always welcome her return, though, it was like we could barely stand being away from each other even if it was only one room away. We'd even work out together. We were one of those couples that make others who see us sick. With each other all day, every day. We were totally wrapped up in each other, oblivious to the outside world.

We'd be in bed naked and share our pasts. I'd tell her about my mother and father, about Koa, I even told her about what I did for her mother. She cringed at this one. I told her that her

mother, despite her flaws, was a great, tough lady. She was someone I respected. She told me about her mother, things I didn't know, like how her mother's mother was forced into the role of comfort woman for the Japanese soldiers during the occupation before the end of WWII. Raped by hundreds of soldiers. Though she never said it, Mama-san was probably half-Japanese. Claude told me how as this woman's daughter, her mother kind of became the same thing. Except Americans replaced the Japanese. After her youth was swallowed by the appetites of young men, she'd fled from Korea poor, pregnant, and disgraced. She was raped by an American soldier when she lived in a brothel by the thirty-eighth parallel. Though most called her "whore," she, like her mother, was more of a slave.

Claude told me that she, too, respected her mother greatly, how sometimes when she thought about her mother's past, she was in awe. But then she told me how she thought her mother let the ugliness of her past rule her. How money became her god, how she'd do anything to get it. She couldn't believe that after all her mother had seen, knowing where she came from, she exploited women whose situations were similar to hers when she was young.

When we were lying together in bed one night, Claude spoke over the hum of the air conditioner. "These women from Korea and Vietnam, these women who my mother employs as hostesses, masseuses, and strippers, they need the money and will get it any way possible, even whore themselves. My mother knows the lifestyle sucks, and yet she perpetuates it for her own profit. I don't get it."

"Hey," I said, "another thing I don't get is why is it that it's mostly Koreans and Vietnamese who are in these businesses?"

"You don't know? What were the last two major wars the U.S. fought in?"

"Korea and Vietnam?"

"The natives were trained. These were the businesses they ran for the soldiers during the war. So some of them, when they came here afterwards, knew it was a money-maker and just continued doing it."

"That makes sense," I said. "I guess Koreans get a bad rap for it. You know, peddling sin and all."

"I know, it pisses me off. Koreans get a bad rap for a bunch of stuff. You notice every bad driver in Hawai'i is a Korean lady? Every little grocery store, the ones that sell pornos behind the counter, is owned by a Korean. A bar on Keeaumoku or Kapiolani isn't called a 'bar,' it's called a 'Korean bar.' All of us aren't bad-driving bar and grocery store owners. But people like my mother perpetuate it."

I sighed. "But like you said, maybe it's all she knows."

"I totally respect my mother and I understand why she is how she is, but sometimes I hate her for trying to push her obsessions on me. For her, life is all status. Mercedes and Gucci. Shit, I was almost named Mercedes. She wanted me to go to a 'name' school, get a 'name' job, and marry a 'name' kind of guy. When I was a kid, she was an absolute tyrant. Watched over me, like a hawk or something, making sure I was doing all my homework. Sending me to Punahou with the rich kids. Didn't let me go out on weekends. She saw no present for me, she just wanted me to see the future. What is the future, anyway? It's just something that's going to happen no matter what we do."

I looked at her and smiled. "It must be hard, though. To do what she doesn't want you to do considering she's done so much for you."

She pulled the covers closer to her neck. "That's the worst part about it. Sometimes when she's on me about something I can practically see the love and hope pouring out of her. She loves me so much sometimes I hate her for it. It makes me feel guilty and ungrateful."

I touched her face. "So what do you do?"

"I used to fold all the time. When she was unhappy with something I was doing, I'd correct it, no questions asked. But then after a while I got worn down. I used to look in the mirror and not see much, you know. I'd see me, but I couldn't see anything inside. I felt like this non-person, destined to be a doctor and to marry one, destined to have kids, destined to die a grandma. My future lacked imagination, it lacked substance. That's when I found the ocean. I started to surf. I told her I was going to college here at U.H. It was a horrible scene. I told her the day she got my acceptance letter from Stanford. That's another thing about her, she always used to open my mail. Sometimes I wanted to report her to the feds."

"What happened?"

"She threw a fit. She even threatened to disown me, can you imagine that? But she calmed down after giving me the silent treatment for a few days. For me, for her too maybe, those were the most horrible few days. I felt so guilty. I'd lie up at night just imagining my mother working in that brothel in Korea, fucking G.I.'s left and right. About her crammed in some boat being shipped illegally to Hawai'i. Can you imagine? She didn't even come here by boat. Her uncle sent her money for a ticket, and she flew over. But there I was, imagining her pregnant in some barge, stuffed in a room with a hundred other Koreans, standing in puddles of piss, shit and vomit. When she finally talked to me, I think she asked if I was hungry or something, I just burst into tears. She hugged me and called me a silly girl. She's still pissed that I didn't go to Stanford, but she accepted that I stayed."

"So what about when you told her you were majoring in art history?"

She laughed. "That one wasn't as bad. She just called me 'pabo,' you know, stupid in Korean, and it kind of blew over. I think someone told her I could become a professor in the field

and it cheered her up. It's like she figured there was a chance for me to become a doctor yet. She told me intellectuals are greatly respected in South Korea and it would be just fine with her if I got my doctorate and became a professor. Can you imagine? A PhD was like the last thing on my mind."

"Pabo, ah. She was calling me stupid all these years and I didn't even know it."

We laughed together. "So what about it?" I asked her. "Are you going for a PhD?"

"I don't know. Maybe. I'd have to go to the mainland for it, though. I mean, if I wanted to teach here. U.H. doesn't hire U.H. students."

Suddenly the discussion was dropped. She pulled the covers over both our heads, climbed on top of me, and began kissing me. I gladly gave up the conversation. I think we both knew that we were getting into a discussion about the future. Like she said, the future was going to happen no matter what we were going to do. But I think both of us wish now that we'd had that conversation. It might have opened our eyes, and we might have been able to see what was coming next.

■ ■ ■

About eight months after we met, Claudia got pregnant. It was inevitable, really, we kind of always let safe sex stand waywardly on the side of the road while we raced past it. Maybe we both knew it was going to happen, but we just didn't want to bring it up. But there she was one day, sitting on my leather sofa, waiting for me to return. I opened the door and as soon as I looked at her she told me. She wore this kind of blank look, not sad, not happy, maybe just waiting to see how I'd react. I tried to confront her with the same poker face while my mind raced.

I thought about how I was when I was a teenager, how I was just a year before, how this would have never happened. I

thought about how stupid I had become, how this love thing wasn't so good after all. It was something that seemed to make your mind not work logically, it was charged with RPM's, made you run hot, made you blow your engine.

I looked at her and somehow knew she had ideas of keeping the baby. I felt the future hit me and it felt like I was jumping into an ocean of freezing water at night without a light. I started to shiver. Once again, I didn't know what to say in her presence in a tough moment. I felt it would be imprudent to reveal my truest thoughts.

Suddenly the words, "fuck it," flashed into my mind in big, bright neon, Vegas-style letters. Those two wonderful words that many of us cling to. It's like your mind, it can conjure up all sorts of rationalizations, arguments, and the debate can go on and on, but when you say, "fuck it," it's like the ace in the hole because there's no real argument that can stand against it. "Fuck it" can mean you made a decision or you let life make the decision for you while you were totally uninterested in it anyway. "Fuck it" is absolute, it covers all bases. When I was a kid, I could say it on a whim and make my problems instantly evaporate. But as I got older it became a harder thing to say, and with Claude around it was almost impossible to say, but in my mind, for an instant, I said it anyway. I didn't mean it, though. I couldn't mean it. I looked at her and she looked like she needed cheering up. So I said, "Is it mine?"

For an instant her face looked shocked. But she caught on, she always did, and she said in a quiet, over-dramatic voice, "Well, it's between you and this other asshole I've been dating, this Japanese asshole who always seems to want to make jokes in serious situations."

"You slept with an asshole like that? Seems like you get what you deserve."

I sat next to her on the sofa. I put my hand on her leg and she put her hand on mine. My mind began racing again in the

silence. I looked around my living room and saw no evidence indicating that this was a room created by a father. I looked at the big screen television, the Bose stereo. I saw all the wires sticking out from the back. I looked at the glass table and it made me feel nervous. I looked at the lamp on the side of the sofa and thought how easy it would be for someone small to touch it and burn themself. I looked at my bookcases and thought about how much inked paper there was there to eat. My eyes finally fell on the framed Otsuka print, on the eyes of Miyamoto Musashi, and I trembled. I didn't want to look at it, but I did. I saw his angry slanty eyes stare at me. His swords were sheathed, but he was attacking with two wooden sticks. His purple and yellow kimono was decorated with Kabuki-like faces. The faces wore looks of sorrow, pride, and rage. No, I wasn't made to be a father, just as my father wasn't made to be a father, but it seemed I was going to be a father, anyway. I was going to be a father with no war to run to.

I looked at Claudia and noticed that she was looking at Musashi, too. "Jeez," she said, "you gotta get rid of that thing, it's kind of creepy."

"You crazy? Musashi's my boy. He's my friend."

"No," she said, "he's your idol."

"Well, we're a package deal."

She laughed. "Well, so are we."

I thought for a second. Then I said, "Fair enough."

So for the first time, we began to plan our future. I told her I wasn't really anxious to marry, not because I didn't love her, but because none of the Mrs. Hideyoshis in my family ever faired too well, and I wanted to keep her around for a long time. She agreed to this. "Well maybe we should give the baby my last name then."

"That sounds like a great idea to me. In fact, if we ever do get married, I'd like to take your name too."

We laughed and lifted the boulder of the future together. It didn't feel as heavy as we thought it would. But then, people didn't start climbing on while we walked with it yet.

❖ ❖ ❖

Claudia's mother did not take the news well and I lost my job. Claudia lost her apartment. Claude was pissed at Mama-san and decided that she would never speak to her again. I figure this pissed Mama-san off even more. But she didn't blame Claude, the blame fell directly on me. I'm pretty sure she got the idea in her head that I had crossed the line, that I'd finally done something that had ruined her daughter's life. And I finally got it through my thick skull that me being Japanese probably didn't help much either. Well, in Hawai'i, Koreans are known for their tempers. Mama-san took this to another level. She snapped so loud I should've heard it coming. Suddenly Honolulu wasn't big enough for the both of us.

After three weeks of not speaking with her mother, Claudia finally broke down and decided that she would meet Mama-san for lunch. The silent treatment was hard on her, too, I mean, she and her mother were really close despite their differences. I remember after about four days of not talking to her mother, Claude told me, "This is the longest I've gone without talking to my mother."

So I was kind of glad that she was going to have lunch with Mama-san. I guess at the time I had this notion that family mattered. Even I, who fucking hated my father, called him once in a while to see what was going on. So I encouraged the lunch and told her I would stay home and sit on my sorry, unemployed ass.

Like so many times in my life, I found myself waiting. But for the first time in my life I was waiting for something good. Waiting for something that meant the world to me, something

that belonged to me, something that I belonged to. I wasn't waiting for death, I was waiting for life. But it wasn't coming. I was cruising on my sofa, reading an issue of *Time*. After a few hours, the clock began ticking really slow, slower than it had when I was taking shitty community college classes. I began telling myself they must've made up and decided to do something that night. I stood up after several hours and looked out my window. I looked down at cars stuck in traffic on Kapiolani Boulevard, some of them had their headlights on. They were waiting for the light to change. The sun was setting, but I faced the north so I couldn't see it. I turned around and shut off the T.V. I decided that I'd work out to kill time.

I returned home after about an hour and a half, flipped on the light switch and checked our bedroom. She wasn't home. I looked at the clock and saw that it was a little before eight. I went to the kitchen and looked in the refrigerator. I wasn't really looking, though, it was like I was just zoning out, enjoying the cool air that shot out on my face. "What can Mama-san do? She can't do shit," I told myself. I thought about the fact that Claude was Mama-san's daughter, and I knew that Mama-san wouldn't hurt her own daughter. I relaxed a little and closed the fridge. I walked to the bathroom and decided to take a shower. I was starting to feel stupid, overly concerned, uncool. While feeling the hot water wet my weary body, I told myself I was worrying like an old lady. Claude was fine, hell, if anyone can change a person's mind about something, it was Claude.

At about ten o'clock I was wishing Claudia had a pager. But she hated pagers, she always told me they were like leashes. I sat on the sofa, telling myself, "Now you worry." I looked at the clock. I looked up at Musashi. I stared at Musashi. I told him, "Fuckin' A," and got up to grab my keys. I decided to go to Club Mirage and see if Mama-san was there. Just then I heard a key go into the front door. Relief hit me. I dropped my keys and prepared

a big smile for her. Instead of seeing Claude, however, I saw three slick-looking Korean grave-diggers, dressed in black slacks, thin dark-gray coats, and Italian dress shoes, walk in one by one, all three meeting my smile with their own. I refused to let my smile crack, even when I saw the first one open his coat and pull out a nickel nine-mm.

I watched as two of them quietly destroyed my apartment. The one with the gun casually watched me. He was sitting on the sofa while I stood in front of him. His hair was straight and long. It was put back in a ponytail. A thick gold chain dangled from his neck. It wasn't a rope chain like mine, instead it was a figaro chain with thick gold links. Every time he smiled, he revealed unusually small, yellowish teeth. They were as crooked as hell.

The other two went through every room, pulling out every drawer. One came out of my bedroom with the shotgun. He was short and chubby with a wild, eighties-style curly head of hair. He smiled and I smiled back. The other, the one who was bald and had this thin, sorry excuse for a mustache, looked through my books and pulled out a thousand dollar bill out of *Macbeth*. He showed it to the others and said something in Korean. The other two laughed. I watched as this guy opened all of my books, taking every bill he found. After he'd finish a book, he'd just toss it on the carpet. He was getting out of the texts what he was looking for. Soon a pile formed, in one stack books, in another, my money. After he got all he could find, he gathered the money and separated it into two big rolls. He stuffed each roll into his front pants pockets.

The Korean with the small yellow teeth and nine-mm got up from the sofa and began looking at Musashi. The one with my shotgun, the chubby one, covered me while the nine-mm guy walked up to the print. He stared at it for a while, then the other two began yelling words to him in Korean. He ignored them and continued looking at the picture. After a minute or so,

he turned around, looked at me and smiled. "You tink look like you? You samurai?" He laughed, and the other two politely joined in. He turned back around, faced Musashi, and took him off the wall. He cracked the glass with his fist and pulled the print out of the frame. He crumpled it up and threw it at me. The three of them laughed. They said something in Korean and the one with the shotgun dropped it on the floor while the bald one opened the door. The asshole who'd crumpled Musashi walked behind me and said, "We go now." I followed the other two to the elevator and felt Mr. Yellow Teeth walking behind me.

When we were in the elevator, I suddenly remembered that there was my soju-drinking friend, the security guard, waiting for me at the bottom. I tried to formulate a quick plan while the numbers in the elevators flashed, counting down. At floor fifteen, I figured I only had to worry about the one behind me. At floor fourteen, I remembered that I had no way of knowing whether the other two were armed or not. At floor twelve, I thought, one of them had grabbed my shotgun. At floor eleven, I realized that this didn't mean shit. At floor ten, I decided I needed to take my chances anyway, and just assume that the one behind me was the only one armed. At floor nine, I figured I'd yell "help" right after I turned around and hit the asshole. At floor eight, I scratched the idea of hitting the one behind me, and decided it would be better if I went for his gun. At floor seven, I tried to figure out in what order I'd shoot these mother-fuckers. At floor six, I decided I'd shoot the ones in front of me first, then turn around and save Mr. Yellow Teeth for last. At floor five, I questioned this decision, because, if I had my back to him, I'd be vulnerable. At floor four, I figured it was better to have my back turned on two guys rather that one. At floor three, I suddenly realized that I was thinking about all this killing and I'd never killed before. At floor two, I thought about Claudia, and decided that I wouldn't even hesitate.

When the doors opened on the first floor, I realized that I was fucked, and this whole plan would probably get me killed. When we walked toward the Korean security guard, I knew I was afraid to die and that Claudia had made me afraid because she'd given me something to live for. When we stopped at the guard I looked at his bulldog face, and suddenly I remembered that he was Korean, and it came to me. I was surrounded by Koreans. When I saw the one who had the shotgun put his arm around the guard, I knew the plan would not work. I had to go wherever they were taking me. Before I stepped into the revolving doors of the building's entrance, I said to the guard, "I'll be back for you, mother-fucker."

When we got outside the building, two cars were waiting. One was a charcoal gray Mercedes sedan, the other was a new-looking black Chevy Blazer. I squinted and saw the faint lines of a driver in the Benz, but the Blazer was empty. Mr. Yellow Teeth led me to the Blazer, while the other two stepped toward the Benz. I was put in the back seat of the Blazer, followed by Mr. Yellow Teeth, who sat down beside me. He smiled and his sharp little crooked teeth looked almost canine. After a couple of minutes, the two others stepped into the Blazer. The chubby one with the curly hair sat on the other side of me in the back, while the bald one with the baby mustache went to the driver's seat. I heard the Mercedes engine start, and as it pulled past us, I looked as the red lights became smaller and smaller.

On the long freeway drive in their black Chevy Blazer, the driver in front of me sucked on a cigarette and blew smoke out the window. I sat in the back between the other two, ugly teeth on one side, ugly hair on the other. None of them talked, but the two sitting with me never let their eyes off me. Mr. Yellow Teeth rested his right forearm on his lap, so that the gun in that hand was pointing at me at all times.

I sat there feeling pretty defeated. I stared down in front of me, looking at the plastic compartment which separated the two

front seats. I wondered what was in it. I thought about the moment I had walked through the revolving door at the entrance of the Marco Polo building, how I should have tried to pull something then. Regret and shame were starting to percolate in my mind. I should've stopped the door or something, I should have forced them to react. I thought, fuck, I should've forced them to do something there. I hated myself, my cowardice. I starting thinking there was no way they would've killed me there. It was too public, they risked too much. These guys were working with reason, with their minds sharp and intact, they weren't pissed off or anything. There was no way they'd risk so much on something that could land them, that probably would've landed them in jail for life. I thought hatefully, I'd missed my chance. I should've tried to run while we were in a public place, shit, I can still run fast, I thought.

God, I hated myself then. I felt like I was doomed to die because I was unwilling to chance death, unwilling to risk everything. I thought about Claude, and for a while, stuffed in that Blazer between those two Koreans, I hated her, too. I wouldn't be in this mess, I thought, if she had made me let her leave that night at Black Point. There was no way, I figured, I'd be in this if she had not made me love her. I blamed her for making me soft. Suddenly it wasn't only my cowardice which had prevented me from acting when I should have, but I realized that behind the cowardice hid Claudia herself, hiding there with, yes, two syringe arms of her own, sucking out what my father had put there years before. The regret and shame that was percolating earlier turned into a raging boil. I hated her, myself, Mama-san, and these three Korean fuckers that were taking me someplace far away.

Then I got even deeper into the roots of my hate. Wait a minute, I thought, I wouldn't even have gotten the fucking job with Mama-san if I didn't know how to kick ass. That Samoan would've licked me if I was who I was meant to be. I was meant

to be a regular guy afraid of the water. Suddenly it was easy to add my father to that hate checklist, a list he'd topped for many years anyway. Then I thought, who's next? Shit, Koa, yeah, Koa, if I didn't run with him in Kahaluu, I wouldn't be used to being around big guys and that Samoan would've been so scary-looking to me that I wouldn't even have thought about stepping between him and his appetite for destruction. If it weren't for Koa, I wouldn't have been capable of feeling like a big shot. Shit, that Samoan too, I hated him, too. He should've been able to kick my ass easy.

So for the remainder of that ride into the country, into the remote farming areas of Waimanalo, this was my state of mind. I constructed this huge list of hate. By the time I felt the Blazer stop, things like cancer, swords, Musashi, the artist Otsuka, syringes, heavy bags, all races of men including Japanese, even the invention of the automobile, made the list. Every image I could conceive, I hated.

When the Blazer stopped, and Mr. Yellow Teeth led me out, I looked around and recognized where I was. It was a pig farm. The animal smell and remoteness of the place was my first clue. I looked toward the mountain and saw a huge pen under the moonlight, the biggest I had ever seen. Thousands of pounds of cement blocks and corrugated sheet metal sat under the enormous tin roof. I knew from the drive over that we were miles away from the nearest house. I felt the barrel of a gun press against my back. Mr. Yellow Teeth led me to the pen while the chubby Korean and the bald one, both armed with flashlights, walked in front of me.

There were hundreds of pigs in that pen. Each one was separated by stacked cemented blocks, walls from which rose thick metal poles which held up the tin roof. As we walked through the center aisle, the two men in front of me kicked each of the rusted gates they passed. The pigs were being woken up

and with each kick the collective snorting became louder. I looked into the gates I passed and saw the inter-connected channel system which allowed cleaning water to run through and exit each cage efficiently. Suddenly I wished the water was turned on, wished I was small enough to jump into this canal and drift outside with the rest of the filth.

By the time we got to the front of the pen, the sound of snorting, hungry pigs saturated the air. The Koreans had to talk loudly to each other over the sound. The three of them surrounded me, while Mr. Yellow Teeth never took his eyes off me. The bald one laughed and pointed to the slop cooker. It was a huge pot in the corner of the pen. He said something in Korean and the other two laughed. I had never been so angry in my life. Then a sense of calm hit.

Suddenly the sound of squealing pigs and the laughter of the Koreans was drowned out by the sound of my beating heart. I heard it beat, and it beat strong and fast. I wondered if the three Koreans heard. How couldn't they? I thought. Then, when I felt the barrel of the gun push into my ribs, and I looked at that fucking Korean, *yobo* mother-fucker smiling at me with his fucked-up small yellow teeth, I felt like the most powerful man who'd ever walked the planet. I felt like I had to gain some control over myself or I'd begin to rise above the ground with my throbbing power, unable to exact my revenge on the world. Suddenly I felt myself grow bigger. My power made me bigger, heavier so I would not float away. When I looked at the three Koreans, I began to see children, three kids with a toy gun who pushed me too far. They looked so small. So when I looked at Mr. Yellow Teeth and smiled, I think he saw my power, too. Who couldn't see it. I was a god.

I stood there between the three, in the center of the triangle. Mr. Yellow Teeth said something to the other two, and they began opening the gates of each cage. My arms were crossed in front of

me and I stared at Mr. Yellow Teeth. After several minutes, the two who were letting the pigs loose came back with a herd of pigs following them. Out of the corner of my eye I saw the bald one move in front of me with a lit cigarette dangling from his mouth. The wind blew against the rising smoke, spreading it into nothing. The smell of the pigs was strong, and several of them bumped my legs. The bald one looked at me and flicked his lit cigarette at me. I felt it land in the cradle of my folded arms. I let it rest on my arm, let the cherry burn my flesh. I stared at Mr. Yellow Teeth and felt my mouth work itself into a smile. I continued to let it burn until I finally saw their confidence shatter, until I was sure they saw me, saw my state, saw my godliness. Mr. Yellow Teeth took a step back and tripped over a pig behind him.

The four of us were on all fours scrambling for the gun. I felt like hundreds of pigs were bumping into me as I looked in between all of the hoofs which walked by me. Then I saw it. Underneath one of the white pigs, a flash of nickel appeared. I quickly crawled to it, feeling the rough cement scape my hand and knees. As I grabbed the gun, I felt pig drool fall on the back of my neck. I stood up and waited for the three Koreans to do the same.

Suddenly Mr. Yellow Teeth realized that the gun was in my hand. He slowly stood up and looked for me. He smiled and put both hands up. A few seconds later, the other two stood. They looked at me then Mr. Yellow Teeth. Mr. Yellow Teeth said something in Korean, and all three of them rushed me.

I was Achilles in Aristeia, Musashi in *Void*. "C'mon," I said. I let them take a few long strides, then fired three times. Three heads exploded brains, skull, and blood. They didn't even get two steps close to me.

While the pigs screamed and scattered, I checked their pockets for my money. None of them had it so I took theirs,

maybe about seven hundred dollars. They must've given the money to the driver in the Benz, I thought. As I shuffled through their stuff, taking off their non-digestable belongings, like Mr. Yellow Teeth's thick gold chain, the pigs calmed. I went over each body twice and ended up with a pile stacked with wallets, chains, watches, and belts. I picked the stuff up and headed for the Blazer. Before I left, I waited outside of the pen. After I heard the sound of pigs feeding and the crunching of bones, I threw the pile of stuff on the passenger seat and took off.

I was going to go home, then head to Club Mirage, but the country drive gave me the opportunity to stop by the beach and get rid of the gun, chains, and other stuff. I found a secluded cliff hanging over a channel, and tossed it all over. I watched as the the gun disappeared into the darkness. I decided to take my time getting home. I figured it was Mama-san's turn to wait. Wait and sweat while something she didn't see coming, a divine wind, a Kamikaze, was flying her way.

While on the long drive, I opened the plastic compartment between the two front seats. I looked inside and saw a cellular phone, a flashlight, and a tanto knife. I thought about getting rid of the Blazer, but then I figured there'd be a lot of time for getting rid of the car. I assumed that those three nobodies, those three nameless killers who used to exist in a world that very few knew about, wouldn't be missed for a long time, and this Blazer of theirs wouldn't be missed even longer. I looked down on my burnt forearm and smiled. It throbbed, reminding me that I was alive.

When I got to town, I stopped the Blazer in front of the Marco Polo building. I looked through the window and saw the Korean security guard sitting in his chair, staring at the security cameras in front of him. I pulled the tanto knife out of the compartment and walked toward the revolving doors. When I got to the guard, he looked up. I smiled at him. He just sat there, paralyzed, while I stared at him with my smile. He put his head

down and seemed to wait for whatever I was going to do. My hate, which was not as strong as it was at the Waimanalo pigpen, began to fade even more. I wanted to kill him because to me he deserved to die, but I realized that I wouldn't. He was nothing, sitting there waiting for me to judge his fate. I felt a slight nausea creep into my stomach. His weakness made me sick. Killing him would've been slaughter. I wanted him to get up and fight for his life, but I knew he wouldn't.

It was then I understood why he'd let the Koreans take me, why he'd given Claudia an extra set of keys. He was weak. I looked at him and began to think that such a creature was defenseless prey. I was not a lion, a shark. I did not hunt prey, I hunted predators. This guard was not worth my risk in killing him, I had bigger fish to fry.

I looked down at him. I bent down and put my mouth an inch from his ear. "I'm going to my car now to get something," I said, "I'll be back to get the Blazer I left outside. You just sit here and do what you always do. Nothing. If you touch that phone while I'm gone, you'll die. You touch that fuckin' phone I'll fuckin' kill you. Then after I kill you, I'll find your fuckin' family and kill all of them, too. After that, I'll go straight to the airport, straight to fuckin' Korea, and I'll kill any fuckin' relatives you happen to have there, too. You touch that mother-fuckin' phone, even put your fuckin' finger on it, and I'll fuck your world for life. You understand, mother-fucker?"

He nodded. I saw sweat on the side of his head, I saw his wet sideburns.

"You do nothing, which you like to do anyway, I won't fuckin' do shit to you. After tonight, I'm out of here anyway. But you do one thing that fucks me, I'll never disappear. I'll be the last thing anyone who knows you will ever fuckin' see."

He nodded again. Satisfied, I walked out toward the garage. My words to the security guard had pumped my blood up again,

and this was good because I was desperate to keep my rage high. I walked up to my Porsche and suddenly realized I didn't have my keys. I yelled, "Fuck!" and put my hand through the passenger side window. The alarm blared, echoing in the covered garage. I quickly opened the door, opened the glove compartment, and took out my gun. Suddenly I found myself looking up at my rearview mirror and I saw the Bronze Star hanging. I laughed and grabbed it. It was then that I saw my right hand. The blood was running down my fingers, running across my green, SYN tattoo. The SYN was soon covered in my own blood. I took off my shirt and wrapped it around my hand. I put the Bronze Star in my pocket and walked out of the garage, leaving the blaring alarm behind me.

When I got back to the Blazer, the faint sound of my alarm had finally stopped. I looked through the window and saw the security guard still sitting in his chair, not daring to look up. I started the engine and made my way to Club Mirage.

When I got there, parking was a bitch. Suddenly I had a good idea. I parked the Blazer illegally across the street, knowing it would get towed. I wouldn't have to worry about it after that. I paused before I crossed the street. I heard sirens in the distance. I thought about my plan, and I realized I didn't have one. I tried to let my rage ebb from my mind so I would have room in there to think. Okay, I thought, first I get Claude or find out where she is. Second, I kill that fuckin' Mama-san, and anyone else who's with her. Third, I...Ah, fuck it, I thought, liberating my mind, I'll just let what happens happen.

I walked across the street shirtless, feeling the gun and the Bronze Star I had stuffed in my pocket. I took my blood-soaked shirt off my hand and grabbed my gun. I wrapped both my hand and the gun with the shirt and walked toward the entrance. The bouncers, my ex-coworkers, put their arms out to indicate that I was to stop, but I walked right past them and went through the red velvet curtain.

Prince's *Let's Go Crazy* was playing. The first dancer I saw was Iris and she was busy squirting milk from her breasts at eager customers. I looked at one customer, a young local guy wearing a white Gotcha t-shirt, wiping the milk off his forehead with his fingers. He licked his fingers. I looked at his shirt and saw streaks of wet spots that looked the color of semen under the black lights. I looked back at Iris and smiled. She wasn't smiling. She brushed her strand of white hair out of her face, stopped dancing, and looked away. She must've seen the shirt wrapped around my hand.

I felt a hand wrap around my arm. It was Kaipo, one of the bouncers who followed me from the front door. I put the gun to his stomach and said, "Where's that fuckin' old cunt?"

He looked at me and I knew for a second he thought about it. He looked into my eyes and practically told me he was thinking about trying to be a fucking hero. But then I think he remembered who I was. I was Ken-fuckin'-Hideyoshi, you fuckin' with me, you fuckin' with the best. So after that brief second, he looked down and said, "She's in one of the party rooms."

When I got to the room, I opened the door and saw her sitting in between two men. I looked at them closely and recognized them as the two cops I had seen that first night when I was hired. The night of the crazy Samoan. The Portagee sat on her left, the Japanee sat on her right. Both were out of uniform. I walked through and closed the door with my foot, never taking my eyes off them. I looked at Mama-san and couldn't read any signs of surprise or fear on her face. I looked at the two cops and noticed that they seemed unworried and confident. I lifted my gun and pointed it at Mama-san. She shifted slightly. Then I heard the Portuguese cop say, "Hey, put dat fuckin' gun down."

I ignored him. "Where da fuck is Claudia?"

"She go home," Mama-san said.

"Where?"

"Home, to your apartment."

I looked at the Portagee cop. "You hea dat?" he said, "Now get da fuck outta hea, befo' we trow your Jap ass in jail."

I looked at his Japanese partner. He didn't say anything. I felt my arm getting tired from holding up the gun. The tiredness crept from my arm and started spreading to the rest of my body. I looked at Mama-san again. I began realizing that the paint on her face prevented me from seeing the real woman. It was like a kabuki mask of anger.

"You fuck wit' me again," I said, "I no give a shit if you fuckin' Claude's madda. I goin' fuckin' kill you. She no stay home, I coming right back ova hea, and I goin' fuckin' kill you. So you tink about what you telling me. Cause if I come back, I no kea if you get fuckin' fifty pigs ova hea. I fuckin' kill 'um all."

She smiled. "You fuckin' dirty Japanee. Tink you can just take my daughter."

The Portagee cop jumped off his seat. "I goin' tell you one more time, you get da fuck outta hea you fuckin' Jap or I goin' fuckin' bury your madda-fuckin' ass!"

I looked at him and smiled. "You fuckin' fat fuck, try right now. I no fuckin' kea, I fuckin' kill you right now." I pointed the gun at him. I wanted to shoot him. But I was so tired. I wondered if I even had the strength to pull the trigger.

Suddenly the Japanese cop stood up. "Nuff arready. No worry, she stay at your apartment. But I goin' tell you one ting. When you get to her, both of you betta run. Mama-san disowns both of you, so you betta get out of town. Cause, you get Mama-san on your ass arready, and now you get da cops against you, too. Not only you goin' lose, but your girlfriend might lose, too."

I looked at Mama-san before I left. Her eyes did not avoid me. She hated me and I wanted to kill her. Fuck, I wanted to kill her so bad, but I was so tired. I watched as she sat there, quiet and still. It was like nothing could upset her. She was giving up her

only child, and still she sat there and just ate it. Even though I hated her and wanted to kill her, I still felt an enormous amount of respect for her. This lady saw some even worse shit then me, I thought. I asked her, "Where's my fuckin' money?"

"You pay for Craudia, you pay for my nephew's life," she said.

I wondered which one of the Koreans was her nephew, whether he was the bald one, Mr. Yellow Teeth, or the other one. The knowledge that I had killed Claudia's cousin made me even more tired. I lowered my arm, turned my back to them and opened the door. I felt someone behind me rushing forward, heard the steps, but I didn't turn around. I heard another body crash into the one that had charged me. Japs sticking together. Without looking back, I again closed the door with the heel of my foot, but this time I was walking out and not in.

When I got back to the Marco Polo by cab, I saw Claudia sitting on the curb in front of the building. She was wearing a clean white t-shirt and denim shorts. Suddenly my tiredness evaporated, and I was excited. After I paid the Vietnamese cab driver and turned to the curb, I noticed that she still sat on the curb, unmoved. I sighed and sat down beside her. With her head down she looked at the shirt still wrapped around my hand and touched it. I looked down, and totally forgot that I had never let go of the gun. She looked at her fingers and rubbed her thumb and index finger together. Then she wiped her fingers on her denim shorts. I looked at her feet, which were planted on the asphalt, and noticed that she was barefoot. I put my unsoiled hand on her leg. She leaned her head against my naked shoulder.

I looked out to the street and watched the cars whiz by. It was probably past two in the morning, but cars were always on Kapiolani Boulevard. As each car passed, I suppressed a sudden urge to laugh. "They don't know," I said to myself, "they don't have a fuckin' clue."

As I sat there watching the cars, Claudia climbed on top of me. She sat on my lap facing me, her arms and legs wrapped around me. She squeezed me hard and I squeezed back. I became aware that our bodies began rocking. The movement began to soothe me. I wondered whether I was rocking her, or she me, or whether we were rocking each other.

■ ■ ■

We were woken up the next morning by the sun shining through our bedroom window, and when my eyes opened, I felt Claudia's arms around me. I felt the stickiness which was squeezed together where our flesh touched each other. I looked over to her and saw that her eyes were already open, for how long I didn't know. I looked away and felt the throbbing in my hand. We had bandaged it the night before and I saw that the now reddish-purple dried blood had failed to penetrate completely through the white gauze.

I sat up. She let go. "What time is it?" I asked.

She sat up. "About eleven."

I stood and walked toward the bathroom. I turned on the water in the shower and stepped inside thinking about the night before, wishing that I could tell myself it was a dream. But I knew it was real, it felt real, and if I had any doubt, the throbbing of my hand, the burning of my forearm, combined with the pain the water was now causing, told me it was definitely real. I began to peel my bandage off slowly. I'd learned at an early age that when dressing sticks to a wound, it is better to wet the area first, let the dried blood soak up the water, then the adhesive of blood would dilute. After my hand and bandage were completely wet, I peeled off the last layer of covering. I slowly clenched my fist and was glad to feel that I hadn't broken it. I looked down at my knuckles and saw two big cuts, cuts which probably required stitches. I looked at the burn on my forearm and saw that a

bubble had formed. When I popped the bubble, a clear liquid ran down my arm. A wrinkled layer of dark gray skin remained. More scars, I thought, more scars. I ran the water over my hand and, after a while, the pain began to numb.

Claudia entered the bathroom and stepped behind me in the shower. She picked up a bar of soap and rubbed the bar into a wash cloth. She began to wash my back. "So, what do we do now?" she asked.

I thought about this for a moment. I knew we had to get out of town. I thought about other places we could live on the island and suddenly I began to feel tired again. Without turning around, I said, "I don't know, but we gotta get out of town. It's not safe for us here."

I felt her scrub the small of my back. "I know. We gotta get out of here. I was thinking, maybe we should get really far away and start over. You know, no family, but our own. What about the mainland?"

I cringed. There was no way I was going to the fucking mainland. Fucking wall-to-wall haoles there, the rat race, a world filled with people I couldn't relate to. I turned around, grabbing the soap and cloth away from her. I told her to turn around and began washing her back. "C'mon Claude, you know I couldn't survive up there. Fuck, up there they expect their Asians to be docile. How many haole asses would I have to kick before I got any respect up there?"

Without turning around, she said, "Well, I don't know what else to do. I mean, at least up there I could do a PhD or something. And we'd be far away from all of this. To me it seems like the only option."

I put an extra coat of soap on her shoulders. "I don't know. For me, I'd rather we stay in Hawai'i. Here, I'm somebody; here, I'm respected. Up there, I'm just a Jap. Besides, I don't have the money anymore to send you to school. And what kind of job

would I get there? I don't have a degree. I'm telling you, if I go up there, they'll make me invisible. I read about how they make people invisible up there. I'll be invisible and I won't like it."

She turned around and grabbed the soap and cloth from me. She lathered up the cloth and began scrubbing my chest. "I don't know," she said, "I thought maybe being invisible would be good for us for a while. Besides, what kind of job can you get here?"

"I can get a job. Here, I know people. Up there, with the haoles, shit, they'll treat me like a damn peasant, and give me a job to match. Treated with that kind of disrespect, I'll probably go off like those post office guys up there do all the time."

"And you're not going off here? And stop saying 'haole,' like it's a bad word. Remember, I'm half haole."

"Yeah, but not by your mother's choice."

At that I felt her suddenly scrub hard underneath my belly button. I grabbed the soap and cloth from her and said, "Hey, watch it down there." I lathered up the cloth and began scrubbing her chest and arms.

She tried to convince me that the mainland was the only choice, and I was determined to fight her on it. Suddenly, I came up with an idea that would kind of solve our problems. It would be a compromise, and I thought carefully before I pitched it. "Okay, this might sound a little wild, but let me finish before you say anything." She nodded. "Okay, let's go and stay in Ka'a'awa for a while. I figure we can stay with my father rent-free, we could work and save money, then as soon as we have enough, we can take the first flight to the mainland."

I looked at her and she frowned. "I thought you hated your father? Why would you want to go back there?"

She was right, I still hated him. But I figured if she was so hot on the idea of going to the mainland, I'd need a good amount of money before we went. I didn't want to scrounge up there. If I was going, I wanted at least to have some power, some assurance

that they wouldn't be able to treat me the way they'd treated my mother. Also, if Claude was going to convince me to leave, I wanted a chance to spend time in the country, so I'd have a chance to say good-bye. Besides, I was an adult and I figured there was no way my father could abuse me any more. The times I had talked to him on the phone, he seemed to speak to me with respect. Suddenly the idea sounded really good to me. I figured, what could the old man do to me now? I was grown up. And if he did do anything, it would give me a chance to do what I'd wanted to do for years. I'd beat his fucking ass. Then I started thinking about Koa, and how much I missed seeing him around. Yeah, I began thinking, yeah, let's go to Ka'a'awa.

While scrubbing her stomach I said, "Listen, if we go to the mainland, there's no guarantee we can get jobs. We need jobs. We need the medical. How else are we going to pay to have this baby? I figure I can work with my father in construction. Get a job immediately. It's bus' ass, but good money, and the baby will be taken care of. I figure we stay until the baby can travel. Make money, then bam! We get off this rock."

She stopped my scrubbing hands with hers. "Your mind is set then?" she asked.

I nodded.

"Well, promise me you'll stay out of trouble when we're down there. Promise me that nothing will happen between you and your father. Promise me that we won't get stuck there."

I shrugged my shoulders. "Yeah, yeah, I promise. Don't worry, there's no way I'll let us get stuck there. I don't want to be stuck there."

And I meant it. I didn't want to be stuck there, I just wanted to spend time there so I could kiss the Windward side good-bye forever. So we washed the rest of each other's body in almost silence. We only heard the streams of water strike the tub below. It was a good quiet for me. I thought about going

back over the Koolaus and began feeling anxious. I wondered what Koa and Kahala were up to, I wondered what my father and the rest of the boyz, like Freddie, were up to. We were going over the mountains, going to my territory. Mama-san could not reach me there, not with her lackeys, not even with her town cops. If she tried, her soldiers would get stomped. Her kingdom ended at the foot of the mountains, and beyond this she had no jurisdiction. We'd be safe there, I thought, there was no way she could touch us.

As I scrubbed between Claudia's toes, I suddenly realized that she hadn't asked me about last night. I was glad. I began to realize why my father and grandfather had never told me what I wanted to hear about war, about killing. You just don't feel like talking about that stuff. It's ugly and boastful. You tell people that you've killed and you start feeling like a criminal even if you were innocent. It was great of Claude not to ask. And as I scrubbed the last of her toes, the love I felt for her was even more powerful. I'd do anything for her.

✥　✥　✥

One day later, we had everything packed and loaded into my new Nissan Pathfinder. I had traded in my Porsche to get some extra money since I had lost what was hidden in my books. In fact I'd sold those books, too, because since that night with the Koreans, I had really lost my desire to read. I think I got like two hundred dollars for over a hundred books at Jelly's. Evidently, they weren't worth shit. Anyway, Claude and I were packed to go and, ironically, I was about to travel down the Pali with nine thousand dollars in my pocket.

So the black Pathfinder was packed and ready to go. I was anxious to leave. I was surprised how easy it was to tell my father that I wanted to come back. He seemed enthusiastic about it and

guaranteed that he'd get me a job. When I told him that he'd be a grandfather, he sounded happy.

I looked through our things. It didn't look like we'd left anything behind. I even brought Musashi with me. Against Claude's wishes, I had picked up the crumpled print and tried to smooth it out. It was permanently wrinkled, but I had him re-framed anyway. I didn't know where I was going to put him, if I was going to hang him up at all. I knew my father would've probably liked the print if it wasn't wrinkled, but because it was, I didn't think it would fly with him to hang it over the swords or something. I stepped back from the Pathfinder and looked to see if everything appeared secure. On the roof sat our queen-sized bed and two longboards. I checked the rope. I looked toward the apartment and saw Claudia walking into the revolving door.

When she came out, she was carrying my shotgun. I laughed at the sight as she walked slowly toward me, acting like a commando or something. She looked like one of those girls in one of those cheesy B-action movies. She put the shotgun in the back and went to sit in the driver's side. I laughed and went to the passenger side. She started the engine. "Okay, tell me where to go."

So we drove down the Pali. There was no rain that afternoon, but as I looked toward the mountains, I saw waterfalls brushed on the green mountains. She took the tunnels and a bright sun greeted us. I squinted and put my hand up to shade my face, thinking about my other trips on the Pali. I remembered wondering as a child whether my mother's spirit lived here. I remembered laughing at the idea as a teenager after my surfboard had launched off my roof. I looked over at Claudia. She was looking over the cliffs. "This might be cool," she said. "I always thought the Windward side was one of the nicest places on the island."

"Yeah," I told her. "When I lived here, me and my friends used to call it 'God's country.'"

"I thought you don't really believe in God."

I shrugged. The hairpin turn sling–shotted us toward the bottom. We rolled down the steep pour of asphalt, and I heard the wind whistle against the Pathfinder, trying to blow us back up.

<p style="text-align:center">✛ ✛ ✛</p>

Ken stood up and rubbed his eyes. Cal shook his head. Why had Ken feared the mainland so much? It was an irrational fear, probably motivated by reading old books by dead black writers and the hate he felt for white people in general. Cal rubbed the swastika tattoo on his forearm. If Ken had gone to the mainland, he probably wouldn't be here, Cal thought.

Ken walked to the stainless steel mirror and turned his back to it. He tried to look over his shoulder to see the reflection of the tattoo. "I hate these fuckin' mirrors," Ken said. "You can't even fuckin' see your reflection in them."

Cal tried to imagine what Claudia looked like. Putting together her Korean and Caucasian blood was like trying to put together a jigsaw puzzle. He tried to put Asian eyes with a big haole nose. Then he tried to put haole eyes with long, black Asian hair. He had seen hapa girls before, but it had been a while. This is stupid, Cal thought, what the fuck is a big haole nose or long Asian hair anyway?

Giving up on the puzzle, he looked at Ken. Fucking murdering mother-fucker. Three Koreans dead. Japs killing Koreans, just like before the war. It had made Cal nervous that Ken was discussing his unsolved acts of murder knowing that Tavares was listening. He wondered if Ken cared. He wondered if he would've killed, too. He probably would've, he thought, because if those guys were left alive, they would've come back after him. But then, he didn't know if he would've had the strength. He wondered if he would've had the hate to kill three, which was two more than his one.

He remembered the night he'd found out his wife had been sleeping with some waiter in Waikiki. Her sister, who she didn't get along with, told him over the phone. "Now don't over-react, Matt. But the whole family knows about it."

His pride was destroyed. The intense love he felt for her melted to hate. He went straight to a bar, then four hours later staggered home. He didn't plan to kill her, just kick her out of the goddamn apartment. When he got home, the kids were sleeping and she was sitting on the sofa watching T.V. "Hi, honey," she said.

Hi honey. These were the words that made him snap. The fuckin' audacity, the fuckin' hypocrisy. Cal raised his fist and smashed it down on her nose. She stood up and tried to hit him back. Cal grabbed a fistful of her black hair, dragged her to the balcony, and slammed her forehead on the metal railing. Her legs collapsed, then he pulled her up. Instead of screaming, she clamped her teeth down on his neck. He screamed and shoved her away. The small of her back hit the railing and she flipped over it. Half-gainer onto Kuhio Avenue.

When the kids came out, he turned around. "Where's Mom?" his daughter asked. Suddenly he realized he'd never even told her why he had hit her. He didn't even give her a chance to tell her side. He walked past his kids and to the bathroom. He splashed water on his face, then looked up into the mirror. He saw his father staring back at him. Cal had puked in the sink.

Ken sat back down in front of Cal. Cal looked at the kanji on Ken's back. He'd finished coloring in the big symbol and outlining the smaller, vertical symbols on the left. He only had to color those in to be finished. He wiped off the blood and ink. Cal managed to give the symbols an authentic, brushed-on look. It seemed to be coming out real nice. "Well, looks like we're on the home stretch," Ken said.

Cal was glad that Claudia was coming to visit Ken the day after tomorrow. It meant that he didn't kill her. But Cal also knew Ken wasn't in prison for killing the Koreans. If he had been, he would've probably been a lifer. Who did Ken kill? He knew Ken was doing time for manslaughter. Cal tapped Ken on the shoulder. Ken turned around, but Cal couldn't ask him. Instead, Cal waved forward.

"Thanks, man," Ken said, "Thanks. Nu'u was right. You're just a fuckin' master Freud, silent style."

Cal smiled, wondering what Ken thought the wave meant.

"Listen," Ken said. "let's get some sleep. When Claude and the kid come the day after tomorrow, I don't want to look bad. I haven't seen them yet. Let's get some sleep and take it easy tomorrow."

Cal was relieved. After he put away his gun, he curled up in the fetal position on the top bunk and fell asleep.

■ ■ ■

An hour later, as the sun rose, Cal awoke in a mute scream. He wet his palms with the sweat and tears on his face. He then wondered how long he was screaming. He could've been screaming for hours, and nobody would've known. He felt like such a rookie.

He threw his blanket to the ground and stepped off the top bunk. The sleeping Ken didn't flinch. No dreams for him tonight. Cal thought about his own dream and realized it was the first time it had happened to him in years. He'd dreamt about his wife's funeral. It was a funeral he'd never had the opportunity to attend. His kids were there, his son dressed in a black suit two sizes too big for him. His daughter was licking one of those enormous swirl lollipops, which she'd loved, but she was crying at the same time. Cal walked to the casket, sad that his wife had died, but happy no one could see him because he wasn't there in body. Just as he was about to look into the casket, a familiar voice rose from the back.

It was himself. It was himself and his father in the same body, dressed in a tuxedo that didn't seem to fit. The figure had a voice. "That's my boy," he said. "That's my boy. Don't let any bitch fuck around on you, son. You fuckin' kill her if it happens. That's my boy."

Just before he'd woken up, his children were about to look at him. That's probably what made him scream.

Cal walked to the faucet and ran water on his face. He tried looking into the dull, stainless steel mirror, and realized Ken had been right. You can't see yourself in these mirrors. After a while in prison, your self becomes only what you carry in your head. Ken knew it, and Cal was forgetting it. Ken's stories, his blues, were reminding Cal of his own.

The dreams, the dreams of a rookie were back. The dreams of guilt, the dreams of pain, the dreams of life outside the walls. The dreams that ended in screams. Cal didn't know how to feel about this. At first he was sad, because he'd tried, over the years, so hard to forget. He'd been content with being an animal, a silent mouse among cats, during his imprisonment. So part of him hated that Ken was making him feel human again. He didn't want to feel human, because he knew he'd been a bad human. But on the other hand, guilt was refreshing. Emotion was refreshing. But he knew he had to control it. These things led to dillusions of grandeur, of hoping to make right what had gone wrong. They were dangerous thoughts for a prisoner to meddle with. Cal climbed back on his bunk and told himself he was dead to his children and this was best. He didn't fall asleep until the sun started to rise.

It was one of those nights of sleep that felt like you just closed your eyes and it was time to get up already. It was time for breakfast, and Cal was exhausted. But the smell that woke him up was not brewing coffee or frying bacon, it was the smell of prison that Cal's nose perked to in the morning. The smell of unwashed beddings, the smell of two men, he and Ken, who hadn't taken a shower in two days.

Ken stood up and walked to the toilet to piss. The smell of piss and body odor opened Cal's eyes wider. Ken flushed the toilet and raised his right arm. He put his nose in his armpit. "Damn, it's time to shower."

Cal planned to take one too, after breakfast. Even though he was tired, he felt like having a productive day. And one of the only productive things you could do in high security was clean yourself. He envied the prisoners assigned to kitchen duty. He envied any prisoner who got to work for pennies an hour. It was funny, most of the felons in Halawa had avoided regular work on the outside for most of their lives. But in prison, work was a privilege. It wasn't that the work wasn't monotonous, it definitely was. But in prison, two monotonies were better than one. Cal got off his bunk and waited with Ken for the buzz of the door.

It was immediately evident in the cafeteria. Nu'u had lost the power. He was still avoided by the inmates of Quad Two, but it was Ken who the

guys like Johnny, Sean, and Geronimo made a special effort to walk around. It was now Nu'u's move. Did he want to try and take the power back?

Cal sat with Ken wondering if Nu'u would make his move. When Nu'u didn't come and take some of Cal's breakfast, Cal knew that Nu'u was scared. He smiled. As cellmate and friend of Ken, he was in protective-protective custody.

Ken looked up from his food and caught Cal's smile. "It's easier in high security," he said. "In middle, I had to fight for my life. I mean, I know it must've been no picnic for you being the only neo-Nazi down the hill, but being Japanese wasn't the greatest thing either. Hawaiians run the show."

Cal nodded. He remembered the first time he'd gotten beaten in prison. He picked up the T.V. Guide, and that was it. The beating of his life, three-on-one. No, being a supposed neo-Nazi in Halawa hadn't been fun. He hoped Ken hadn't had similiar experiences.

"Sometimes," Ken said, "I think losing some of those fights would've been smarter. I felt like fuckin' Jeremiah Johnson down there."

Cal smiled. He liked that Redford pic. Cal reached inside his oatmeal, but remembered that there were no cigarettes for him today.

Ken noticed. "So how do you get your cash in high security?"

Cal shrugged. He didn't really know how cash flowed in from the outside. He'd never gotten cash directly from the outside. He was paid for doing tattoo work. Sometimes cash, sometimes drugs, sometimes cigarettes. He usually traded in the second two for cash. He suspected that some inmates got their stuff from guards or other employees of the state. But Cal wasn't the guy with the connections. He only knew one guy from the kitchen who over-charged him for cigarettes. And Cal was running out of money fast. He'd been splurging the last couple of days.

"Man, in middle security, it was easy," Ken said. "There was everything inside. Everything was for barter. And visitors could bring you stuff. Clothes, smokes. Uncle James would bring me stuff. I have to start a whole new deal in here."

After breakfast, Cal and Ken went back to their cell. Ken decided that they wouldn't work on the tattoo until that night. Cal suspected that

he was waiting for Tavares to be at work. Tavares was off today, which meant he might be working the graveyard. Cal guess that Ken wanted Tavares to hear the entire story.

Ken brushed his long hair. He shaved and brushed his teeth. When lockdown was over, he was the first in the shower. Cal felt vulnerable sitting out in the quad, without Ken by his side. But there was only one small shower stall for each quad, so all he could do was wait. He kept his eye on Nu'u, who seemed unaffected by the power shift. He was as loud as ever. This time he was playing dominoes with Geronimo, jeering everytime he won.

Cal wondered what he would do if Nu'u made a move for Ken. He couldn't warn Ken vocally, so the only thing he could do was try to slow the big Samoan down and hope Ken would respond quickly. When Ken finally got out of the shower, Cal was relieved. It was his turn and nobody suggested otherwise.

When Cal came out of the stall a clean man, the stench of the prison seemed worse. Many prisoners showered only a couple times a week, and some even less. Sometimes it would get so bad that the guards would have to force them to bathe. After all, none of these guys were going to a prom anytime soon. The smell was so bad that Cal imagined a mist coming from some of the prisoners, like that skunk from the Looney Tunes. He quickly walked to his cell and got dressed. He brushed his teeth two times and brushed his balding head.

So another day ticked by. It was a good tick for Cal, the first good one in years. It was a day where Cal started feeling half-human again. It was time to finish the tattoo.

Ken sat in front of Cal. His back was a series of welts and scabs from the thousands of little black blood wounds. Cal got the gun buzzing and checked to make sure he still had enough ink. He did. Ken cleared his throat and began to speak. It was time for the final chapter.

chapter four

"Wind's gonna blow so I'm gonna go
Down on the road again.
Starting where the mountains left me,
I'm back where I began."

Waimanalo Blues
Country Comfort

SUPERNOVA

*I*t's funny, when you're running in Hawai'i, there's no border you can cross, no life-line of safety. You're on an island, and you end up running in circles, surrounded by the largest ocean in the world. It's like you're locked into a ferris wheel that never stops, or you start feeling like that mechanical rabbit they have at dog races. Sooner or later the dogs catch you and all hell breaks loose. I understand why Claudia wanted to go to the mainland. It's like she'd said that first day we went surfing. For her the ocean was escape, it was a place of endless possibilities. For me, however, the ocean had always been a visible void. Living on an island all my life, I was always conscious that it existed, that it was there, that no matter where I'd go, I'd come face to face with it. The ocean was all around me, it fenced me in. It was a fence I'd often like to climb, and I'd do so every time I surfed or dived. But to go beyond the fence? It seemed ridiculous. To paddle a surfboard out toward the horizon, to venture so far that I would not be able to paddle back, the ocean was not a place of possibilities for me, it was a place of recklessness. That's probably why I liked it so much. Going out into the sea was always surfing. Tempting the ocean to break you, letting the waves chase you. It was a game. But for me, paddling out to the horizon was no game, it was suicide. Where Claude saw life way out there, I didn't.

We were moving to the Windward side. Claude drove us on Kamehameha Highway, where its two lanes pushed traffic in

opposite directions at dangerous speeds. Kam Highway had always been famous for its accidents. There were always collisions, and most of the time death was involved. We drove along the coastline. I saw the blue waters turn shit-brown. I smiled. Home, I thought.

A couple of minutes later, I looked out the window and saw Puana Castle sitting on top of its hill. I pointed my finger up toward it and told Claude, "That's where Koa used to live."

She looked up. "Where does he live now?"

"Waiahole."

"When's the last time you saw him?"

"Jeez, I don't even know. The wedding, I think. No, I saw him once or twice after that. He drove into town a couple of times and we went drinking."

"You must miss him," she said.

"Tomorrow, after we finish unpacking, I'll call him."

She nodded. She seemed distant, like she had other things on her mind. I figured she was nervous about meeting my father. When we passed Waiahole, and the water turned blue again, my eyes were drawn to Chinaman's Hat. I remembered passing it that day my father had brought me home after I stayed with my grandfather for a couple of months. I remembered seeing it the day my father had picked me up from Koa's house, that week after he beat the shit out of me. I realized that once again I was being brought home, and that every time I had returned, my eyes never could resist Chinaman's Hat.

It never looked like a hat to me. It had always looked more like a neanderthal's head rising from the ocean. It was rocky, hard. It was covered sparsely with green vegetation. Near the top, the rocks formed a brow. Below this brow, there was an indention, a space for deep-set eyes. The island had no chin, instead the neck swept outward, like the neck of a heavyweight boxer. The immovable sculpture ended at the tip of the shoulders. You couldn't tell from the distance of the highway that there was an underwater

cliff behind the island. It was a cliff known to be a favored place for sharks, it was a cliff where the Bay became a vast ocean.

A few minutes after we had passed Chinaman's Hat, I told Claudia which driveway to pull in. She pulled up behind my father's truck. I told her to honk the horn. After she pressed on the steering wheel, my father stepped out from the screen door. He looked older. A little more gray on the sides. The skin under his chin was loose. He walked with a slight limp and smiled.

When Claude turned off the engine, I stepped out of the Pathfinder and walked up to my father. He stuck out his hand. I shook it. "So what, stranga," he said, "I guess town was too tough, ah?"

"Nah," I said. "I just missed home."

"Yeah, right."

Claudia walked toward us. She smiled at my father, then kissed him on the cheek. "Hi, Mr. Hideyoshi," she said. "Thanks so much for letting us stay for a while."

"Ah, no worry. Dis my son. You goin' have my grandchild. You guys family. Das da style down dis side, family take care of family."

She thanked him again and the three of us stood there wondering what we should do next. Claude broke the silence. "I guess we should start putting this stuff in the house."

My father nodded. "Yeah, das one good idea. I help you guys."

When Claudia walked to the truck and began unloading things from the back, my father smiled at me. "Now I know why you went town," he said. "You neva like da medakas on dis side, so you went town and got one swordtail."

I laughed. The image of medakas, the plain, gray guppies which inhabited the mountain streams, popped into my mind. I pictured a big school swimming against the current, not moving forward, but just propelling themselves enough so they wouldn't get swept further downstream. Then I imagined a brilliant red

swordtail swimming into a school of them. The long sliver of its tail moved like a snake. The medakas stopped their effort and let the down-pouring water push them away. I looked back at Claude. She was a swordtail.

■ ■ ■

We got everything in by sundown. Afterwards, the three of us sat outside on the picnic table, our faces lighted by a Coleman lantern. I looked down at the cooler. The white lid read Hideyoshi in faded gray letters. My father was drinking his J&B, I was having a Miller Lite, and Claude was sipping a Diet Coke. My father told Claudia stories about me when I was young, how I'd gotten picked on in school. We all laughed. He told her about Koa, how Koa and I had always gotten into trouble. I looked over at Claude and couldn't tell if she was really having a good time or if she was just faking it out of politeness. After he told her about the time Koa and I had been arrested in Kailua, how he had to pick me up from the police station, I asked, "So how is Koa?"

It took him a few seconds to start. "Not bad," he said. "Not good eida. He jus' got laid off couple months ago. I got him one job afta you left. He was working wit' me. He was good too. Fucka was working, he was going church."

I laughed. "Koa was going church?"

"Yeah," he said. "You heard of 'Hope Chapel'? Fucka was going couple times a week. He used to tell me at work, 'C'mon, Uncle, come church wit' me, maybe you not going be as mean if you go church.' I used to laugh. I'd tell him, 'Eh, I like being mean.' We'd both laugh. He knew church wasn't for me, but I tink he was jus' asking to harass me. You know him, always making trouble wit' me. But yeah, dat guy, he was going church wit' Kahala and his son. He was working. He had couple more kids. He was putting in ova-time. Den all of a sudden, da fucka neva show up fo' work. Was one big project, too. We was putting

on one addition on one hotel in Waikiki. Fo' one week he neva show, neva call. Afta dat, Hayashi had fo' fire him."

I took a gulp of my beer. "What happened?"

My father sighed. "I don't know. He come by, once in a while, have couple beers wit' me. One time I asked him. He just said, 'Shitty, work.' I neva say anyting. I figured, he know what he doing. I taut, maybe he get one betta job lined up. But fo' couple months now, he neva work. I tell him, 'Eh, you betta get one fuckin' job, you get one wife, kids, family depending on you.' He jus' tell me, 'No worry, Uncle, I get 'um.' I don't know what he doing, but tomorrow maybe you should call him."

I nodded. "I'll call him tomorrow."

I looked over at Claude and she seemed to be just soaking all of it in. My father stood up and walked toward the house to mix himself another drink. I looked across the street at the beach. The unlit water was black with white surf washing the shore. I leaned toward Claudia. "How do you like the view?"

"It's dark," she said. "I can't really tell if I like it yet."

As she said it, my father walked out of the house with his re-filled drink. He limped toward the bench while a little bit of J&B spilled over the rim of his plastic cup.

Claude and I went to bed an hour later. She stood up to turn off the light. I heard her cautious return to bed. She was in an unfamiliar room. When she finally got back, she said, "Damn, I guess I'm in the country."

"What do you think?"

"I don't know, I'm still feeling it out. Do you guys talk about anything else except working and fighting?"

"Yeah, we talk about fishing and hunting, too."

"You're joking, right?"

"Of course. We also like expressing our feminine sides. You know, my father can go on and on about his feelings, about how sometimes he feels a lack of tenderness in his life."

Claude hit me with a pillow.

When we woke up the next morning, my father had already left for work. I got out of bed and cooked breakfast. I heard Claudia run to the bathroom. Morning sickness. When she got out, she looked at the food and ran back into the bathroom. I laughed. She skipped breakfast.

After I ate, I decided to give Koa a call. As Claude dragged herself toward the television, Kahala answered the phone. "Ken," she screamed, "oh my God, I haven't seen you for so long. How are you?"

I told her I was fine. I told her I had moved back, I told her about Claudia. I asked her how she was doing.

"Not so good," she said. "Having all these babies was hard on my body. Jeez, when you see me, you probably won't even recognize me."

I told her I was sure she still looked as great as ever.

She kept denying it. "No, no. I look like an old lady, like a mom. I'm always chasing these kids around. Besides Koa's not much help. Did you hear? He's not working. I don't know what I'm going to do. I think he's hanging out with Freddie again. Sometimes he doesn't come home at night. Ken, you don't know how many times I felt like calling you, you know, calling you for that ticket, that escape ticket. But I always figured you were busy with your own life. Besides, I know you offered me a ticket, but you never did say whether I could bring kids, too. The thought of my three kids hanging all over you, I knew you wouldn't want that."

She was rambling. She was acting like she hadn't spoken with anybody for weeks. I had forgotten all about that night at the graduation party. I forgot that I had told her I'd help her out if things got too rough for her. I shook my head. I had been drunk that night. I couldn't believe she remembered what I had offered, that she took it so seriously. "Yeah, it would've been hard," I said.

"Hey," she asked, "when are you going to come over to visit?"

"Hopefully today. Give the phone to Koa, I'll work something out with him."

"He's sleeping, but hold on, let me wake him up."

I heard the soft sound of her feet running. I heard her say, "Koa, Koa, wake up."

I listened to the soft sound of Koa swearing at his wife. I heard my name. Then the soft sounds were broken by Koa's booming voice. "Ken, you fucka! What you doing? Where you stay?"

I told him about my return. "Stay ova dea," he said. "I coming right ova."

"Nah, I go come ova dea. I like you meet my girlfriend Claudia."

He was quiet for a few seconds. Then he said, "Nah, I come ova dea."

"Nah, I go drive. Plus I like see your kids, too. More easy if I drive. Only get me and Claudia."

"O.k., o.k., I give you da directions."

When Claude and I drove into Waiahole, she seemed to enjoy the sights. "Wow," she said, "it's so beautiful here. Maybe this is God's country."

I looked out the window. The only things I saw were broken-down houses in mosquito-rich country. "Do you really think it's that nice here?" I asked.

"Yeah, it's so green. It's like anything can grow here."

I couldn't believe she couldn't see the ugliness, the unpaved roads, the rusted-out cars, the old wooden houses. She was blind to the poverty that hid in this jungle. I followed the directions that Koa gave me and was led to a dusty, gravel driveway which was marked by a mailbox with rusted holes in it. It amazed me how fast the salt air corroded it. The box was held up by a wooden pole. The pole leaned to the left. I tried to read the painted

numbers on the box, but they were too faded. It didn't look like the mailbox would be standing for much longer.

When I first saw the house, I figured Claude would change her mind about the beauty of this area. It was more like a shack than a house. Half of the house was built with unpainted wooden planks, the other half was a skeleton. The unfinished half looked like it should have been three more rooms, instead it was a series of wooden beams, roofed with shingles, but without walls. The hollow space was occupied by a picnic table. The house was surrounded by a field of wild California grass. The long, thick stalks of grass stood at least three to four feet high. It was as if the house would be buried by the invading grass within a month.

At least the driveway was clear. A path of gravel led to the house. But even on the driveway I could see the grass struggling to grow from beneath the rocks. There were patches of grass between the tire marks. I looked over to Claude. She looked back at me. "When did they start building?" she asked.

"Like five years ago."

Just then two children came running out of the California grass. They appeared on the driveway about ten feet in front of me. I stopped the truck. The older one, the boy, fearlessly looked through the windshield. He looked like a Puana, only he wore Kahala's thinness. He was shirtless and his shorts drooped down his skinny waist so that the waistband of his briefs was visible. The younger child was a girl, shorter and fatter than her brother. She also looked into the windshield, but her look was more inquisitive. She was wearing stained, lavender corduroy pants and a red, long-sleeved cotton shirt. Both were barefoot. After standing still for a few seconds, they ran toward the house. Their feet scurried across the sharp gravel and they left a dust trail. I looked over at Claude. Without looking at me, she said, "More than anything else right now, I want to take a washcloth to those kids."

I smiled. She seemed to be getting it.

I parked behind the Puanas' blue Ford truck. There were three bumper stickers on it. One read, *Hope Chapel* in blue letters. The second one, *Keep Da Country Country*. And the last one, in rainbow letters, *There's No Hope in Dope*. Claude and I stepped out of the Pathfinder and we were greeted by the smiling face of Kahala Puana.

She had exaggerated on the phone. She did not look bad at all. In fact, in a way she looked better. Her body was still the same, thin, waifish. But her face looked more mature. It held sharper features. I looked at those green eyes which she was famous for in high school and they seemed less playful and more interesting. She ran up to me and kissed me on the cheek. Then she did the same to Claudia. At that moment they looked almost like sisters. They were both thin and about the same height. They were both tanned. And both had that hapa look. Though Kahala's hair was brown and Claude's black, and Kahala's eyes were green, while Claude's were brown, I don't know what it was, but to me, for an instant, they looked like two swordtails, like two sisters. Evidently, country living hadn't beaten all of the Ahuimanu upper-middle class out of Kahala yet. After Kahala kissed Claude, I noticed that she still hung on to Claude's hand. Kahala looked at me. "It's been so long," she said.

I smiled. "Yeah, about five years."

Kahala looked at Claude. "So how long are you guys staying down this side?"

Claudia looked over to me. "Oh, I don't know. Until we get enough money to move to the mainland."

Kahala laughed and let go of Claude's hand. "Wow, Ken, planning to step up in the world? First town, now the mainland." She looked back at Claude. "In high school, you should have seen, he was so smart."

Claude looked at me. "Yeah, he's a regular smart-ass."

We all laughed. "Where's the Hawaiian?" I asked.

Kahala sighed. "Still sleeping. He didn't come home till about four in the morning last night."

Just then the house door opened. "Hey, neva mind talking shit about me behind my back." It was Koa. He threw me a cold beer and waved us into the house.

"It's fuckin' eleven in the morning," I said. "You must be outta your mind if you think I going drink dis beer now."

He laughed. "Why, you one fuckin' townie now? Rememba you stay country. On dis side get no such ting as too early." I cracked open the beer and followed him into the house.

The four of us ended up sitting on the picnic table on the skeleton side of the house. I sipped my beer and looked at Koa. He had changed. His hair was longer, especially in the back, where a rubberband held a big bush of it together. He had a goatee, which made him look even meaner. But the biggest change was in his body. He was even larger, maybe even larger than his father. He must've passed the three-hundred- pound mark. I looked down at his forearm, which rested on the table, and I saw that he had a new tattoo. His entire right forearm was covered with a black, triangular pattern. It was a Hawaiian tattoo pattern. I looked at his enormous hand and saw it wrapped around his beer can. I looked at his SYN tattoo and noticed it was faded, but not sour-green like mine. He didn't look like the same guy who graduated with me. It was like those flower leis which covered his neck on graduation day died and wrapped around even tighter.

"So what, you fat shit," I asked, "how much you weigh now?"

"Shit, look at you," he said, "all pumped up from da weights. Hah, pretty boy. You see dis here." He rubbed his stomach. "You see, real men have bellies."

Kahala playfully slapped his stomach. "Yeah, you should see, Ken. The last time I was pregnant, he was still more fat than me."

I felt Claude's silence. When I looked over to her, I noticed she was pre-occupied with something by her legs. I looked closer and saw a swarm of mosquitoes circling her calves. "Hey Koa," I asked, "you no more mosquito punk?"

"Oh, I'm sorry," Kahala said, "let me get one."

Koa smiled. He looked at Claude. "You know why da mosquitoes biting you? Fresh blood, das why. Like you get haole blood. Shit, Ken was gone fo' so long, da mosquitoes probably biting him, too."

Just as he said it, I became conscious of mosquitoes buzzing around my legs, too. I took down a gulp of beer and tried my best to ignore it.

Koa laughed again. "No try fool me, you Japanee fucka." He looked at Claude. "You should've seen, young kid time when I used to take him surfing. Dis guy was always pretending he not scared of sharks. And he taut he was fooling me. But I used to catch him looking ova his shoulda. Shit, I neva even like surfing dat much, but was worth taking him out jus' fo' watch dat fucka pretend."

I looked at Claude to see if she caught the story. But she was still pre-occupied with the mosquitoes. They must've really been going after her. I grabbed her hand and held it. Just then Kahala walked out with a lit mosquito punk. I saw the tip of the green coil glowing orange. Kahala bent down by Claude's feet. She put down the punk. "The mosquitoes used to really go after me at first, too," Kahala said.

"Thank you," Claudia said.

We talked all afternoon. Koa called out his kids and introduced them. The oldest, the boy, was named James, after Koa's father. The second oldest, the chubby girl, was named Ariel. Both politely greeted us and ran off. Kahala told us their youngest, a baby boy named Kealii, was staying with Koa's parents for a while. Throughout the conversation, I pitied, but was also amused

by Claude. She sat there, trying not to scratch her mosquito bites while trying to pay attention to the conversation at the same time. After the mosquitoes were chased away by the mosquito punk, the smoke began irritating Claude's sinuses. Every so often she'd sneeze and pull a tissue out of her purse.

Finally, when the sky's lightness began to dull, and I was drunk off my ass, Koa asked the inevitable question. "So why da fuck you moved back here anyway?"

I looked over at Claude. She was silent. I was wondering if she wanted to hear me tell the story, wondering if she wanted to hear the details of the night I killed at the pig farm. And for the first time, I wanted to tell it. I was drunk and began feeling proud of what I did. But something kept me from telling it. Instead I told them, "We were kicked out."

Koa sighed, not satisfied with the answer. "What about you," I asked. "What happened to you? How come you got fired from work?"

"Cause I neva show." He paused, then said, "Come, I like show you something."

I got up, kissed Claude on the cheek, and followed him into the California grass. I felt Kahala's eyes on me. After we got about twenty yards around the house, I saw a clear patch. In this bare patch was a cement block with an iron handle attached to it. The top of the block was level with the ground and only an iron handle protruded from the surface. Koa reached down and pulled the handle. He pulled up the cement block. The smell quickly followed. "You see dis," he said. "Me and your fadda dug dis cesspool while you was in town. Took us ages. But every Saturday, we would wake up early and dig dis fucka. Sometimes my dad, my uncle guys would come down and help. But you know dose fuckas, dey drink every weekend, so most of da time dey was too hung over to come down and help, and when dey did dey was so sick and lazy dat dey neva do shit anyway."

Koa put the cement plug back in the ground. "Look at my fuckin' house," he said. "It's one fuckin' joke. Funny too, cause when my dad gave me da land, I taut only easy build one house." He squatted down and took the last sip of his beer. He crushed the can and threw it. It disappeared in the tall grass. "What, you going work wit' your fadda?"

I nodded. "Yeah, I guess. Fuck I need da money, I need da benefits. Claude stay pregnant."

Koa smiled and spit on the ground. "Shit, working wit' your fadda is buss ass you know. You seen him? Last yea, he had fo' get surgery on his knee. Das why he limp. Fuck, you should see dose old guys at Hayashi's. Fuckas drop like flies. Bad knees, bad backs. But man, you hurt yourself, you get fuckin' paid. Your fadda got fifteen grand for his knee, and he neva even lawya up. I told him, 'Uncle, get one fuckin' lawya, sue da fuckin' company fo' big bucks.' Da fucka went jus' look at me funny and said, 'Shit, I not li'dat. I not goin' make like one haole.' He said dat, and I taut about it real hard. I taut, 'Fuckin' haoles, dey get 'um. Fuckas no give a shit. Dey smarta den us.' You should see, none of da old timas dat get hurt sue da company. Dey jus' take whateva settlement dey get."

He stopped. I thought about the possibilities. For a moment I found myself wishing I would blow my knee when I started working with my father in construction.

"Hey," Koa said, "go grab couple more beers and come back."

I walked back to the picnic table and Kahala and Claude were gone. I found a note on the table. In Claude's handwriting it read, "Kahala and I took the kids and went out for dinner. Be back in a few hours. Love, Claudia." I walked over to the cooler and took out a couple of beers.

Koa and I cracked open the beers. We moved back to the picnic table. Koa lit a lantern and put it on the table. He went to

his truck and turned on the radio. The dial was on one-o-five-point-one, the Hawaiian station. Makaha Sons of Ni'ihau's *Take Me Back to the Country* was playing. Koa sat back down. "You know, your fadda probably told you, I was good for a while. I would work my forty-hour weeks wit' one smile. I would work on da house on weekends. Man, I taut, I married now, I cannot fuck around. Dis was when Kahala was pregnant wit' James. I figured, I one family man now, I betta provide fo' da family. Man, I used to buss my ass! Shit, da boys at work used to tease me, call me pussy-whipped and shit. But I would jus' smile, and tell dem, 'I get betta tings for do den get drunk.' But half da time I wanted fo' stay. Shit, I was eighteen years old, I wanted fo' party, too."

He stopped to go take a leak. I thought about what he was saying and felt sorry for him. Then I realized that the job he was describing was going to be mine. I felt the loss of a college education. For the first time, I regretted dropping out of school. I felt lost.

Koa came walking back and sat down. I looked into the light of the lantern and saw termites flying toward the light. They were bouncing off the glass. Then I heard Koa's voice. "So, what happened wit' you in town?"

I told him the story. I told him about the crazy money I had been making there. I told him how I had met Claude and how I was eventually banished from Mama-san's world. I told him about Mr. Yellow Teeth and the other two nameless Koreans I had killed and left for the pigs. Koa listened to the story like a child would a bed-time fairy tale, eyes wide open.

When I finished the story, he gulped down the rest of his beer and reached in the cooler for another one. He cracked it open. "So actually Claudia fucked it all up for you."

This surprised me. "No, no," I said, "fuck dat. Da pregnancy thing, that was both our fuck up. But what happened next, dat was all Claude's madda's bad. I tell you Koa, I wanted fo' kill dat

bitch so bad. I had da fuckin' gun pointed right at her face. I neva give a shit about da cops. I would've killed dem too. If wasn't for Claude, I'd be in fuckin' jail right now. Besides, we going have one kid. Maybe das one fuck up, or maybe not. Why, you regret having your kids?"

Koa took a sip from his beer. "Shit, you sound like me when I found out Kahala was hapai. One side of me was worried, I taut I fucked up, but da odda side said, 'Right on, I going have one kid.' But I telling you, it's not all dat it's cracked up to be."

I didn't really want to hear it. I mean, I knew he loved Kahala, but in my mind, they couldn't match me and Claude. Koa and Kahala were high school sweethearts, Claude and I were soul mates. I shrugged.

Koa smiled. "I know what you tinking," he said. "You tinking you all in love, and das enough. But I telling you, sometimes not enough. Your fadda told you I was going church? You know why I was going church? Because I was beating up Kahala. When Kahala told my madda and fadda about it, all three of dem walked up to me one night and said, 'You betta go church.' So I went church twice a week."

He paused to take a gulp of his beer. "Fuck," he said, "I was into it too. I fuckin' believed. I stopped hurting Kahala, I worked on da house even harder on da weekends. I figured, hard work and all, it going make me one good person and den I going heaven." He laughed. "I was one fuckin' mess."

I finished my beer and grabbed another one out of the cooler. I was extremely drunk. I carefully opened my beer and gave Koa my best poker face. He smiled. "So what happened den, how da ting turned all to shit?" I asked.

"You should've seen me. I was one fuckin' big ass pussy. Fuckin' Kahala loved it, though. 'Hey Koa, take out da trash.' 'Hey Koa, watch da kids while I go run errands.' 'Hey Koa, I goin' go out wit' my girlfriends, cook dinner.' For yeas was da same ting.

One odda kid came. You can imagine, I was working fuckin' full-time, sometimes ova-time, working on da house on weekends, and let me tell you, was one bitch fo' do da plumbing, and den on top of all dat, sometimes I was cooking dinna and watching da damn kids? I get all dis shit goin' on and sometimes Kahala would say tings like, 'Oh, how come we no go out sometimes. How come you no take me out.' Sometimes I wanted to kill dat fuckin' bitch, but den I taut about God and I would hold 'um in."

He stopped and pulled out a joint from his pocket. He lit it and took a hit. He held in the smoke and passed it to me. I waved it away. He coughed out the smoke. "Take one," he said. "Dis da good shit. Purple strain. I got 'um from Freddie last night."

"Nah, I'm good." I knew the mixture of weed and drunkenness would make me sick.

"Nah, c'mon, for old times' sake. C'mon, you and me, we braddas. Take one hit from your bradda."

I took a hit. I coughed out the smoke. My stomach slightly convulsed, and I swallowed a ball of puke. Koa laughed. "Lata tonight, we go check out Freddie. We can get some coke from him."

I was thankful I had seen Freddie once in a while when I was living in town. Whenever he'd dropped off stuff for me to sell to the strippers, he knew I was clean and meant to stay that way. If I saw him with Koa, he'd back me up in my refusal to blow a few lines with them. He knew I had helped him catch blue cats and I was a better hunter off drugs.

Koa was astounding me. He had been tanking beers since eleven in the morning. He had put down well over a case and the alcohol seemed to still be energizing him. I had been sipping my beers during the afternoon, so I had only put down about a cold pack. But it was enough to make me feel ill. I wanted to get his mind off of going to Freddie's. "So what happened den?" I asked, "When you went quit da church and your job?"

"Oh, yeah. Anyway, one night, couple months afta Kealii was born, I was home watching T.V. Was right afta work and was fuckin' raining hard. I was falling asleep in front da T.V., den I heard Kahala screaming. She was yelling, 'Koa! Come, hurry up!' I grumbled to myself, den I followed her voice to da batroom. She was screaming because all kine shit wata was coming out of da tub. I told her fo' get out and I went in da tub wit one plunga. Wasn't doing shit. Den I taut about it. I got out of da tub and walked outside. Da whole time Kahala was yelling at me cause my feet was leaving all kine shit wata on da floor. Fuck, she was getting on my nerves. So anyway, I went outside to da cesspool. I was getting all wet from da rain. I took one flashlight wit' me and lifted da cover. Sure enough, da fuckin' cesspool was full. Somehow da fuckin' rain went get into da cesspool and da fucka was over-flowing. So I left da cover off. I figured maybe not going have as much pressure if da cover stay off. I walked back inside da house. Fuckin' bitch was yelling at me again, dis time cause I was trailing fuckin' rain wata in da house.

"I grabbed one bucket and started taking da shit wata out of da tub. But every time I would dump da bucket, more fuckin' shit wata would come up. Pretty soon, da shit wata was coming out of da toilet, too. You should've seen, I had all kine towels on da batroom floor, and I had one big pile by da door so da wata wouldn't go into da odda rooms. Da whole time I was filling da bucket up wit' shit wata and dumping 'um out da window. Fuck, you rememba in school, da day I met you in English, we read about dat one guy who was in hell and he had fo' push da big rock up da hill every day, foreva? Every time he would get da rock up, da fuckin' rock would roll back down. I rememba I used to tink dat story was stupid. Rememba when I told da teacher, 'Fuck I wouldn't do dat. I would tell da boss of hell, fuck you, and not touch dat fuckin' rock.' But den dea I was, standing in a tub of shit, doing da same fuckin' ting dat guy was doing in hell. Only worse, at least dat

fucka neva have to deal wit' da shit wata. I figured, I stay in hell now anyway, why da fuck I trying fo' be so good?"

He stopped and took a last hit from the joint before he put it out with the tips of his fingers. He put the roach in his pocket. He let the cloud of smoke out of his mouth. "So anyway," he said, "dea I was feeling like one jackass and in comes Kahala, all piss off. She said, 'I taut you knew how fo' do plumbing? What you did wrong? How come dis happening?' Right den, I had it. I went punch her right in da mout. Afta she landed on all da towels covered wit' shit wata, she looked up at me, all surprised. Den she went get pissed off. She called me one fuckin' asshole and tried fo' slap me. Even more I went lose 'um. I grabbed her fuckin' head and went push um down into da tub. I tink I would've drowned her too if James neva come in da batroom crying and screaming, 'Dad, let go of Mom.' I telling you right now, I almost went kill all of dem. But I neva. I let Kahala go and she took da kids to my fadda's house. Dose fuckas neva told me go church again. Dey neva tell me shit again."

"So what you goin' do?" I asked.

"Nothing, bradda. Fuckin' party. I tell you one ting, if you ask me, Claudia went fuck you up. Just like Kahala went fuck me up. Fuck, I could've went college, played football. You rememba B.Y.U. went offer me one scholarship? Fuck, I tell you dis right now. I regret da day I went get mixed up wit' Kahala. As far as I'm concerned, she fucked up my life."

I wanted to tell him something that would change his mind. But I knew I didn't have the words. No one did, his mind was set. I reached in the cooler and pulled out two beers. We cracked them open and toasted each other. "So what? You not scared you goin' get caught?" Koa asked.

"Nah, not really. Nobody gives a shit if a few fuckin' nameless Koreans disappear. Fuck, dey give less of a shit about da Koreans den dey do us."

Koa nodded. "Das right bradda, dey no give a shit."

Just when the world started to spin, I saw the headlights of the Pathfinder creep up the driveway. I was relieved. Before it got to the garage, the Pathfinder veered off the driveway and charged through the California grass. I stood up.

"Sit down," Koa said, "das just Kahala. Dat's how she tells me da grass needs to be cut. Fuckin' cunt, she always does dat. She probably just seeing how good your car can cut grass."

I sat back down and tried to look through the window as the Pathfinder passed me. I could only see one silhouette through the windshield, but I shrugged and told myself I was totally wasted. The Pathfinder pulled to the back of the house, where I couldn't see it, and stopped. After about a minute, it came tearing out from the back and pulled up to the garage. The kids poured out of the car and ran into the house. Claude and Kahala spent another several minutes talking until I walked up to the window and knocked.

Despite Koa's pleas to me to stay and drink more, I hugged him and Kahala good-bye. Claude waved casually to Koa and gave Kahala a giant hug. Claude drove me home. She was talking to me on the ride back, but I didn't really hear her. I spent the ride with my eyes closed, resisting the alcohol-induced spinning of my head.

■ ■ ■

When Claude and I woke up the next morning, we spent it puking together. Once we had to puke at the same time, so we shared the bowl. After we finished, we both slouched down and laughed. I figured puking together was like one step away from marriage. My head was pounding, so I opened the medicine cabinet and took some aspirin.

Claudia spent much of the morning teasing me and yelling in my ear. I chased her around the house, but after the first few

strides, my head would hurt so much that I would quit and wait for her to come back and torture me again.

It wasn't until the afternoon that Claude and I discussed what we heard from Koa and Kahala the night before. We were lounging on the sofa when she brought it up. "I heard some interesting stories from Kahala last night."

I nodded. "I heard some trippy stuff, too."

"How can he do that to her?" she asked. "How can he make her life a living hell?"

I shrugged and turned on the T.V. "I don't know. I guess he just got fed up."

Claude grabbed the remote control and turned the volume down. I saw the little green bars on the screen disappear one by one. "Fed up?" she asked. "I don't care how shitty your life is, there is no excuse in the world for beating your wife."

"You're right. Of course there's no excuse. But I can see his side, too. Can you imagine how hard he was working? Putting in forty hours a week building just so he could spend his weekends building, too. I'm not saying what he does right, but I can understand why he lost it."

Claude frowned. "What about her? She had to stay in that sorry excuse for a house every day for the last several years. Chase those kids around. Now she not only has to do all of that, but she has to worry about money, too. Koa isn't getting unemployment because he pretty much quit by not showing up. Kahala thinks he's dealing a little, but she never sees that money. She can't get a job because there's no one to take care of her kids. She can't afford a sitter and she's afraid of leaving them with Koa. She's so stuck. And it's him that's keeping her there."

I was getting irritated. I knew she was right, but she was talking about Koa like he was some kind of monster. Besides, the image she had of Koa hoarding drug money was ridiculous. Koa had never made much money as a dealer because he was a user,

too. I sighed. "So what do you want me to say? You want me to say that my friend is the biggest prick in the world? Yeah, Kahala's fucked. Koa's fucked. Their children will probably grow up and be fucked. We shouldn't be even talking about it. We can't do anything about it."

"You can talk to him." Her voice grew louder. "I talked to her..."

I interrupted Claude. "What did you tell her?"

"I told her that she should talk to him. If he doesn't listen, I told her to give him an ultimatum: change or get out. I told her, if he doesn't change, leave his ass."

I shook my head. It made sense that Claude could get to Kahala, though. They both grew up in a more civilized and sheltered world. "Why are you getting involved? You just met them. Besides, the last thing you want right now is Kahala poking at Koa. You don't know him, Claude. She'll be poking at him, and it'll be like poking at a bee hive. You should've told her, if she leaves, leave quietly."

Claudia stood up. "Leave quietly? Like she doesn't have the right to speak up? She should stomp out of that crummy house. You guys better come out of the stone ages."

"You guys? When did I get mixed up in this shit? I don't know why the fuck you're getting all hot about this for. What, is it a 'sisterhood' kind of thing? Shit, you don't even know Kahala and you're giving her advice, putting all kinds of ideas in her head."

"Putting ideas in her head?" Claude stomped to the bedroom and slammed the door. I shook my head. She didn't know what the fuck she was doing. All of that women's right's shit, it might be great in civilized society, but Claude was on the Windward side now, in the area where feminist ideas were squashed by the fists of men. Suddenly, I had this image of Claude getting some of the neighborhood women to picket Koa's skeleton

house. They were holding big signs, walking through the California grass. They were chanting, "Wife-beater, wife-beater, wife-beater, beat it." I knew I had to get Claude out of the Windward side before she got somebody killed.

<center>❖ ❖ ❖</center>

I started working with my father the following Monday. Before the sun was up, we started our drive to the industrial district by Honolulu International Airport. With a cup of coffee in one hand and the steering wheel in the other, my father talked the entire way up the mountain. I leaned my head against the window and closed my eyes. It had been years since I had to wake up so early.

"Hey, boy. What's wrong? You sick or someting?"

I lifted my head and leaned back on the seat. "I'm all right."

He laughed. "Look out hea. No mo' traffic. Roll down dat window and breed in dat clean morning air. I always drive down early so I miss da traffic."

"You mean we're going to be early?"

"I told you grab one cup coffee, but you neva like listen."

I sighed and leaned my head back on the window.

When we got to his building, my father drove past the high wire fences which surrounded Hayashi headquarters. He parked the truck and we walked into the office. The air conditioner hummed as we stopped at the front desk. "So what?" my father said. "My boy's paypawork all done?"

The secretary, a plump Japanese woman with badly permed hair, handed me a manila-colored card. "All set, Ken. Your fadda can show you where to punch in." She looked at my father. "You neva forget, ah? I know you getting old."

My father smiled. "Yah, Clarisse, I getting old, but no worry, I can still get 'um up."

Clarisse shook her head. "Yeah right, it probably fell off arready." She looked at me. "Jus', no be like your fadda, boy, and you should be fine."

I was getting pretty damn sick of being called "boy". I followed my father to the time clock and we drank coffee for the next half hour while we waited for the clock to read "six." I put the card in the time-clock and a loud punching sound came from it and made me jump. It sounded so ominous, so final.

After we clocked in, my father and I, along with the rest of the crew, jumped into the company trucks and drove to Kunia, where Hayashi Contracting was building new housing. We drove past the pineapple fields and entered a large dirt tract which held over a dozen skeleton houses. These incompleted homes were different from Koa's. The wooden beams were pale and new, and the metal clamps which held the beams together were bright and shiny. The beams were being roofed with red Spanish shingles. It occurred to me that Koa had spent his weekdays building houses which would inevitably turn out better than the one he'd been building on his weekends. My father pulled the truck to the side of one of these houses. "You ready, boy?" he asked.

Little did I know, "boy" was to be my name for the rest of the day. Johnny, the fifty-something-year-old Filipino foreman called me "boy." Kamaka, the Hawaiian who always wore a thick, leather weightlifting belt to work, called me "boy." Even Mark Sanchez, the skinny, twenty-year-old Portagee called me "boy." At Club Mirage there had been times when customers would call me "sir."

On the way home with my father, with my body broken down from all of the carrying I'd done, I stared at him until he looked back. When his eyes finally reached mine, I said, "You tell dat Mark if he eva call me boy again, I going break his fuckin' ass."

My father smiled. "Yeah, I rememba when I started afta I got back from Nam. Da fuckas used to call me 'boy' too."

"What you did?"

"I ate 'um. I had one wife an' kid. I wasn't about fo' get fired."

"What about Koa? Did they call him 'boy' too?"

"Yeah, sometimes."

I leaned my head against the window and sighed.

<div align="center">✠ ✠ ✠</div>

Five days later, while Claudia and I were spending the Saturday afternoon together quietly reading in our room, Kahala called. "Hey Ken," she said, "what are you doing today?"

Claudia looked over the page of her book at me. I think she was still a little pissed about the argument we'd had the week before concerning Koa and Kahala. "Cruising with Claudia."

"Hey, guess who I heard from? Cheryl. You remember Cheryl, yeah?"

Cheryl. The Ahuimanu girl who got away. I immediately wondered what she was up to. "Yup. How could I forget?"

"Listen, she's visiting her parents today, and she wants to have dinner. You should see, Ken. She's a lawyer. I told her you were back on this side, and suggested that we all go out together."

"What about Koa?"

"I haven't seen him for the last couple of days. His parents have the kids tonight. C'mon, Ken. It'll be fun."

I put my hand on the speaker and tugged on Claudia's leg. "You wanna go out to dinner tonight with Kahala and her friend Cheryl?"

"Sure."

I put my mouth back by the speaker. "Where'd you have in mind?"

We ended up meeting at Flamingo's, a restaurant very similiar to Sizzler's. With its salad buffet and affordable steak

dinners, it was one of the most upscale restaurants on the Windward side. Kahala and Cheryl had beat us there, and when Claude and I walked up to the booth, both stood up and threw hugs at me. After I introduced Cheryl to Claudia, we all sat down. Cheryl and Kahala sat on one side of the booth, Claude and I sat on the other. Cheryl had picked up a few pounds from high school, probably from all the reading she had to do in law school. That's the scary thing about reading too much, your mind hardens, but your body turns to jello. I switched my eyes to Kahala. Despite having three kids, she was still thin and her body was hard.

"So, what have you been up to, Cheryl?" I asked.

Before Cheryl could answer, Kahala spoke up. "You should see Ken, Cheryl, she's an attorney for Johnson, Marcus, and Yamasaki. She makes the big bucks."

"I don't know about that," Cheryl said. "But I guess I'm doing o.k."

"Where did you go to school?" Claudia asked.

"Oh, for undergrad, I went away to the University of Washington." She looked at Kahala. "Kahala was supposed to come with me. But anyway, I majored in English up there, and came back home for law school. I just finished my clerkship with Judge Murdock a few months ago, and was offered a job by Johnson, Marcus, and Yamasaki. Civil litigation."

"So what are you doing back on this side with the dregs?" I asked. Before she could answer, a waitress came and asked us if we were ready to order. Kahala and I ordered Bud Lites, Claudia ordered a Diet Coke, and Cheryl ordered a glass of Chardonnay. After the waitress left, Cheryl looked back at me. "Are you kidding? You guys are great. I'm just sorry that I didn't have the time to visit this side more often."

"She's very busy," Kahala said. "I haven't seen her in ages. But we still talk on the phone sometimes."

"That's great," Claudia said. "I don't even know what happened to most of the people I went to high school with."

"She went to Punahou," I said. "Snob, rich haole central."

Claude gave me an evil look. Cheryl reached over the table and put her hand on Claudia's arm. "Poor child. I know some of those Punahou people from the Outrigger Canoe Club. Haoles worshipping the legend of Duke Kahanamoku, then driving away in their B.M.W.'s. It's not a pretty sight."

"So, hob-nobbing in a private club now, ah?" I said.

"Tell them how many hours you work," Kahala said.

The waitress came back with our drinks. Cheryl looked at Kahala. "Yeah, I'm busy. Sometimes I'll do seventy-something hours. But anyway," she looked back at me, "I can never stay too far away from the Windward side. Remember, it's God's country. I wanna buy a house and raise kids here."

I almost spit out a mouthful of beer. "What?"

Claudia nudged me in the ribs. "See, I told you it was beautiful here. And you were trying to change my mind."

I laughed. "So what do you think, Kahala? How beautiful is it here?"

Claudia elbowed my ribs again, only this time harder. Kahala looked up at me. "It's a fuckin' hellhole."

We all sat quiet for several seconds. Cheryl cleared her throat. "So what about you guys?" she asked. "I hear you're expecting."

Claudia smiled. "Actually, I don't know what to expect."

Another waitress came to our table and asked if we were ready to order dinner. Everyone grabbed for their menus. "Maybe a few more minutes," I said. Then I looked at Cheryl. "So what about you? Are you going to be married with children anytime soon?"

"Are you kidding? After you broke my heart in high school? Kahala didn't tell you? I'm a lesbian."

I hid my head under the menu, then heard giggling. Claudia playfully slapped me on the back of the head. "You idiot. She was joking."

I looked up. "You men," Cheryl said, "think that our lives revolve around you. This isn't a Ken-centric solar system."

They all laughed. I looked at each of them and suddenly realized that I was surrounded by three beautiful and intelligent women. Instead of feeling proud, I was feeling a bit out-gunned. I looked at Cheryl. "I thought it was a Ken-centric solar system." I put my arm around Claudia. "That's what she keeps telling me."

Claudia slapped the top of my head several times. Kahala and Cheryl laughed. "All right, enough already," I said. "We better order before the waitress kicks us out."

After Cheryl, despite my protests, paid for dinner, we all walked together to our cars. Kahala, Claudia, and I watched as Cheryl drove off in her Lexus. "You should see her apartment in town," Kahala said. "It's awesome."

I looked at Claudia and she smiled. We both knew what was going on. Kahala was seeing what could've been if she hadn't married. Also, as two people who had lived in a nice condo, the idea wasn't as magical to us as it was to Kahala. "Well, we better get going," I said.

Claudia kissed Kahala on the cheek. I did the same. Kahala waved and took a few steps back. I grabbed her arm and pulled her toward me just in time.

"Jesus, watch where you're going!" I said. The blaring horn of a speeding low rider truck filled my ears. "That car full of kids almost fuckin' ran you over."

Kahala looked over her shoulder as the car tore through the parking lot. Then she looked back at me and tears dripped down her eyes. I didn't know what to say. Just then, Claudia gently pushed me away and hugged her. "You all right, honey?"

Kahala cried in Claude's arms and it pissed me off. I wasn't pissed at Kahala, but angry at whatever made her cry. I looked through the parking lot to see if the low rider was still around. When I turned back to Kahala and Claude, Kahala peeled herself away from Claude and looked at me. "I'm sorry. This is so fuckin' dumb. It's not like my problems have anything to do with you guys."

Claudia grabbed Kahala by the shoulders. "You tell me what you need, dear, and we'll see if we can help."

"Don't," Kahala said, "don't get me going. It's too embarrassing. Not that my situation is too embarrassing, but the fact that I have to jump on any charity from you guys is too embarrassing. You guys, I need money."

Her green eyes focused hard on mine. They shined with an amazing amount of sudden stoicism and power. I looked away.

"Of course," Claudia said, "How much do you need? We know you're not working and that fuckin', no-good husband of yours is out frying someplace."

"I need about two hundred."

Claudia took her checkbook out of her purse. She called me over so that she could write the check on my back. Before she started writing, I turned around. "Wait a minute. Don't write the check." I pulled out my wallet, pulled out two hundred dollars, and looked at Kahala. "I don't want Koa to know where this money is coming from."

Claudia was about to say something, but I gave her a hard look. She shrugged and put her checkbook back in her purse. Kahala kissed me on the cheek and whispered, "Good thinking." She kissed Claudia then walked away.

While driving, I was purposely brooding in the Pathfinder. Finally Claudia spoke. "What?"

"I don't feel good about this."

"What's wrong with you? She's your friend, she needs help."

"It's not that simple."

"Of course it is. And she needs more than just two hundred dollars."

I looked at her. "Don't write any checks to her."

"I didn't mean money. She needs our support so that she can finally leave Koa."

I sighed. "Don't meddle."

"What are you afraid of? Koa? C'mon Ken, I know you're not afraid of anybody. Violence is your second nature."

"How would you know? You've never seen me violent."

"I've heard."

"From who?" Then it came to me: her mother.

"From you."

I looked at the speedometer. I was going way too fast. "Okay, listen. This has nothing to do with fear. It has to do with friendship and respect. If Koa and Kahala asked me for anything, I'd give it to them, no questions asked. But Koa would never take money from me, and if he knew about this, he'd be hurt and insulted. It's like I'm cleaning up his mess or something. Or it's like I'm taking pity on him. Can't you understand that?"

"Codes, it's all personal codes with you. I'm talking about someone's life, and all you can give me is some goddamn macho code to justify why we shouldn't help a friend in serious need. Not only a friend, but her children, too."

"You don't have to worry too much about the kids," I said. "Uncle James and Aunty Kanani will always make sure that they're taken care of."

Claudia didn't respond. She ignored me for the rest of the ride. As we drove by Chinaman's Hat, I could barely see the island in the dead of night.

When we got home, Claudia walked past my father without saying a word and slammed our bedroom door. When I walked in, my father smiled. "What's the problem?" he asked.

"Ah, I don't know. Looks like I'm couching it tonight."

"Son, dis is my house, and dat's your room. You shouldn't be sleeping on da couch."

"C'mon, Dad. You must know how it is."

He sighed. "Not really, bradda. Dat swordtail of yours is not like your madda was. Your madda grew up hard, so she neva need any kine. But your girl, she kinda spoiled, ah? Her madda probably gave her whateva she wanted from little kid time. Das da problem wit' swordtails. Some of dem need pump, gravel, wata filta, and live food. Sometimes dey even need plastic plants and dose ceramic castles in dea tanks."

"Mom wasn't a swordtail?"

"Yeah, she was one swordtail, but da kine you find in da riva. She was strong, rough, not like da aquarium kine."

But she died, I thought, as my father continued talking about Claudia. But she died.

❖ ❖ ❖

The next day Koa called and asked if I wanted to surf. Since Claudia was still ignoring me, I decided to go. Before I left the house, however, I noticed that the katana was out of its glass case. Then I heard the sound. It was that "chain gang" sound, the sound of a prisoner striking stone with a giant sledge hammer. It was coming from outside, behind the house. After I put my surfboard on the roof of the Pathfinder, I walked to the backyard to see what was going on. My father was standing in front of a stack of large, thick bricks, while Claudia stood by him with the unsheathed katana in her hand. My father saw me and smiled. "Come Ken, I showing Claudia someting."

I walked and stopped beside him. "Claudia," he said, "try again."

Claude lifted the sword over her head and swung down on the brick. The blade hit the stone and small pieces of brick popped into the air. My father smiled. "Look at da blade."

I walked to Claude and inspected the blade with her. There wasn't the slightest blemish on the shiny metal. "I hit the brick like five times," Claude said. "And still, there's nothing."

My father gently took the sword from Claudia. "Yup, our ancestas really knew how to make swords. You see dis katana? Da guy who made 'um neva just hamma and sharpen da blade one time. He heated, hammered, and folded. Heated, hammered, and folded. Da guy probably folded da ting ova hundred times, each time pressing da metal togetta, making 'um stronga and stronga. When he finally sharpened 'um, da sword was so strong dat even stone cannot ding da blade. Nothing can. You see, no matta what you do to da sword, da ting always going stay sharp and shiny."

"How come you didn't show me this before?" I asked, wondering why he was showing Claudia instead.

"Neva need."

Claudia was still staring at the blade. Without giving warning, she grabbed the katana from my father and swung down on the brick again. The brick cracked in half and my father laughed. Claude inspected the blade again. I looked, too. There was nothing there. "Where you going?" my father asked.

"Surfing."

Claudia looked at me. I turned to my father. "Probably only for a couple of hours. I feel like I need to get out in the water." I looked at Claude. "You wanna go to the beach?"

"Who else is going?" she asked.

"I'm supposed to pick up Koa and his brother Ikaika."

"I'll pass."

"No worry about us, Ken," my father said. "I can entertain her."

I shrugged and looked at Claudia once more. She gave the sword to my father and walked into the house.

■ ■ ■

When I picked up Koa and Ikaika, they put their boards on the roof and threw a cooler in the back. "I bought couple cases beer," Koa said.

Both of them cracked open two cans of Miller Lite and offered me a cold one. I shook my head. "C'mon, bradda," Koa said. "Jus' have one fo' da road. Where we goin' anyway? Sandys?"

"Fuck Sandys," Ikaika said. "We go town."

I looked in my mirror at Ikaika. He was a lot bigger than he had been in high school. Though he wasn't nearly as big as his older brother, he still easily exceeded two hundred pounds. His clean-shaven face was framed by a head of curly black hair. It reminded me of Freddie's hair. "What Freddie stay up to?" I asked.

"Cruisin'," Kaika answered. "I tink he went town fo' business."

"What you was doin' last night?" Koa asked. "I call your house but your fadda said you and Claudia went dinna or someting."

"Yeah, we went dinna. Why, what you guys did?"

"I was hangin' with Freddie," Kaika said.

"I was looking fo' my fuckin' wife," Koa said. "She was out till late. When she came home, she told me she went out dinna wit' Cheryl. You rememba Cheryl, Ken? Ho, she wanted fo' jump your bones."

"Wanted your hot beef injection," Kaika said.

"Wanted fo' ride your boloney-pony," Koa said.

"Wanted fo' take old one-eye to da opt... opt... What you call one eye docta?" Kaika asked.

Koa turned around and slapped Kaika on the side of the head. "Shut da fuck up arready. I tol' you you should've finished high school, you dumb motha-fucka."

"No slap me," Kaika said.

"Shut da fuck up," Koa said, pointing his finger at his brother. Then he turned back to me. "Fuck, you rememba da movie *The Godfadda*? Fuckin' Kaika back dea is like our Fredo." He turned back around to face Ikaika. "No make me haff to send you fishing wit' Ken ova hea."

Koa and Ikaika got into a slapping war. I laughed and said, "Both you guys, shut da fuck up arready."

"Yeah, Kaika," Koa said. "Befo' Ken send you to da pig farm."

I turned to Koa. "Hey, nuff arready."

Koa put up both of his hands and smiled. "O.k., o.k. Anyway, where was I? Oh yeah, fuckin' Kahala. She tryin' fo' tell me she went dinna wit' Cheryl. Fuck, we neva see Cheryl fo' yeas. I heard she one lawya or someting. Big shot. Like she would all of a sudden want to have dinna wit' Kahala."

"So what you tink, den?" I asked.

"I wouldn't tink anyting, but den I found two hundred dollas in her purse."

I bit my bottom lip and felt Koa's eyes on me. "How'd she get dat?"

"I don't know, maybe she get one shuga daddy. What you tink, Ken?"

I kept my eyes focused through the windshield. "Nah, Kahala would neva fuck around on you. She not crazy."

Ikaika leaned toward the front and rested his forearms on the backs of the seats. "Yeah, she would. Fuckin' Koa treats her like shit. Her shuga daddy probably treat her nice, give her money, and he probably get one dick twice da size of Koa's."

Kaika's laughing was interrupted by an elbow to the forehead. Koa was trying to climb over his seat to get to Kaika.

His ass hit my shoulder and the Pathfinder swerved to the side of the road. "Koa, get your ass back in da front," I yelled. "You goin' get us all killed."

Koa sat back down. "You shut up fo' da rest of da trip," he told Kaika.

Kaika sulked in the back. "So, what happened?" I asked Koa.

"What you mean, what happened?"

"Wit' Kahala."

"Oh. Me and her got into one big fight. She left wit' da kids. I tink she went to my parents' house. Ah, fuck 'um arready."

When we got to the Sandy Beach, Kaika stayed in the Pathfinder and drank beers while Koa and I paddled out. I had to paddle slow because Koa was slow and out of shape. When we passed the shorebreak and got to the second set of breakers, I heard Koa huffing and puffing. When he tried to duck underneath the first set, the small two-foot wave knocked him off his board. I shook my head and paddled past the breakers. I looked out toward the horizon and thought about seeing Cheryl the day before. It was funny, I hadn't felt any attraction. I was just thankful that I hadn't hooked up with her in high school and pulled a Koa and Kahala. I would've fucked up her life. But why didn't she tempt me? Maybe because her position as a new upper-class attorney kind of made her the enemy. Maybe it was because I was so hung up on Claudia. I didn't know why I was asking myself these things. I should've been glad that there wasn't an attraction between me and Cheryl. My life was complicated enough.

Instead of thinking about it anymore, my mind turned to the prospect of work the next day. I sighed just as a wave knocked me off my surfboard. When my head emerged from the water, I looked back at Koa and Kaika. I thought about Freddie, and saw, instead of my friend and his brother, two blue cats treading water. I wondered if I was the one that had gotten away.

❖ ❖ ❖

Over the next several months Claudia's belly grew. And with it grew her unhappiness. I wasn't having a good time of it myself. She was big and she hated it. She didn't glow, she glowered. She seemed to feel tied down by her growing belly, like it kept her from doing all the things she wanted to do. It seemed like roots grew from her stomach, roots which drove downward and wrapped themselves around the huge rocks under the Ka'a'awa soil. She spent some of her days reading the classifieds, looking for jobs in the field of art. She spent other days staring at the television screen, seeing worlds which were not hers. She spend every day pissing constantly. I think the nights were even worse for her. Every so often, she'd get this really bad, cramp-like feeling. Sometimes it would come when she'd simply roll over. She'd try to bear the pain as best she could. But the worst part about the nights for her was that the doctor told her, a woman who had spent all of her life sleeping on her back, to sleep on her left side. The doctor had told her that sleeping on her back would put pressure on the vein which gave the baby oxygen. He told her that the baby was pushing her organs to the right side of her body, so sleeping on the right side put pressure on these organs. She couldn't move, she couldn't sleep. Through these months I think the only thing that made her happy was that Kahala had ended up leaving Koa. She had moved out with the kids and was staying at Koa's parents' house. Claudia felt like she had made a contribution. But besides that, she wasn't liking her situation. What made matters worse was that she and my father weren't getting along.

After about a week the politeness which two strangers share had passed, my father started in on her. Most of it was jokes, but sometimes it sounded like my father was dead serious. Some of it was about her weight, or how much she ate. He said things

like, "Eh, no eat da whole refrigerator, ah. I scared that when I go work, I goin' come back and da whole house goin' be gone."

At first she laughed, but soon the laughter faded to indifference, then to retaliation. "Don't lie," she'd say, "the only thing you're scared of is that I might take down your liquor collection with it."

Soon his laughter faded. After a while, most of their conversations sounded like spiteful insult contests. The worst appeared when my father got on Claudia about being Korean. Every time Claude did something wrong, like burn food or not tighten a faucet enough, my father told her, "Must be da Korean blood." Sometimes he got her for the haole blood, too. These came when she didn't wash her dishes or she left a newspaper scattered on a table. "Must be da haole blood," he'd say.

One Thursday night, about seven months into her pregnancy, they had a real race war. The night started off quiet enough. When I got home from work with my father, Claudia was in the shower and my father looked on the stove and saw that Claude had cooked his favorite, ox tail soup. He tasted it and smiled. I walked to the bedroom happy. It seemed like Claude and my father were not going to get into it tonight. As I was undressing, the phone rang. It was Kahala.

"Hey Ken, it's Kealii's first birthday on Saturday. You and Claudia have to come. It's going to be a huge deal, you know, like graduation. Koa's dad is putting up the tarp and everything."

"Sounds great. Ask Uncle James if he needs help."

"I'll tell him to call you, but we might be all right. Koa and Ikaika are supposed to help."

"So you and Koa are talking?"

"No, it's over. I mean, he's still the father of my children, so I expect to still see him around, but I think he's realizing that the marriage is done."

"I'm sorry to hear that."

There was silence. Then she asked, "You know what?"

"What?"

"I'm so glad you came back home. Without you and Claude coming back, I don't think I would've ever left Koa. I saw you guys that night and thought, that's the way it should be. I almost forgot what a good relationship looked like, but after seeing you guys and talking to Claude, I remembered. It's best for both me and Koa that we get divorced. He has to get his shit together and I have to take care of these kids. Besides, I'm still young, right? I was feeling ugly for a while, but it's funny, after leaving that house in Waiahole, I started to feel good about myself again."

I shook my head. I didn't want to take responsibility for their break-up. "Well, as long as you're happy, Kahala."

"I am. I'm totally happy."

After I hung up, I changed my clothes and walked out to the living room. I saw Claude and my father sipping on their bowls of ox tail soup, talking and laughing. I smiled, walked into the kitchen, and made myself a bowl.

The race war began after dinner. Claudia, taking her empty bowl to the sink, accidentally dropped it. My father looked up from his plate and said, "Damn yobo."

Instead of picking up the shards of ceramic, Claude walked back to the table and motioned her head toward the glass case which held my father's two heirloom swords. Above the swords hung my wrinkled Musashi print. "Why do you still have those swords?" she asked. "The Middle Ages ended centuries ago. Oh yeah, wait. I forgot. The Middle Ages in Japan only ended one century ago."

He looked up at her. "Yeah, Japan came charging out of da Middle Ages. And one of da first tings dey did was beat da shit out of Korea."

"Yeah, after the white men showed you guys how to use boats and guns. Without the white people's help, I doubt Japan could've even built ships that could've reached Korea."

I looked over at the swords and wished that I could grab the smaller one to kill myself with. My father looked at me and pointed to Claudia with his fork. "Listen to her," he said. "She acting like Christopher Columbus was Korean or someting. Like da fuckin' Koreans had good boats."

He looked back at her. "You know, once da Japanese learned how fo' build da boats, dey built one of da most powerful navies in da world. What da Koreans did? Dey just kissed our asses and made more kim chee."

I was tired. The construction business exhausted me because I was a "new guy," and I did a lot of the grunt work. I sighed and tried to ignore them. Claudia sat down. "Yeah," she said, "look at what's left of that great empire now. Japan doesn't even have an army anymore. Either half of Korea could mow Japan down right now."

"Shit," my father said, "Japan could buy one fuckin' army. Das why dey no need one. Fuckin' Japan could buy Korea. Shit, I tink I could buy Korea. I get about twenty bucks on me right now."

Claude's face was turning mean. Tears were welling in her eyes. "Yeah right," she said, "my mother's Korean and she could buy this house of yours in a snap. She could buy this house and the ones on both sides of it."

My father's face began its transformation. The devil brows began to arch and the eyes began to turn mean. "If your madda so great, why you no live wit' her? Why you free-loading over hea? Shit, if your madda taught you about birth control..."

I stopped it. "Dad, stop arready. Both you guys, stop. Nuff arready. Shit, I like eat my dinner in peace."

Claudia stomped to our room. My father let out a quiet laugh. "Fuckin' Koreans."

I got up and followed Claude. I heard my father's voice as I walked away. "Hey, boy, where you going? I neva teach you fo' be one whipped boy..."

I walked into the room and closed the door behind me. Claudia was sitting on the bed watching her hands shake. I grabbed them. She looked up. "I gotta get out of here, Ken. I can't live with that prick. Pretty soon I'm going to end up killing him."

I sat down beside her. "Listen, this is no fuckin' picnic for me either. But we gotta stay and save money. I told you, once the baby is born and we have enough money, we're out of here."

"We should've just gone straight to the mainland. We wouldn't have to deal with this shit on the mainland."

She was beginning to worry me. She was talking about the mainland like it was some kind of wonderland. Shit, we were going to run into a whole different set of trouble there. I put my arm around Claude. "Pretty soon, pretty soon." I put my other hand on Claude's stomach.

She laughed. "You better love this baby, Ken, because it's the last one I'm having."

I didn't know what to say. I didn't really want to have another baby either, but I didn't want to tell her that. Then I remembered the phone call I took while Claude was in the shower earlier that night. "Oh, speaking of babies, it's Kealii's first birthday this weekend. I forgot to tell you, Kahala called to see if we could make it."

Claude sighed. "Sounds good. I could use a party. But is Koa going to go?"

"Probably, I mean, it's his son's birthday."

"What about your father? Is he going?"

"I doubt it. He was never one for parties."

"Yeah, let's go. Instead of driving to work with your father tomorrow, I'll drop you off and go shopping for a present in town."

"Sounds good."

Claude turned on her left and sighed. Her back was facing me. I heard my father's loud footsteps pass our closed bedroom

door. Claude coughed. I smiled. "So how do you like the country now?" I asked.

"I see it clearly now and I don't like what I see."

The next day we ran into the Friday traffic. It seemed every day the Windward side got bigger, but it was funny because everyone I knew was saying they were making less and less money. Claudia and I made our way up Kahekili Highway where the new traffic lights just seemed to cause more traffic. As we neared Kaneohe, the car went over rough patches of new asphalt, the remnants of road construction. As we neared the Pali Highway, I looked toward the mountains and saw the unfinished tunnels of the H3 Freeway. It was a thirty-year construction project whose costs had set U.S. road records. "Hey, why are you taking the Pali?" I asked. "Likelike is faster."

"I think Pali might be faster, less cars. I don't know, it's an experiment. Besides, I like the Pali better, it's nicer."

I looked back up at the H3. "What the fuck," I said. "Kaneohe to Pearl Harbor? What three people have to take the H3 from Kaneohe to Pearl Harbor every morning?"

Claude smiled. "Well, if it'll take three cars off the road every morning, I'm all for it. Look at this traffic. It's madness."

"Yeah, but I figure it'd be better if we got rid of people instead of building more roads."

Claude sighed. "Well, I'm all for leaving. I don't think this side of the island exactly creates an ideal atmosphere for child-rearing. I have nightmares of our baby taking one of those swords out of that ridiculous glass case and killing himself. Actually, I have nightmares of me taking one of those swords out and killing myself."

"Hey, I grew up with those swords around and look how good I turned out."

She laughed. "Yeah, you're a real catch. Hey, how did he convince your mother to marry him anyway? Did he drug her or something?"

"Don't lie, you love him."

"Yeah, I love him to death."

It was a good question. I really didn't know how my father had gotten my mother. But I figured behind every bad-tempered old man there was once a young care-free rebel. I mean, even Darth Vader got laid once. I looked back at the H3 and wondered if it was really built on ancient burial grounds like the Hawaiian protestors said it was. I thought this as we headed for the Pali Highway, the place where the most famous Hawaiian battle took place. By the time we got to the battleground, the sun was rising and we were one in a huge row of slowly moving cars.

Claudia dropped me off at Hayashi Construction. Before she left, I leaned into the window. "Pick me up at four?"

"I'll be here."

I kissed her on the cheek, walked away, and clocked in. My eight-hour day of pushing wheelbarrows filled with cement and carrying long beams of wood was about to begin. I walked through the gate wondering when I'd actually ever get to hammer or weld something. It was weird to think of hammering as some kind of promotion. It disgusted me.

I walked through the gate and was greeted by my father's smiling face. We had left before him, and he waited outside to gloat. "What took you guys so long?" he asked.

"We took the Pali."

"You guys mental or what? Dis place stay by da airport and you guys taking da Pali? Likelike is faster."

I began walking toward the building and my father followed. "I don't know," I said, "Claudia likes the Pali better. Besides, she was thinking that maybe the Pali is faster."

"You fuckin' kidding me. She know her miles or what? You two must've drove at least five miles more den me. I guess das fuckin' Korean logic, ah."

We walked through the door. The other guys were waiting by the time clock in the warehouse, smoking cigarettes and drinking coffee. "Dad, you gotta lay off the Korean shit. It drives her nuts. And when she gets nuts, she makes me nuts. Please Dad, give her a break."

He smiled. "You know, son, you right. I should watch what I say in my own house."

Just as I was about to lose it, my father walked up to the rest of the guys, shook their hands, and began telling them how his son got whipped by a Korean swordtail from town. I felt like that same kid who he used to hit over the head with the wooden backscratcher. I wondered how much I was willing to tolerate.

<div align="center">✛ ✛ ✛</div>

Claude picked me up late at about a quarter after. When I got into the car, she said, "Sorry, traffic."

I nodded. "So what'd you do all day?"

"Well, I picked up Kealii's present. Take a look." She handed me a Liberty House department store shopping bag. In it was a folded unused box, packing paper and two baby-sized Polo shirts, one blue, the other burgundy.

I sighed. "Jeez, Kealii will grow out of these things in a month. How much did they cost?"

"About thirty dollars."

"For both?"

"Each."

I smiled. Crazy bitch, I thought. I put the two shirts back into the bag. "So what else did you do?"

There was a pause. Then she said, "I visited my mom."

This surprised me. "I thought she disowned you."

"Actually I've been talking to her for a while now. I think she's sorry about what happened."

"You don't even know what happened."

"She told me."

"She told you? What'd she say?"

"She said she threatened you to leave me. That she'd have you arrested if you stayed. She said you yelled at her and things got heated. And that after you guys argued you finally left."

"That's all?"

"Yeah, that's about all she told me."

I looked at her, trying to determine if she knew more. She must've known more, considering she saw my bleeding hand and my burnt forearm that night. I wished Koa was with us. He could usually tell when someone was lying. I was tempted to tell her the true story, but then, I didn't come out looking too good in that version either. I had killed three people. I had been prepared to kill her mother. So I let the subject drop. We drove home with nothing much to say to each other.

Dinner that night was a fiasco. Claudia had refused to eat at the same table with my father and my father refused to apologize for the night before. Claude waited in the room until my father went to sleep, then went to the fridge and got something to eat. Trying to ignore the whole thing, I spent most of the night watching T.V. in the living room. I was tired. I was beginning to realize that my life was becoming the life Koa had described. I was coming home after work and often regretting it. At least tomorrow was Saturday, I thought. I'd go to the party, get drunk with Koa, come home and pass out.

When I went back to the bedroom, Claude was already sleeping. She'd left a dirty glass and plate by the bed. I sighed and took them to the kitchen to wash them. After I was done, I grabbed a beer from the fridge and watched Jerry Springer. The panel was full of family members fighting and I laughed. In the middle of all the screaming, there was this shrink trying to calm everybody down. No one listened. I fell asleep in

front of the T.V. that night with an empty beer bottle in my hand.

■ ■ ■

The phone woke me the next morning. It was Uncle James. "Hey boy," he said, "what you doing today? Come down, help us set up fo' da party."

Just then, I saw my father walk out of the bedroom. His hair was messy and he was wearing only his boxers. His gut hung over the elastic waistband. He reached for the bathroom door knob, but it was locked. I heard him say, "Fuckin' Korean."

I put my mouth back near the speaker on the phone and said, "Yeah, Uncle, I'll be right over." I looked out the window and saw dark clouds forming over the ocean.

It was the same deal as the graduation party Koa and I had on top of Puana hill years before. We hung up the same blue tarp, set up the same tables, and we even put everything in the same place. Everything and everybody looked older, though. The tarp had lost its crisp color and was looking dull like a real sky. The wooden tables were chipping at the edges. Most of the folding chairs had lost some of the rubber nubs on the bottoms of their legs. Some of the chairs were rusting badly.

While I folded out the chairs and put them at the tables, I watched the old uncles set up. Most were fatter then they had been at the grad party. Some of them limped now, or easily ran out of breath. Koa's cousins, the guys closer to our age, had begun cultivating their own beer bellies. Then there was the growing number of children, a lot of them rail-thin. It was like the evolution of the country folk was happening in front of me. After unfolding the last chair, I looked over to Uncle James. "Where's Koa?"

He sighed. "I don't know. I tried calling da house, but no one answered. Fuck, da odda one, Kaika, Koa's younga bradda, I

don't know where he stay, too. When both dose guys missing at da same time, me and Aunty Kanani start fo' worry."

Uncle James pulled a cigarette out of his t-shirt pocket. It looked tiny in his enormous hand. Despite his panting, which had been caused by the hanging of the tarp, he lit it and took a long drag. "Sometimes, Ken, I wonder. What's wit' dose kids? Fuck, me and Aunty Kanani, we tried our best. But dose kids of mine, dey still come out fucked up. Dey eidda fighting or doing drugs. Da kids nowdays, I no understand. I wish Koa came out like you."

"Uncle, I ain't dat good."

"I know, but at least you stay hea showing kokua. Fuckin' Koa, dis his own son's birtday, and he not helping. At least you still know, family gotta take care family."

He never knew, I thought. He never knew that almost every time I was here on this hill, I was running from my family. I looked over the edge of the hill and saw that a few new houses had sprouted around the area. These were nice houses, two-story, with clean yards and shiny metal fences. When I looked at the older houses, they looked ugly as ever. Wearing either dried, crispy-looking wooden shingles, or rusting corrugated metal roofs, the houses looked like old wounds capped with crusty scabs. I looked out into the bay and noticed there were fewer flat bottom boats tied in the shit-brown water. All of a sudden, it started raining hard. I watched the rain pelt the ocean. The water reminded me of the story Koa had told me about his cesspool problems. I wondered if it were possible for the brown sea to overflow and reach the top of the hill.

I turned around and faced the mountain. It was still as green as ever. I thought about what I had said to Claudia the day before in traffic. How it would be better if more people left and fewer roads were built. I suddenly realized that people were going to be leaving, people who could no longer make a living in Hawai'i.

But then, more people would be coming, too, people who could afford to live here. I looked at Uncle James. "Things are changing, Uncle."

"Das da truth."

Like my father, he looked old. Old, tired, and run-down. The rain had wetted down his curly black hair. He dropped his cigarette and stepped on the cherry. The cigarette butt floated in a forming dirt puddle. He let out a violent cough, then smiled. "Ken," he said, "do me a favor, run store and go buy about three more cases beer. Here, I give you da money."

He reached into his pocket and pulled out a wad of bills, mostly ones. He handed me the wad. It was sprinkled with lint. I walked toward the Pathfinder dodging brown puddles, and I wondered how many more generations of Puanas the family would be able to pump out on this hill.

I left the hill to pick up Claudia at five. It was still raining, but when I got back home, she was waiting outside with a pissed-off look on her face. Before I could even turn off the engine, she pulled herself into the Pathfinder. "I can't believe you fuckin' left me here."

I smelled the rain in her hair. "What could I do? Uncle James needed my help. I can't leave him hanging. Koa didn't show so he needed another man as soon as possible."

"You could've at least waited until I got out of the shower."

"The party is tonight. We had to get it done."

She threw me a clean shirt and said, "Fuck you."

That's when I realized we were pretty far away from Schmaltz City.

She didn't even let me shower. While we were driving to Kahaluu, I watched the big raindrops strike the windshield. The wipers weren't fast enough to wipe them all off. I thought about how my and Claude's relationship had been. The laughter, the lack of concern for the future. Somehow things had changed,

and time was now a concern, therefore an enemy. Our lives were filled with questions of "when." When will the baby be born? When will we get out of Ka'a'awa? When will we move to the mainland? When will we get the money to make our escape? Time was like this burly interrogator shining a light in my face and threatening to kick my ass.

What we were stuck in now, it wasn't working for me. I looked over at the passenger side and what I saw revolted me. I saw a young, bitchy, pregnant woman, who probably found me disgusting, too. I thought about how Koa dealt with his feelings and it was beginning to make more and more sense. Why not say fuck it? I could hook up with Freddie, deal drugs, get my own place in the country and say fuck the world. Instead, here I was, working my ass off and coming home to shit. I focused back on the road and thought, I could just drop her off at the party and keep on driving. But where would I end up? I was on an island. I'd end up in the same place after driving in one big circle. As we passed Chinaman's Hat, I envied the little neanderthal island, all by itself out there, out in the ocean, but close enough to the shore. I re-focused on the road. I swore I saw a sign which read, Schmaltz City 2000 miles.

As we passed Kualoa Beach Park, I told Claude, "We gotta talk."

She sighed. "Yeah, I know."

"Is it going to work?"

"It could've if we went to the mainland instead."

"Yeah, maybe."

"So what do you want?" she asked.

"I want it the way it was."

"I don't know if we can get back there. Nobody invented the time machine yet."

"If it didn't work, what would you do?"

"Go crawling back to my mother."

We occasionally glanced at each other. But for the most part, I was looking out of the windshield watching the rain, while she fiddled with the air conditioning switch. We didn't talk for the rest of the ride. I began thinking that the dive light which we shared went off a long time ago and I didn't even notice it. Or maybe I got my own light again?

When we got to the party, we walked our separate ways. I went straight to the bar. Claude walked toward the dull blue tarp and greeted Kahala with a kiss on the cheek. I was surprised to see Cheryl there, smiling away.

Koa, Kaika and Freddie showed up at nine, about when the rain stopped. All three were frying from coke. I was glad to see them. The four of us gathered by the cooler and cracked open beers. I looked over Freddie's shoulder in the direction of the tarp, where I saw Kahala, Cheryl and Claudia playing with Kealii. I looked at the rest of the people at the party and noticed that their eyes avoided us.

I felt a hand on my shoulder. I looked up. Koa was grinning. "What's wrong, bradda, you no look too happy. See, I told you da life wasn't all it was cracked up to be."

Freddie laughed. "See, you guys stupid, hooking up wit' one girl and living wit' her. Me, I jus' nail 'um for about a month, den when I get tired, I fuckin' dump 'um. Fuckin' Kaika, learn from dese two braddas. If we catch you getting married and shit, we goin' mob you."

They laughed. "Shit," I said, "at first was fuckin' great. But now, I don't know. Just shitty."

"I know, brotha," Koa said. "Fuck, at first, I was stoked I had Kahala. But damn, my eyes went open. I glad she staying ova hea away from me."

It finally happened. Instead of Koa reading my lie, I read his. I knew when he said it, that it was killing him that Kahala had left him and hadn't come back. Before I could brag about my detection, however, Freddie spoke up.

"See, you guys so fuckin' stupid. It's like dese chicks sucked out your brains wit dea pussies. Fuckin' good ah at first. Dey fuck your brains out, do any kine. But afta a while, you notice, dey no give your brains back."

Kaika laughed. "Ah, you two stupid fuckas."

Koa stared at him. "What was dat?"

"Nah, nah," Kaika said.

"You betta 'nah, nah' you fuckin' little drug addict piece of shit. You betta tink befo' you open your fuckin' mout."

I could see the rage building up in Koa. I looked at Freddie, who seemed to be enjoying it. "Hey, cruise," I said, "dis one fuckin' party. Jus' relax."

Koa looked at me. "Relax? You, you Japanee motha-fucka. You take off fo' fuckin' yeas and you come back and you tink you can tell me what fo' fuckin' do? You and your fuckin' chick come down hea and start giving my wife money? You tink I neva know, ah? You should know you cannot lie in front of me. Now beat it. Dis is one family matta. Mind your own fuckin' business."

Just as I was about to walk away, I heard Kaika's voice. "Fuck you," he said.

I think maybe Kaika thought it was three against one, that if Koa attacked him, Freddie and I could pull Koa away from him. He was wrong. Without saying anything, Koa hit him right on the bridge of his nose. It was as if Kaika's nose exploded. Blood shot everywhere. Some caught my shirt, some sprayed on Freddie's face. I looked back at Kaika. His nose was this drooping mass without cartilage to hold it up. It looked like a popped balloon pinned to his nose. Before Kaika could even touch his nose, Koa hit him again. This time, Kaika went down. Freddie grabbed one arm, I grabbed the other. Koa flung us around like rag dolls while he repeatedly kicked his brother in the ribs. Finally, Uncle James showed up. Without hesitating, he blasted Koa right

in the jaw. Koa stopped kicking Kaika and looked up. It was like he was responding to a tap on the shoulder.

Koa pulled his arms away from me and Freddie. "Hit me again, you fucka," he said to his father.

But Uncle James just said, "Go. Get da fuck off my property. And neva come back."

"Okay, you fucka, but befo' I go, you betta give me back my wife and kids."

"Dey no like live wit' you," Uncle James said. "In fact, nobody like live wit' you. Now get da fuck outta hea."

Koa ignored him. He marched toward the tarp, where Kahala and Claudia were holding the kids. Cheryl stepped away from them. Uncle James, Freddie and I followed Koa. As Koa walked, the people parted. We followed in his wake. When he got to Kahala, she gripped the baby Kealii tightly. The baby began crying and Kahala didn't look up at Koa. Claude did, though. She stared at him, pregnant and completely unafraid.

Koa stared at Kahala. "C'mon, we going home."

Kahala was quiet. She just stood there and rocked Kealii, who was screaming his head off. I looked at Cheryl, wondering if that lawyer mouth of hers would start. She was frozen.

Claudia spoke. "Get the fuck out of here."

I only had about a tenth of a second to feel admiration and pride toward Claude. Before Koa's fist reached Claude, I managed to snap out of it and grab his arm. He swung his other arm at me and hit me on the head. It felt like my skeleton shook. Before he could hit me again, Uncle James grabbed his other arm. Uncle James' wife came on the scene. Aunty Kanani stood in front of Kahala and screamed, "Koa, you get da fuck home!"

The scream was so loud, my ears rang after she yelled it. In fact, in the houses below the hill, the lights began turning on. Kealii stopped crying and looked at his grandmother. The scream seemed to have affected Koa, too. He stopped struggling and

looked at Kahala. "O.k., you fuckin' bitch. Stay. But you betta give me my kids or I goin' fuckin' kill you."

Kahala was still rocking Kealii. Again she said nothing. Claudia looked at me with disgust. "I telling you one more fuckin' time," Koa said. "You fuckin' give me my kids or I going fuckin' kill you."

Kahala remained silent. I noticed Cheryl had left. Aunty Kanani picked up Kealii from Kahala's lap. "You get da fuck outta hea now," she said. "You not touching dese fuckin' kids."

Koa turned around and walked away toward his truck. Kahala watched Koa and then ran. I ran after her, wondering what had made her panic. Even with my speed, I had a hard time keeping up. Before I could reach her, she took off in Aunty Kanani's little Honda Civic. A few seconds after the car had left, I saw Koa's truck whiz by. I ran again. I ran as fast as I could. It was dark. I stepped on a patch of sleeping grass and it awoke, its thorns biting into the soles of my feet. The rain started again in a slow drizzle.

When I reached Kam Highway, I heard metal crash against metal. I tried to run faster. The street lights guided me. The rain fell harder. I heard a gunshot. It was like the amplified sound of wood snapping. When I finally saw the two cars about a hundred yards away, both had toppled off the side of the road. I heard another gunshot.

When I reached the crash site, I saw both cars down the embankment. The Honda was smashed into the thick mangrove plants growing at the edge of the ocean, while the truck was completely turned over. Both cars' lights were still on. I didn't want to look any closer, but I felt my legs move me closer to the Honda.

I climbed down the embankment and felt my feet sink into the muddy shore. I looked through the smashed driver's-side window. Kahala's dead body was held up by the seat belt.

Her head leaned down toward the steering wheel. The bullet had gone through her temple. I quickly stepped back and tripped. I landed on Koa's body. Trying not to look at it, I scrambled up the embankment.

I saw the Pathfinder approach. Before Claudia even made a complete stop, I opened the door and jumped in. "Let's go," I said.

She looked at the smashed cars. I looked at her. "Let's go," I said again.

She turned the Pathfinder around and drove towards Kaʻaʻawa.

I didn't even go into the house. I grabbed my wetsuit and diving gear from the garage and walked toward the beach. I felt Claudia grab my arm. She was saying something, but I wasn't listening. I pulled my arm out of her grasp and marched toward the sand. She was screaming and following me.

When I reached the shore, I took off my clothes and put on my wetsuit. The entire time Claudia was yelling at me. Ignoring her, I put on my mask. When the fog built up in the glass, I couldn't see her either. While I was putting on my fins, I felt her hitting the top of my head. I felt for my dive light, bang stick and spear. I think she took it as a threat. I didn't feel her hitting me anymore. It pissed me off that she thought I would actually spear her or something, that she thought I was like Koa. Before putting the snorkel in my mouth, I yelled, "Get back in da fuckin' house and leave me da fuck alone!"

Before I could hear her response, I quickly slipped into the black water and slithered out toward the horizon.

The water was freezing. The rain dirtied the water, so visibility was bad. I swam over the spot where my father had thrown me in years before. Without even looking for fish, I swam out in the sand fog toward Chinaman's Hat. It was a long swim, but I kept heading out. The tide was high, so the reef in front of

Chinaman's Hat was easily deep enough to swim over. I kept my head down and kicked hard. I shined the light ahead of me. The water was cold and dirty so I couldn't really see too far in front of me. I didn't have enough room in my head to worry about it. All I could really see was the image of Kahala's dead body held up by the seat belt. All I could really feel was hatred for Koa. I kept telling myself that his killing and my killing were different from each other. My body shook because I feared they were not.

By the time I reached the island, I was blowing hard through the snorkel. I took a deep breath and swam behind the island. I tried to look for fish there, hoping the hunt would clear my head. Every time I dove and stuck my head under a deep crevice and saw a fish camouflaged by the dirty water, I hesitated. I was letting fish go left and right. I was making myself even angrier. I stuck my head out of the surface of the water and spit out the snorkel. I shined my light toward the horizon, which was so dark and far away that I couldn't see it. I turned around and shined the light towards Chinaman's Hat. I looked at the massive head and watched the surf crash into the rocks on the back of the island. There was no sand on this side, only a rocky surface. I turned back around, not knowing which direction to go. Suddenly I felt a cramp hit my foot. Reaching for my foot, I dropped my spear. I put the light in my mouth and grabbed my foot with both hands. Bending my toes back, I began to sink. As my head sank below the surface, I held my breath and closed my eyes.

I felt something bump me and my eyes shot open. The light fell out of my mouth, but I caught it with my hand. I shined the light away from me while I spun in circles. I squinted my eyes, trying to see beyond the dirty water. I felt the strong current drag me closer and closer to Chinaman's Hat. Just as I turned toward the island, I saw the tiger shark gliding out of the darkness. It was the biggest I had ever seen. As it neared, I frantically kicked away from it without turning my back. I saw the bubbles rise from my

kicking fins. Through the bubbles, I saw the head of the shark grow bigger and bigger. Suddenly, I felt like giving up. I almost hoped for the shark to reach me and bite me in half. I reached down to the leg of my wetsuit to make it stop kicking. Instead of feeling my leg, I felt the bang stick strapped on my thigh.

I banged the shit out of it. I slammed the stick on its gills and watched as pieces of the shark exploded on the other side of it. It looked like twenty pounds of its flesh had disintegrated from its body. The clouds of blood spread and dirtied the water even more. Like a smoking airplane crashing with wings not big enough to glide, the shark began its decent into the darkness. Its body shook uncontrollably as it disappeared from the shining of my light. With the bang stick in my hand, I kicked my way back to shore.

When I reached Kualoa Beach Park, I ripped off my mask and threw the bang stick and light on the sand. My lungs felt like they were about to explode. I dropped down in the sand. It had stopped raining. I listened to my heavy breathing. I heard the wind blow against the palm trees behind me. I looked toward the ocean and saw the white wash creep upon the sand. I listened and wept as the water hit the sand, making each grain smaller and smaller.

■ ■ ■

I didn't get back home until about four in the morning. Through the entire walk, I had wondered whether Claudia was still at the house. I didn't think so. I didn't think I would be. If she were home, I knew I'd give everything for her. I knew we'd fly to the mainland that morning if that was what she wanted. I had had enough of the Windward side. While walking along the side of Kam Highway, I knew I should've been running, but after the swim, after the entire night, I could no longer run. My legs wobbled with each step I took. I hoped she was home because if she was not, it meant she'd gone back to Mama-san, and if she

went back, I didn't know whether I would chase her. I didn't feel like I could kill or run any longer. When I reached the house, I was surprised to see the living room light was still on. When I heard the screaming, I rushed toward the light.

The place was trashed. The television was turned over, its face of glass shattered. Shards of glass were spread over the carpet. A lamp was also on the floor. The shade was off and the bright bulb momentarily blinded me. I looked at the sofa and saw two suitcases full of clothes open as pieces of Claudia's clothes hung from the edges. My fatigue instantly faded as I saw Claudia, lying in front of the glass case, with my father standing above her with both fists clenched.

"What da fuck is goin' on?"

My father looked toward me. His face was the angriest I had ever seen. "She tried fo' fuckin' leave when you wasn't home. I told her fo' wait, but she neva like listen. I fuckin' told her wait. Den she went tell me 'fuck you' and called me one fuckin' Jap. I no give a fuck who you are, you call me one Jap, I goin' fuckin' whack you."

I ran toward them and shoved my father away from Claude. I bent down and turned her on her back. Tears streaked out of her eyes. She was holding her stomach. Her eyes closed tightly, like she suddenly felt intense pain. I looked up at my father and said, "Call one fuckin' ambulance!"

I looked back down at Claude. She yelled, "Get the fuck away from me!"

"It's me Claude, it's Ken. Don't worry."

"Get the fuck away from me!"

I looked to see where my father was. He put down the phone. "She shouldn't have called me one fuckin' Jap."

After Claude screamed, "Get the fuck away from me!" one more time, I stood up and stepped toward my father. I looked down at his face and said, "You are a fuckin' Jap."

"You dumb fuckin' kid," he said. "I was killing fuckas befo' you was even born." Then he hit me. My legs were still wobbly from all the running, swimming and walking I had done the entire night. I couldn't hold myself up. I felt my legs take three frantic steps back until I felt my heel hit Claudia's body. I tripped and fell through the glass case. After I had landed, I glanced at my hands and arms. Both were streaked with blood. I looked down at Claudia on the floor holding her stomach. Pieces of glass surrounded her. She looked like a swordtail whose fish bowl had been dropped on the ground. My father stepped toward me with that crazy, angry look on his face. He looked magnificent. The hatred pumped through my body, but instead of transforming to rage, my hate turned into something cold. I felt behind me and touched the hilt of the fallen katana. I looked up at my father and smiled. His expression didn't change. I felt my arm pull the blade of the katana from its sheath. My father's face flinched as I jumped at him with the naked blade. For a moment I saw a brilliant light. A light so intense that it should have blinded me. But it didn't. I stared right into it. When the light vanished, nothing was left but darkness.

❖ ❖ ❖

It was the longest session yet. Ken seemed to speak slower during this session, not wanting the story to end. Cal had spent the over-time touching up. The signs of sunlight somehow crept through the cement walls and steel door. Darkness slowly evaporated as a dull light bloomed slowly in the cell. Soon the guards would buzz the doors and notify the prisoners that it was time for breakfast. Cal was neither hungry nor tired. He sat in back of the now silent Ken, looking at the finished tattoo.

Ken got up and stretched. He turned around and shook Cal's hand. "Thanks."

Cal knew the blinding hatred which had brought Ken here. For years he had recognized the cutting of his throat as a kind of penance, a

punishment for what he had done to his wife and kids, but now he missed his voice. He wanted to ask Ken questions, he wanted to tell Ken his story, but most of all he wanted to say, "Hey, even though I'm white, I know your story because it's so much like mine."

Cal felt the scar on his throat. Ken put his hand on Cal's shoulder. "Must be tough not being able to talk."

Cal nodded. "Did you like the story?" Ken asked.

Cal nodded again. "Why?" Ken asked.

Cal put his index finger on Ken's chest. Then he put his other index on his own. Cal moved both fingers away then put them together. He kept both fingers side by side for a few seconds, then extended his arms while the fingers stayed parallel to each other.

Ken smiled. "Either you're proposing marriage or you're trying to tell me that you lived a similar life."

Cal put up two fingers. Ken laughed. "Number two, thank God."

Cal smiled. Ken sat down against the wall. "Well, let me get a little philosophical with you, then. I guess when I think of me, Koa, my father — hell all of the boys, and think about how we grew up, it occurs to me that people are like things being built. I mean, I don't know what they build in places like Beverly Hills, lawyers, doctors, who knows, but I do know what's being built on the Windward side. Bombs are being built. We're like old-time artisans down there, passing down our bomb-making skills from generation to generation. Only, it's not that simple because as we make these bombs we are almost arbitrarily rationed a certain amount of each ingredient. Like take Koa. Uncle James and Aunty Kanani wanted to make a weak bomb out of him but they were given a ton of gunpowder and a short fuse. Me, I think I came with less powder and more fuse, but unfortunately my father was a master bomb builder. The army taught him, I guess. Hell, Claudia, she was like one of those crazy bomb squad people trying to defuse the booby trap. Luckily, when I exploded, she took a step back. My father took it, though. It's the tragic life of a bomb-maker or bomb-defuser, you've got a good chance of blowing yourself away."

Ken walked to his box of books. He picked up his copy of *Native Son* and *Invisible Man*. "You see," he said, "books like this, they show problems and try to explain why. I don't know why. I can say race, but it's not that simple, especially in Hawai'i. It's not just black and white, it's Hawaiian, haole, Japanese, Chinese, Korean, Filipino, Samoan, Vietnamese. I could go on and on. Hell, look at you, you're white, but you went through the same kind of shit. I think of Koa, he's Hawaiian, and even though his people got the total fuck-over, that's not the only reason why he blew up. Me, the Japanee? Fuck, I don't know. All I know is that I'm part-son, part-lover, part-killer, part-Japanese, and part of some DNA strand named Kenji Hideyoshi. It's funny, I think about race and sometimes feel that it would be a lot easier if we were actually that different from each other. I ain't here because of race, I'm here because I'm human. But I'm an individual, too. And as Ken Hideyoshi, all I can do is get the fuck out of here, accept what I am, and make sure I never come back. No matter what happens, though, I live with the comfort that Claude and the kid will be o.k. It keeps me going."

Ken tossed the books back in the box. Cal thought about Ken's story and his own and wondered whether either could have turned out differently. It was a tough question to ask. Nobody in here wanted to think that they always had the power to prevent their fates. But for an instant Cal wanted the truth. He scratched his head. Maybe he could've stopped himself, but he didn't know for sure. Just then the doors buzzed. It was time for breakfast.

Ken was looking at himself in the stainless steel mirror. "Fuckin' shitty mirror. I can't even see myself. Did I tell you Claudia's coming to visit with the kid?"

Cal walked out of the cell silent, with only the promise of the story of what would happen between Ken and Claudia soothing him. He wanted to speak, but he didn't know what he'd say.

As Ken walked out to start on another long tick of the clock, Cal silently wished him the best. He was the last ronin, presently in a world that may have suited him, soon to be released in a world that would not

embrace him. But like the ronins before him, he would search for work that fit him, try to live honorably and maybe even die bloody. It was to live by the sword. Cal was glad for Ken that his son would not have to live the same way.

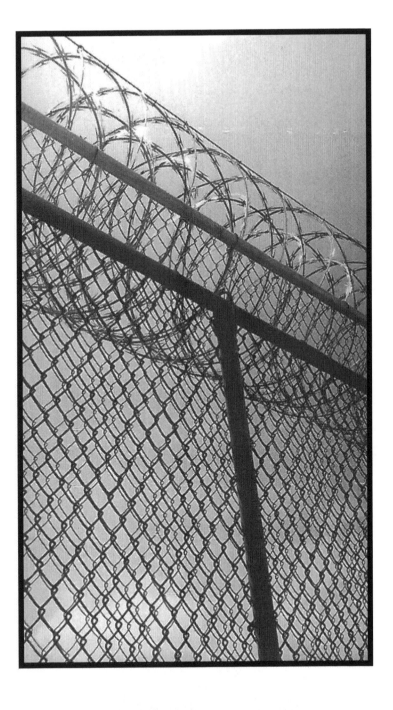

epilogue

"Going, like an ebb tide flowing,"
like a tradewind blowing,
soon you will be far across the sea.
Flying, soon you will be flying,
like a teardrop drying,
leaving just a memory."

Flying
The Peter Moon Band

Claudia Choy sat in her mother's Mercedes. She got up on her knees and turned toward the back seat. "Craudia," her mother said, "you sit down now." Claudia felt her mother's arm push against her lower back. She ignored it and reached her hand out to her baby. Christian, Claudia's two-year-old son, slapped his mother's hand away and said, "No."

Claudia sighed and turned back around to sit down. "Mom," she said, "I told you not to give him apple juice anymore. His teeth are getting rotten."

Her mother laughed. "When you on da plane wit' him, you glad I give him apple juice. If not, he cry and cry."

"Yeah, but you're not going to be the one who has to get him off that stuff when we get to San Francisco. Look at him, it's like his crack. He's so spoiled."

Claudia adjusted the rearview mirror to look at her son. He seemed to be ignoring them. He just looked out the window and sucked on his bottle of apple juice. Claudia pushed the mirror up slightly and looked at the open trunk, which was stuffed with her suitcases. She sighed and tried to put the mirror back where she thought her mother would want it. As soon as she took her hand off the mirror, Claudia heard her mother sigh. Her mother re-adjusted the mirror. "Pabo," she said.

"Mom, don't call me stupid."

"You no touch mirror, and you no complain I spoil my grandson. I'm grandma. I spoil. And you know..."

"Mom, don't start."

"Well, where we go now? We go visit my grandson's father. In jail. In jail."

Claudia's mind flashed to the night her son was prematurely born. She remembered the blood and the pain. She had been blinded by the pain, blinded so much she could only hear the yelling between Ken and his father. She felt Ken trip over her body, she heard Ken fall through the glass case. But she remembered the pain the most, up until the pain became silent. When the pain became silent, she no longer heard son and father yelling, instead it seemed quiet for hours. Then she heard the sound of the blade sliding from its sheath. Her pain returned and she almost lost consciousness. She managed to stay awake, though, not through her own strength, but instead because she felt the hot, gushing liquid as it dumped on her face. It was more shocking than a bucket of cold water to the face, because despite her blinding pain, she knew what the steaming liquid was. This realization sent her eyes shooting open, and when she looked up she saw Ken standing above her, standing there with blood all over his naked torso, with the sword hanging from his clenched fingers, her eyes froze open.

Then her eyes moved up to his face. Behind his head hung the wrinkled Musashi print. It was a disturbing image. His head blocked out Musashi's torso so that it looked like Musashi's arms came out of Ken's head. Both arms held wooden sticks and for a moment Claudia wondered what kind of wood the sticks were made of. She looked at Ken's face and saw it was speckled with blood. She would not have been so scared, it occurred to her, if he didn't look so calm, so serene. But his calmness had shaken her up badly. When he looked down at her with that look, that look that seemed to try to tell her everything was fine, and bent

down and extended his bloody hands toward her, she screamed
and lost consciousness.

■ ■ ■

Claudia watched as her mother took the Halawa cutoff.
"One hour," her mother said, "one hour, den you go airport."

Claudia had already told Ken she had gotten accepted into
a graduate Art History program at Berkeley, and that of course
she planned to take their son Christian up with her. She had
written him often, not wanting to visit, not knowing if she was
ready to see his face. She knew if she saw it too soon, she'd still
see the speckled blood on it and probably pass out at the sight.
She laughed to herself. It had taken thousands of dollars of
psychiatric help for her finally to be able to suppress the image,
to get a solid night of sleep.

The Mercedes pulled up to the gate of the Halawa High
Security Facility. Claudia looked up at the high fence and saw
the razor wire coiled above it. She wondered how many sleepless
nights Ken spent thinking of a way to get past it, but then she
remembered Ken never had the tendency to challenge what he
saw as insurmountable obstacles. She doubted that he had been
serious about moving to the mainland. In fact, during the later
part of her stay in Ka'a'awa, she had seen Ken as her own prison-
high fence, coiled razor wire and all. After they passed the gate,
Claudia felt her palms begin to sweat.

Claudia took Christian out of the car. She grabbed a bag
full of bottles and diapers. She closed the door and stuck her
head through the window. "One hour, Mom. He really should
get to see his son in person before I leave for the mainland."

Kilcha just sighed and waved her daughter on. Claudia turned
toward the building and walked in that direction with her son in
her arms. She wondered if this was where Ken had always been
meant to be. She wondered if there was any way he could have

avoided this. She felt that in killing his father, Ken had not committed a huge crime. She had hated Ken's father so much that his death didn't bother her too much. But as she walked toward the entrance of the building, she remembered the other crime he had committed, the one that had ended the lives of the three Koreans her mother had sent, one of them her cousin Dong Jin.

He had thought she never knew. But she had heard it that first night at Koa's. She'd heard the story told straight from Ken's mouth.

When Koa had called Ken into the bushes to show him the cess-pool that first day in Waiahole, Claudia leaned over to Kahala. "Hey, why don't you take your kids and go out to dinner? My treat."

Kahala frowned at Claudia. "Listen, don't give me some charity trip and don't try to get rid of me, too. You have your nerve, coming to my house and saying something like 'my treat.' Who the fuck do you think you are?"

Claudia was shocked that Kahala took it so badly. "I'm so sorry, I didn't mean anything by it. I'm so sorry. No, what I want to do is act like we all went to dinner. I'll write a note saying that we went, but I'll stay back here and try to listen to what they talk about. I'm sorry, I didn't mean to offend you. It's just that I know they'll hold back if they know I'm around and I really want to understand this relationship between Koa and Ken. I'm trying to understand Ken better and this might really help."

Kahala frowned. "What have you been smoking? Listen, as a woman who has lived with Koa now for years and has listened to him and his friends talk, I'll tell you, you probably don't want to hear any of it. It's all pretty standard macho stuff. And if it's not standard, it's stuff that'll scare the shit out of you. Listen, you're better off coming with us to dinner."

But Claude refused. So Kahala shrugged, called her kids, and jumped in the Pathfinder. Before Kahala left, she told Claudia

that she'd pull the Pathfinder behind the house when she returned. Claudia thought it was a stupid plan until Kahala told her she always drove over the California grass around the house. She told Claude it was the only thing which kept the house from being buried beneath the long, thick weeds. She assured Claude that Koa would think nothing of it, and therefore neither would Ken. They agreed to meet at the back of the house. Kahala rolled her eyes and drove off. Claudia sneaked into the house and listened as Ken and Koa sat down at the picnic table.

As Claudia walked through the doors of Halawa, she remembered listening to Ken and Koa. It was the one great thing about a skeleton house, she thought, sounds travelled easily. Ken called the men he'd killed "Nameless Koreans." But she knew one of their names. Dong Jin. She knew it was him by the way Ken described the Korean holding the gun on him, the way he described Dong Jin's long hair and small yellow teeth. Dong Jin was a name which her great-grandfather had once worn. It was a name which meant a great deal to her family. Dong Jin was not just one man, but he was also a product of survival, a being who lived because others had survived before him, survived Japanese occupation and civil war. He was cherished.

She understood why Ken had killed him. In fact, when she heard the story, she told herself that she would've done the same in that situation, but she still felt like he had amputated a limb from the body of her family.

Claudia met a guard at the desk and was instructed to wait. Several minutes later, she and Christian were led to a room in the back which held a row of partitions. Claude was surprised to see that, like in the movies, she would have to see Ken through a window and talk to him through a phone hanging on the partition. She sat in the chair and waited for her son's father. Christian started to cry. Claudia took a bottle of apple juice out of her bag and gave it to her son.

He didn't look that different to her. A bit skinnier and a bit lighter skinned, but he still walked with the same confidence that had attracted her to him when they first met. Ken sat down in front of her and smiled. They both picked up the phone. They both tried to talk at the same time. Ken stopped and let Claudia speak. "You look good, Ken. So how bad is it?"

"Bad. Fuckin' bad. But hopefully I'll be out of here within a year."

Claudia knew he should have been let out already. He had been charged with involuntary manslaughter and after two years he should have been let out on parole. But Ken had never made this entire ordeal easy on himself. He had refused to hire a lawyer and instead had relied on a public defender. A good lawyer might have gotten him off on self-defense, or at least convinced the court that he was defending his girlfriend and unborn child, but Ken had let the public defender plead the case down to involuntary manslaughter and had gone to jail without a word of complaint. It was because Ken himself didn't really remember what had happened and he refused to have his public defender call Claudia as a witness.

Claudia had not seen any of this process. She was in the hospital when he got arrested and charged. She was instructed by her psychiatrist to stay away from him during his arraignment and sentencing. She heard the story secondhand from the only person who really stuck with Ken through the whole thing, Uncle James Puana. He had somehow found her mother's telephone number and called to tell her what was going on. She was able to tell from the tone of his voice that Mr. Puana thought she should go visit him, but she couldn't bring herself to do it.

So as Claude looked at Ken through the glass, she felt a deep sense of guilt. "I'm glad to hear you'll be getting out soon," she said. "We both know you shouldn't be in here."

Ken's eyes were pre-occupied with his son. He did not even glance at Claudia when he spoke. He stared at his son and smiled. "No, we both know I should."

Ken's eyes drifted up to Claudia. "Did you get the money?"

"Yeah, I did. I got the money from the bank, the money your father left for Christian, the money from the house and car. I left an account for you when you get out. Ten thousand."

"Take it all."

"Ken, you need it more than I do. I have my mother helping me. You're going to need some money to start over."

Ken laughed. "Claude, I'm not starting over. I'm too damn tired to start over. Don't worry, I'm not going to follow you and the kid or anything. In fact, I want you and Christian to stay far away from me. I don't want the kid near me. But start over? I ain't starting over shit. But on a positive note, I ain't coming back here either."

Claudia sighed. "Well regardless, the money will be there."

Ken drummed his fingers on the counter. He looked back at his son. "Don't tell him about me," he said.

"Listen," Claude said, "I don't want to argue. He has a right to know about you. When he asks, I'll tell him. If he wants to find you, I'll show him how. Ken, I'm not ashamed of you, and he won't be ashamed of you. You shouldn't be ashamed of yourself."

Ken's eyes drifted downwards. He looked back up. "Guess what, I got a new tattoo."

"Let's see it."

Ken turned around and lifted his shirt. Claudia saw the enormous tattoo stretched across his back. It was kanji. The black was scabbing. Ken put down his shirt and turned around. He smiled and picked up the phone. "*The Book of the Void*. Sums it up nicely, doesn't it?"

"Your life isn't over, Ken. You can change all of that."

Ken smiled. "Yeah, probably." He drummed his fingers on the counter. "Listen," he said. "Anyway, thanks for coming. But listen, I think I should be going now."

Claudia looked at her watch. She had been there for only about ten minutes. "Come on, Ken," she said, "we have an hour."

Ken's face turned angry. Claudia felt the legs of her chair inch back, scraping against the floor. For the first time she saw the resemblance between Ken and his father. "Listen," Ken said, "I was under the impression that this hour was for me. Well, I'm saying it's over. But before I go back in, I want you to know, that night, that night Koa died, I was ready to go to the mainland. I want you to know, I was willing to go."

Ken looked at his son one more time before standing up. Christian was still silently sucking on his bottle of apple juice. Before putting the phone down, Ken asked, "Hey, isn't he a bit old to be drinking from a bottle?"

Claudia laughed. Ken started to laugh, too. He put down the phone and waved to his son. Christian waved back. With that done, Ken turned his back and stepped to the door. He pounded on it. Claudia watched as he walked through the door without turning around one more time to say good-bye.

On the ride to the airport, Claudia wondered if Ken was going to be o.k. She ran the image of his new tattoo through her head. *The Book of the Void* in Japanese. Suddenly she realized the tattoo wasn't about Ken, that he didn't mean for it to represent only his life. Instead it represented the fate of the entire Hideyoshi line. Most importantly, it represented the fate of the son he would not raise. It was a fate no longer infected by a lineage of hate and pride. Ken had cut the ancesteral thread, and when she realized this, she felt an instant of complete love for the man. He had fought, and he had won. Because of his sacrifice, though unconventional and twisted, she would no longer have to strike an unbreakable blade on stone. Yes, she remembered Ken's father's

demonstration of the sword well. She had gotten the message, but tried not to accept it.

As the car neared the airport, Claudia saw a plane shooting up above her. She wondered if Ken knew he had won. She wasn't sure, but she thought if he didn't, he would. She looked up again and knew that at least she and Christian would be o.k. And she knew that, at least, was enough.

glossary

ahi	yellowfin tuna
aku	skipjack tuna
ali'i	Hawaiian chief
Amaterasu	Shinto goddess of the sun
aumakua	Hawaiian family god
awa'awa	milkfish
bebeddies	men's briefs
bobora	Japanese national
daimyo	Japanese feudal lord
geisha	Japanese courtesan
haole	foreigner; Caucasian
hapa	person of half-Caucasian and half-Asian descent
hapai	pregnant
imu	Hawaiian underground oven
kabuki	Japanese theater developed in the seventeenth century
katonk	Japanese American from the continental United States
lai	leatherback (fish)

lomi	to knead
luau	taro leaves
lumpia	Filipino appetizer or dessert
maile	twiny Hawaiian shrub
medaka	plain, gray guppie found in local streams
Momotaro	the peach boy in Japanese folklore
O.I.A.	Oahu Interscholastic Association
omaka	blue runner jack
papio	juvenile jack
poke	cubed raw fish mixed with a relish
ronin	wave person; masterless samurai
sansei	third-generation Japanese American
solé	Samoan
talapia	cichild found in local streams
weke	goatfish
yobo	Korean

Made in the USA
Lexington, KY
24 June 2012